The J. Paul Getty Museum

 $\begin{array}{c} \text{HANDBOOK} \textit{ of the} \\ \text{Antiquities Collection} \end{array}$

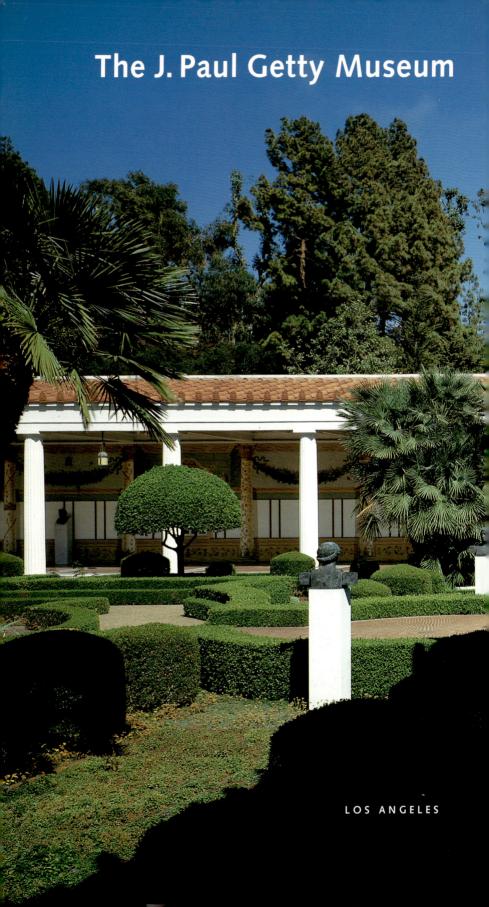

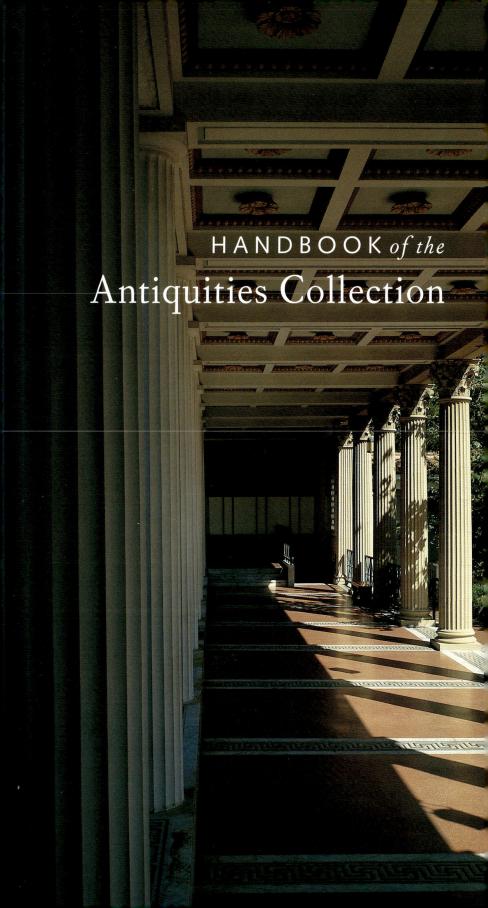

Getty Publications 1200 Getty Center Drive Suite 500 Los Angeles, California 90049-1682 www.getty.edu

© 2002 J. Paul Getty Trust First Edition

Library of Congress Cataloging-in-Publication Data

J. Paul Getty Museum.

The J. Paul Getty Museum

handbook of the antiquities collection.
p. cm.

ISBN 0-89236-663-X (cloth)— ISBN 0-89236-664-8 (pbk.)

Art, Classical—Catalogs.
 Classical antiquities—

Catalogs. 3. Art — California — Malibu — Catalogs.

4. J. Paul Getty Museum— Catalogs. I. Title: Handbook

of the antiquities collection. II. Title.

N5603.M36 J25 2002 709'.38'07479493—dc21

2001006121

Publisher
Christopher Hudson
Editor in Chief
Mark Greenberg

Editor
Tobi Levenberg Kaplan
Editorial Coordinator

Mary Louise Hart

Designer

Jeffrey Cohen

Curatorial Coordinator

Benedicte Gilman

Production Coordinator
Elizabeth Chapin Kahn
Photographers

Ellen Rosenbery with Lou Meluso Anthony Peres

Jack Ross Bruce White

Cartographer David Fuller

Typesetter
G&S Typesetters, Inc.,
Austin, Texas
Color Separator

Professional Graphics, Inc., Rockford, Illinois Printer

CS Graphics, Singapore Printed and bound in

Singapore

On the cover:

Funerary Wreath, detail (see pp. 88–89).

On the title page: Outer

Peristyle Garden of the Getty Villa in Malibu, 1991. Photo: Alexander Vertikoff.

On p. vi: Statue of a Muse (Melpomene or Polyhymnia), detail (see pp. 166–167).
On pp. viii-ix: Colonnade

and wall paintings facing the Outer Peristyle Garden of the Getty Villa in Malibu,

1991. Photo: Alexander Vertikoff. On p. 1: Statuette of a Harpist,

detail (see p. 8).

On pp. 12-13: Statue of

a Victorious Youth, detail (see pp. 44–45).

On pp. 102–103: Seated Poet

and Sirens, detail (see pp. 116–117).

On pp. 128–129: Patera
Handle in the Form of
a Nude Winged Girl, detail

(see p. 136). On pp. 148–149: Snake-Thread Flask, detail (see p. 208). Deborah Gribbon vii FOREWORD

Marion True xi INTRODUCTION

xxiii NOTES TO THE READER

xxiv MAP OF THE CLASSICAL WORLD

The Collection

Preclassical	1
Greek and Eastern Mediterranean	13
South Italian	103
Etruscan	129
Roman	149
GLOSSARY	226
INDEX	231
A C K N O W L E D G M E N T S	237

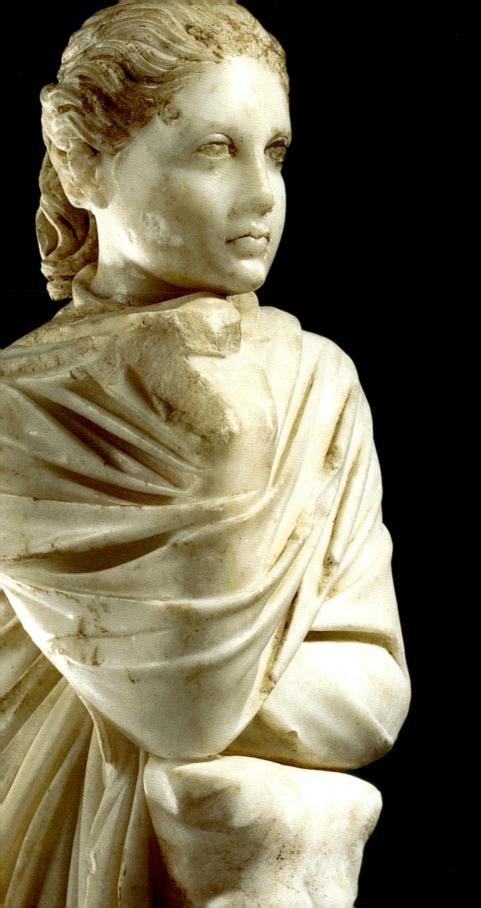

Foreword

Perhaps no collection in the Museum better exemplifies the passions, interests, and ambitions of its founder, J. Paul Getty, than that of Greek and Roman antiquities. Through his travels in the Mediterranean, his reading of specialized literature, his own fictional writing set in Herculaneum, and, above all, his ardent collecting of antiquities, Mr. Getty exhibited a profound personal engagement with the ancient world that lasted from his first purchase in 1939 until his death in 1976. The reasons for his fervent interest were many and included his admiration for the great personalities of ancient history, his nearly equal emulation of or rivalry with other celebrated collectors of ancient art—from Emperor Hadrian to Cardinal Mazarin to Lord Lansdowne to William Randolph Hearst— and his perception of ancient art's ability to evoke the magnificence of the Classical Age. This latter concern, not only to evoke but to replicate antique splendor, was the driving force behind his reconstruction of the ancient Villa dei Papiri in Herculaneum as the setting for his collection in Malibu, California.

Since the days of Mr. Getty, the Museum's collection of antiquities has grown significantly, expanding into new areas—such as Greek vases, funereal objects, and Cycladic art—to the extent that it now rivals the much older collections of New York's Metropolitan Museum of Art and Boston's Museum of Fine Arts, both founded in 1870. The collection is particularly rich in luxury objects and art associated with Classical theater, so it offers a profound commentary on the culture of ancient society.

For the enduring quality and significance of the Museum's Antiquities collection, as well as its expansion, I owe a great debt of gratitude to Marion True, its curator since 1986. Marion and her staff have labored tirelessly to make this collection accessible and meaningful to both scholars and the general public, through publications, symposia, seminars, and lectures. Our desire to stimulate the understanding, preservation, and enjoyment of the ancient world through our collection and related educational programs will culminate in the re-opening of the Getty Villa, with its archaeological conservation training classes and its performances of ancient Greek drama. As a nexus for the study of ancient art and culture, the Villa will truly embody J. Paul Getty's aim to evoke the splendors of antiquity in all their complexity.

Deborah Gribbon

Director, The J. Paul Getty Museum

Vice President, The J. Paul Getty Trust

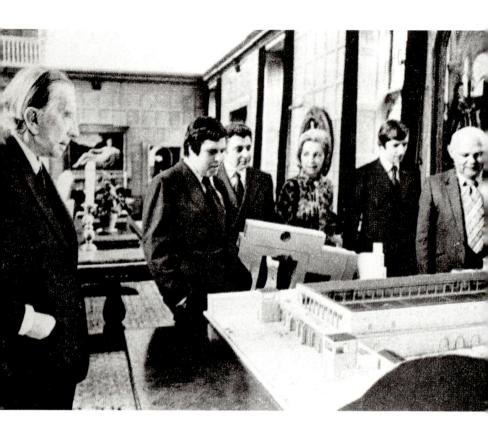

At Sutton Place, his home in England, J. Paul Getty (far left) and guests — among them his longtime assistant and Getty Trustee, Norris Bramlett (far right) — examine an architectural model of Mr. Getty's proposed museum in Malibu, California, 1971.

Introduction

he origins of the Getty Museum's Antiquities collection can be traced to a specific date: July 24, 1939, when Mr. Getty purchased a small terracotta group at a Sotheby's auction in London (fig. 1). Though this appealing composition of a female reclining on a couch attended by erotes would later be discovered to be a nineteenth-century imitation of an ancient group, it signaled a new direction for the 46-year old collector's interests, which until then had been concentrated primarily on decorative arts and paintings. If the first acquisition was rather inauspicious, it was quickly followed by a trip to Rome and the purchase of two fine marble portraits of Roman empresses that to this day remain cornerstones of the sculpture collection: a head of Agrippina (fig. 2) and a bust of Sabina (fig. 3). These portraits would presage Mr. Getty's enduring fascination with ancient Roman culture and Imperial personalities. Over the next thirty years, he would continue to add to his growing inventory of ancient objects bronzes, marbles, wall paintings, mosaics, and ancient glass that recalled for him the importance of the classical past. He was especially drawn to stone sculpture, and his most prized objects came with notable histories and distinguished pedigrees from old British and continental collections.

The pivotal object in the history of the Antiquities collection is the Lansdowne Herakles (fig. 4), a statue of Hercules that Mr. Getty purchased in 1951 from the collection of Lord Lansdowne in London (see also pp. 160–161). The well-documented history of the statue, discovered originally in 1790 near Hadrian's Villa in Tivoli, clearly appealed to Mr. Getty for its associations with the Roman emperor he most admired. It also fired his imagination. A few years later, he wrote *A Journey from Corinth*, a historic

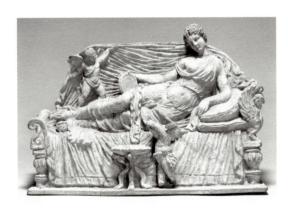

FIG. 1

Female Reclining on a Couch with Erotes, 1850–1875, terracotta, H: 18.5 cm (7% in.); L: 27 cm (10% in.), 78.4K.18.

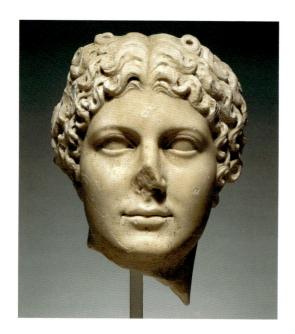

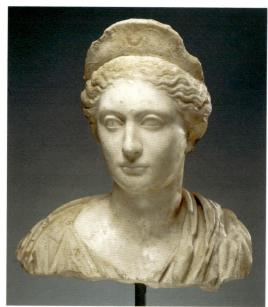

FIG. 2

Portrait Head of Agrippina the Younger, Roman, circa A.D. 50, marble, H: 32 cm (12% in.), 70.AA.101.

FIG. 3

Portrait Bust of Sabina, Roman, circa A.D. 140, marble, H: 43 cm (16% in.), 70.AA.100.

FIG. 4

Statue of Hercules (The Lansdowne Herakles), Roman (Tivoli), circa A.D. 125, marble, H: 193.5 cm (75% in.), 70.AA.109. The statue was first displayed in Malibu outdoors in the courtyard of the Ranch House.

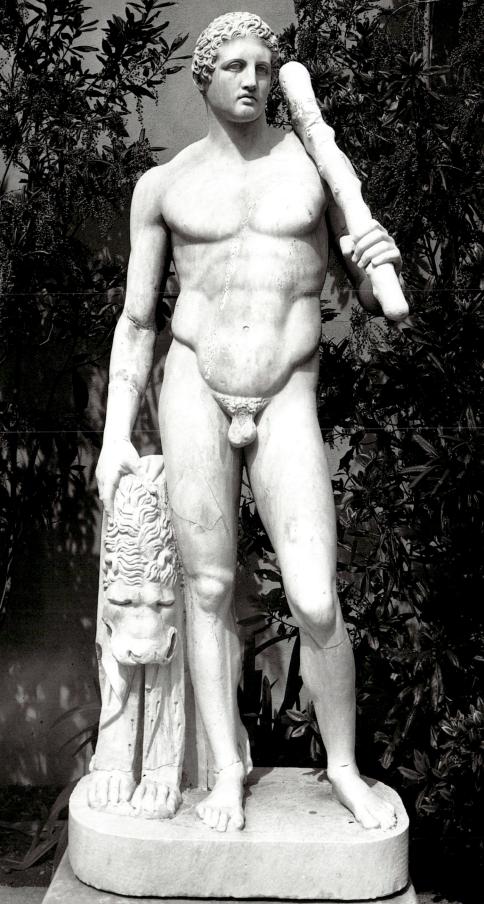

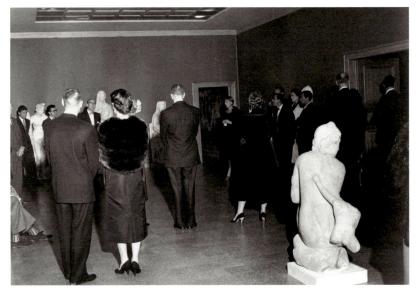

FIG. 5

View of the original gallery for antiquities in the Ranch House in Malibu, 1954.

FIG. 6

A reception at the opening of the Ranch House museum in Malibu, 1954.

novella in which a statue of Herakles plays a key role as a coveted object of veneration. The story follows the career of a landscape architect who flees ancient Corinth in the first century B.C., after the Roman occupation, and starts a new life in the former Greek colony of Neapolis (modern Naples, Italy). One of the settings for the novella was the ancient Villa dei Papiri, a large residence just outside Herculaneum. At the time Mr. Getty was writing, the villa was known only through eighteenth-century ground plans, the collection of ancient sculptures and wall paintings—now housed in the Naples Archaeological Museum—and the famous carbonized book rolls (the vestiges of the ancient villa's Greek library) that had been excavated there.

As his collections grew in importance, Mr. Getty also increasingly felt a responsibility to make them accessible to the public. In December 1953 the J. Paul Getty Museum was officially incorporated; in May 1954 it opened to the public in the Spanish-colonial Ranch House Mr. Getty had purchased in Malibu (figs. 5, 6). This event certainly did not signal the end of his collecting activities, however, and new acquisitions continued to be added to the expanding installations. Toward the end of the 1960s, Mr. Getty began to contemplate the idea of a new museum on the Malibu property to accommodate his collections. Though he seems to have flirted with the idea of a neoclassical structure or a Spanish-colonial addition to the existing Ranch House, he decided, against the advice of his architectural consultants, to build a replica of an ancient Roman villa, the opulent Villa dei Papiri that had provided the setting for *A Journey from Corinth*.

Still covered in Mr. Getty's day by a solid mass of mud and lava that has since been partially removed (fig. 7), the Villa dei Papiri had been mapped by Karl Weber when the site was explored in the eighteenth century through a series of tunnels. These early explorations of the villa had yielded the most exceptional collection of works of art ever found in the luxury seaside homes around the Bay of Naples. The villa also proved to have housed an extensive library of papyrus scrolls. Though difficult to unroll and read, a number of these precious texts were translated and identified as works by the Greek philosopher Philodemos. Philodemos's most important patron was L. Calpurnius Piso, a wealthy Roman aristocrat who was also the father-in-law of Julius Caesar. Known from the ancient sources to have had a house near Herculaneum, Piso has generally been identified as the villa's owner. Certainly Mr. Getty used Piso as the owner of the villa in his romantic story, and his friends claimed there was more than a passing resemblance between the description given there of Piso and the novella's author.

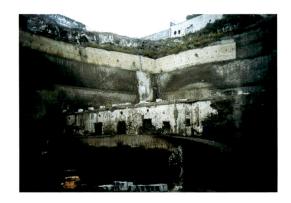

FIG. 7
View of the Villa dei
Papiri under excavation in
Herculaneum (modern
Ercolano, Italy), 1998.

Working with the architectural historian Norman Neuerburg and the Los Angeles architectural firm of Langdon and Wilson, Mr. Getty set out to design and construct an opulent *villa marittima*, or seaside villa (fig. 8). As he himself wrote: "... the principal reason concerns the collection of Greek and Roman art which the museum has managed to acquire ... and what could be more logical than to display it in a classical building where it might originally have been seen?" Surely the Lansdowne Herakles, which in Mr. Getty's novella had been transported from Corinth to be installed in the Villa dei Papiri, was foremost in his mind among the antiquities that inspired this decision. Indeed, he had a special gallery created just for its display in the new museum.

The Getty Villa opened to the public in January 1974 to great publicity and criticism. Derisively reviewed at the time as a rich man's folly that seemed to be an uncomfortable mixture of Hollywood and Herculaneum, the Villa proved to be enormously popular with the public. The lush gardens and seaside setting provided the perfect ambiance for the enjoyment of the collections lovingly installed in the much-expanded galleries.

Mr. Getty made a number of significant individual purchases for the new museum. In this process he was aided by the expert advice of Bernard Ashmole, Lincoln Professor of Archaeology at the University of Oxford, and Jiří Frel, the curator he had hired in 1973 to oversee the Antiquities collection. According to Jiří Frel, Mr. Getty's guiding principles for acquisition seem to have been aesthetic appeal and how well a piece would fit into the Museum's existing collection. To ensure that the Villa had adequate materials to display at its opening, he authorized the purchase of the entire contents of a Madison Avenue antiquities gallery in 1971. Other Greek funerary monuments, Roman sarcophagi, and a good representative selection of Greek and Roman portraits were gradually added to the displays, as

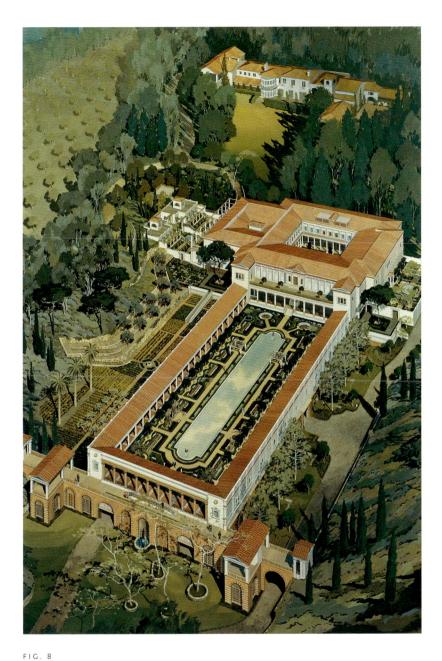

Artist's watercolor rendering of the proposed Getty Museum in Malibu, 1972. Mr. Getty's Ranch House (top) is behind the Museum. Artist: Dave Wilkins.

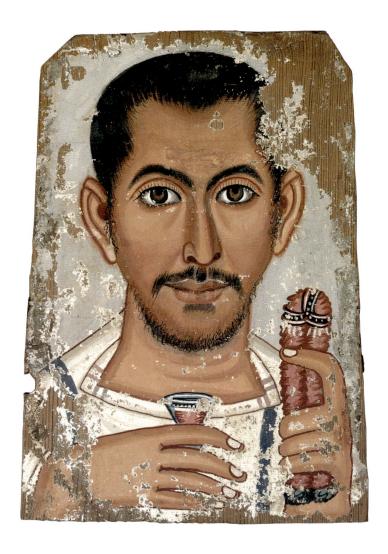

FIG. 9

Mummy Portrait of a Bearded
Man, Romano-Egyptian,
circa A.D. 220–250, tempera
on wood, H: 34 cm (13½ in.),
W: 25 cm (9½ in.), 79.AP.142.

FIG. 10

Cameo-Carved Portrait
of Berenike II, Greek, circa
225-200 B.C., garnet,
H: 1.8 cm (¼ in.), 81.AN.76.59.

well as jewelry, terracottas (including the Seated Poet and Sirens on pp. 116 – 117), and the first Greek and South Italian vases. Finally, Mr. Getty participated in the discussions concerning the acquisition of a monumental Greek bronze, the Statue of a Victorious Youth (see pp. 44–45). Unfortunately, he died before the purchase was completed in 1977.

Following Mr. Getty's death, the Antiquities collection continued to expand as lacunae were filled and whole new dimensions were added to the inventory. The Museum slowly built a remarkable group of Romano-Egyptian mummy portraits (fig. 9), which would offer an excellent complement to the portraits in stone and bronze, as well as a number of more specialized collections, including carved ambers, Greek and Latin stone inscriptions, engraved gems and cameos (fig. 10), and silver and gold *lamellae*, or curse tablets.

Opportunities to acquire existing collections have been especially welcomed by the young institution. Mr. Getty had little interest in ancient vases, and for a long time the collections reflected this lack of enthusiasm. In 1983, Walter and Molly Bareiss's Greek and South Italian vases came to the Museum for a special exhibition. Fortunately, at the conclusion of the show, the owners were willing to part with their fine collection, built over thirty years, and by 1986 it had become the heart of the Museum's permanent collection. (See the neck-amphora on p. 61 for an example.) Another significant area of weakness among the Museum's holdings was in material from the Bronze Age, so when Paul and Marianne Steiner's group of large idols (including the female figure on p. 9) and related stone vessels became available in 1988, it was quickly purchased. The single most important acquisition opportunity for the Antiquities collection came in 1996, however,

with the addition of the magnificent collection of Lawrence and Barbara Fleischman. In 1996, following a successful exhibition in both Malibu (October 1994—January 1995) and the Cleveland Museum of Art (February—April 1995), the Getty Museum accessioned more than three hundred objects, including many important bronzes (for two examples, see pp. 180—181), as a combination gift and purchase from the Fleischmans.

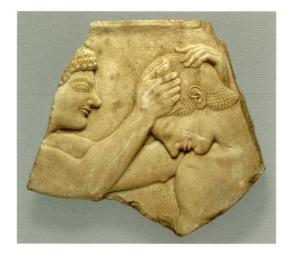

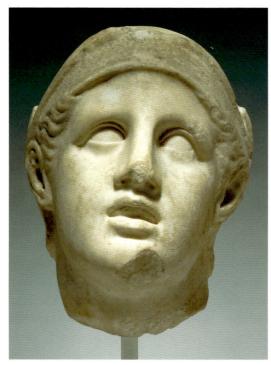

Fragment of a Grave Stele, modern forgery based on a Greek work of circa 520–510

B.C., marble, H: 50 cm (19% in.); W: 57.5 cm (22% in.); D: 9.2 cm (3% in.); 79.AA.1, deaccessioned.

FIG. 12

FIG. 11

Head of Achilles, modern sculpture based on a Greek work of circa 325–300 B.C., marble, H (approx.): 30.5 cm (12 in.), 79.AL.7.

With such an active program of acquisitions, it is inevitable that some mistakes were made. Two major acquisitions from 1979, a marble relief thought to be a Greek work of about 530 B.C. and fancifully entitled *Death of a Hero* (fig. 11) and a marble head of Achilles attributed to Skopas and dated to the later fourth century B.C. (fig. 12) were both later determined to be modern forgeries. In 1985 the Museum acquired its most problematic object — the Getty Kouros (see pp. 16–17) — the authenticity of which is debated. In spite of years of scientific research and scholarly inquiry, no decisive conclusions have ever been reached. Scholars and scientists are still firmly divided in their judgments, and the statue remains one of the enigmas of classical art. A healthy reminder of the limits of our knowledge about ancient art, the Getty Kouros has become something of an icon in the collection, exhibited with a question mark that may remain for many years.

In 1997 Mr. Getty's Villa in Malibu closed for renovations. As part of the decision to build a new, larger facility on a hilltop in West Los Angeles for all the other collections, the Trustees approved plans for the improvement and expansion of the facilities in Malibu to house only the Antiquities collection and related scholarly and scientific research. Because this collection provided the inspiration for the building, it is most fitting that it should return to the Villa. Under the informed direction of the architectural firm of Machado and Silvetti Associates, of Boston, the entire building has been refurbished and much-needed public amenities have been added to the site. Windows and skylights now provide abundant natural light appropriate for the display of ancient works of art, and colorful materials and rare stones reflect the influence of the sumptuous Roman seaside villa that served as the Museum's original model.

The closure of the Getty Villa in 1997 did not prevent the collection's continued growth. Mindful of the setting in which such objects would be displayed, the Museum during this time acquired a solid gold beaker of the Roman period (see p. 199)—exactly the kind of luxurious vessel from which the original occupant of the Villa dei Papiri may have drunk—and a silver gilt statuette of a bull (see p. 196) excavated in Pompei about the same time the Villa dei Papiri was being explored. As Mr. Getty himself wrote, "There are replicas and imitations of ancient public buildings but none of a private structure—so this one should provide a unique experience." It is our hope that the renewed Villa, filled with the now much-expanded collection of ancient art, will continue to delight the public just as its founder intended.

Marion True Curator of Antiquities, The J. Paul Getty Museum

Notes to the Reader

Objects in this Handbook are grouped by culture; within culture, they are organized by medium; within medium, they are generally presented chronologically.

Unless otherwise noted, the largest measurement for a specific dimension is the one given. The following abbreviations are used:

н: Height

w: Width

D: Depth

DIAM: Diameter

L: Length

To show the imagery on engraved gems more clearly, plaster casts are made. Black-and-white photographs of such casts accompany the gem entries in this book.

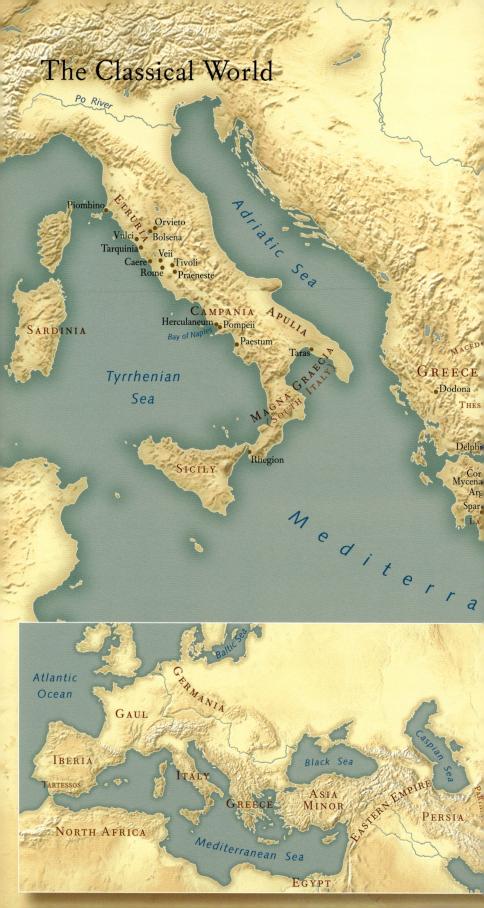

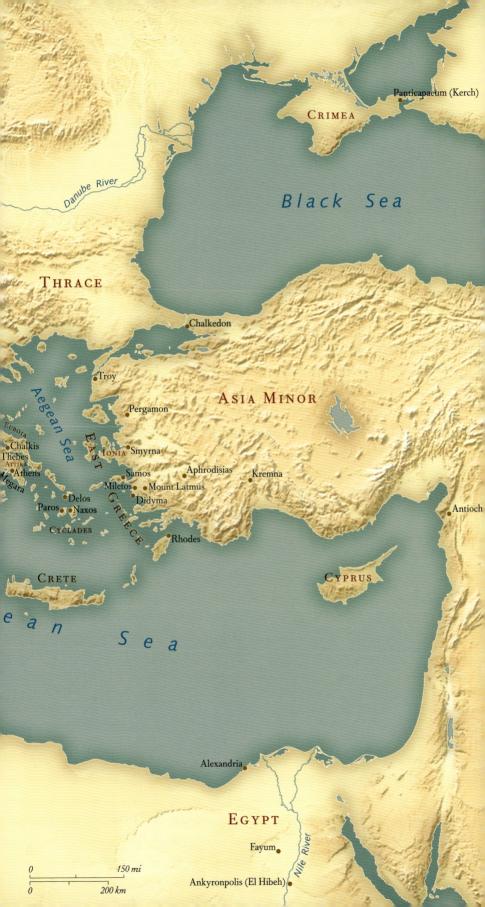

Cypriot

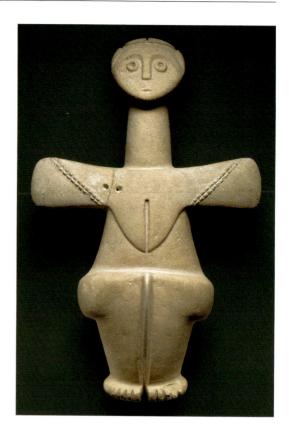

STATUETTE OF A FERTILITY GODDESS

Cypriot, 3000-2500 B.C. Limestone H: 39 cm (15% in.); w (arm to arm): 26.1 cm (10% in.) 83.AA.38

Carved from the local limestone of Cyprus, this female figurine is one of the largest and most imposing sculptures from the Chalcolithic period (3000-2500 B.C.) in the eastern Mediterranean. Although the symbolic significance of the cruciform shape is lost to us, the various elements of the figure stress fertility. With head raised, arms extended, and legs drawn up, the figure appears to be in a semi-squatting position, perhaps giving birth. The phallic character of the head and neck seems intentional, and the configuration of the breaststhe central focus of the figure—implies female genitalia. The V-shape of the breasts is further accentuated by the double bands on each arm, perhaps rep-

resenting jewelry. Most contemporary Cypriot cruciform figures are considerably smaller than this large figure, suggesting that the Getty piece served as a cult image of a fertility or mother goddess. The attachment holes used to repair the left arm attest to the figure's importance. The detailed rendering of the face, which includes nose, mouth, ears, hair, and an open-eyed expression, further highlights the figure's uniqueness. The economy and boldness of design, coupled with an ampleness and clarity of individual forms, set this sculpture apart, imbuing it with a monumental presence unsurpassed in early Cypriot and Mediterranean sculpture.

CYPRIOT BEAKSPOUTED JUG WITH MODELED FIGURAL DECORATION

Cypriot, 2300–1650 B.C. Terracotta H: 44.2 cm (17 1/8 in.) 2001.79

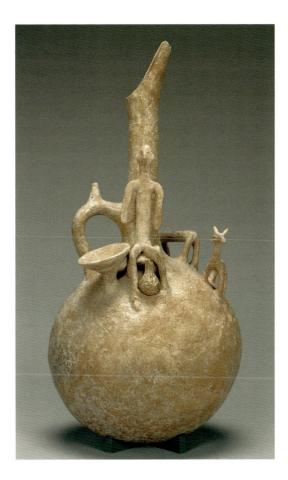

Globular jugs with cutaway or "beak" spouts first became common in Cyprus in the Early Bronze Age (2700-1900 B.C.), perhaps as a result of interaction between the inhabitants of Cyprus and people from mainland Anatolia (Turkey), where such vessels were already traditional by that time. This jug is of a pottery type known as polished ware, perhaps of the red or the so-called drab variety. Although polished ware was common in early Cyprus, this jug is exceptional, as it is embellished with figures modeled in the round along the shoulder. The figures include two deer and a man seated on a stool. On the ground beside the man are a widebrimmed bowl and a jug, not unlike this

one, on which the figural group appears. The scene may portray preparations for milking the deer, or perhaps the moment before bloodletting or ritual sacrifice of the deer. In either case, the bowl and jug would be used to collect the liquid. The presence of the miniature jug within the scene suggests that the full-size jug could likewise have been used for milking or bloodletting activities.

Vases with modeled figural compositions are most often found in tombs, and this jug may have been a burial object. The liquid it held may have been used in funerary rituals or may have been intended to sustain the deceased in the afterlife.

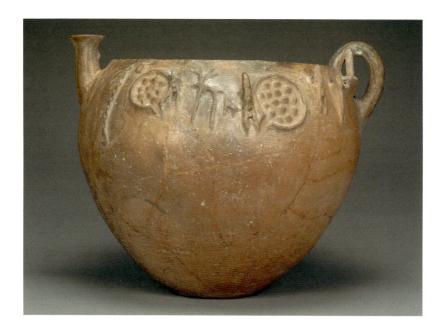

CYPRIOT BOWL WITH HIGH-RELIEF DECORATION

Cypriot, 2000–1900 B.C. Terracotta H: 42.5 cm (16% in.); DIAM (rim): 38.1 cm (15 in.) 2001.78 This bowl is of a ceramic type called red polished ware that is characteristic of the Early Bronze Age in Cyprus (2700-1900 B.C.). The bowl features figural scenes modeled in high relief around the vessel's neck. On one side, four schematically rendered men are accompanied by a deer and another animal, perhaps a faun or dog. Interspersed between the figures are several unidentifiable objects, including two examples of a circular ridge enclosing a number of small, conical lumps. These enclosures may represent troughs filled with piles of crude copper ore, and the men are perhaps in the act of refining the ore, an important industry in copper-rich Cyprus. The distinctly male individuals seen here contrast with the seemingly sexless figures on the other side of the bowl, which, because of this disparity, are thought to be female. The female figures are at work processing small lumps of clay in what has been interpreted as a scene of breadmaking. Indeed, the two sides of the bowl may depict complementary views of men's and women's daily tasks. Scenes of breadmaking also appear on other Cypriot ceramic objects, often from burial contexts. The small breadmakers were perhaps intended to be of service in the afterlife, preparing food to sustain the deceased. In the same way, the men here could be in the act of supplying the deceased with metal goods, such as the adzes, knives, pins, and other implements that are also commonly found in Bronze Age Cypriot tombs.

Cycladic

Cycladic Beaker

Early Cycladic (Cyclades), 3200–2800 B.C. Marble H: 15.5 cm (6% in.)

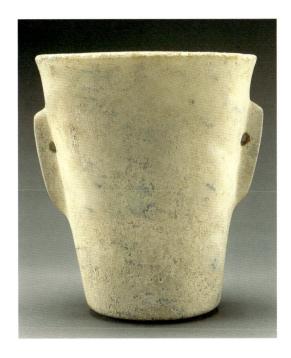

The production of stone vases was one of the most important and characteristic industries of the Cyclades, and it was only on those islands that white marble was used as a primary material for such vessels. The sculptors who carved Cycladic figures or idols probably also made stone vases. The beaker, one of the four basic early Cycladic I shapes, is among the most appealing of the common early Cycladic marble vessels. This particular beaker is among the best preserved and most typical examples of the shape. There are some sixty known examples of the type, which vary in height from a diminutive 7.8 cm to a large 33.9 cm, although most do not exceed 20 cm. The body is essentially a truncated cone and the plain rim is very slightly everted. A pair of vertical suspension lugs is set on opposite sides of the vessel. In rare cases, a female torso is represented on one side of a beaker. In the Cyclades, the beakers from known sources were evidently associated exclusively with graves. It is unclear precisely how they functioned as sepulchral vessels, and there is as yet no evidence that they played a role in rituals of a non-funerary nature. Their shape, however, suggests that they served as containers for liquids rather than solids.

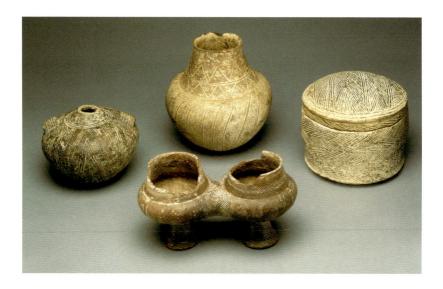

Group of Cycladic Terracotta Vases

Early Cycladic (Cyclades), 3000-2700 B.C. Terracotta H: various, from 9.7 cm (3% in.) to 14.8 cm (5% in.) 91.AE.28-.31 These four vases are typical of those produced during the early Cycladic period. They include a bottle, two collared jars (one of which is a double-pedestal vase, also known as a kandila), and a cylindrical pyxis with lid. Although surely used for a variety of functions in life, many of these vases accompanied the deceased in graves. Shaped by hand, the vessels were burnished smooth before firing, thereby creating a shiny, compacted, and less porous surface.

Cycladic potters of this period often decorated their pots with geometric designs incised into the surface of the vessel; these were usually filled with a white chalky substance that contrasted with the darker surface. The linear decoration may reflect the woven patterns of baskets, although no baskets from the time have survived.

The pottery and other material culture of the period in the Cyclades have been systematically organized into a series of cultures or groups, each named after a specific island or site. The shapes of the Museum's Cycladic terracotta vessels, coupled with the distinctive incised herringbone motifs found on the jar, the pyxis, and the twin kandila, are typical features of the earliest stage of the early Cycladic period, known as Grotta-Pelos culture (3000–2800 B.C.). However, the form of the bottle decorated with the opposed diagonal lines is more characteristic of the next stage, called the Kampos Group (circa 2800–2600).

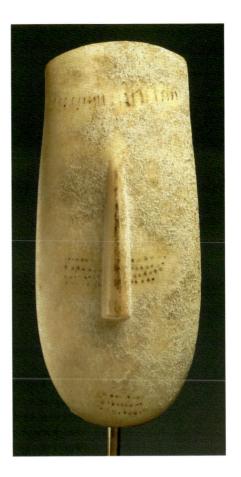

HEAD OF A FIGURE OF THE EARLY SPEDOS TYPE

Early Cycladic (Cyclades), 2600–2500 B.C. Marble with polychromy H: 22.8 cm (9 in.); W: 8.9 cm (3½ in.) 96.AA.27

The appearance and elegance of the flattened and, above all, simplified rendering of the human form in early Cycladic sculpture often strikes viewers as quite modern. Although most such sculptures were less than 30 cm tall, this head, of early Spedos type (named after a cemetery on the island of Naxos), was broken from one of the rare examples that was approximately life size. The head is also quite rare in that it preserves some of the original effect of these figures, with facial features, hair, and occasionally jewelry added in paint. Short vertical lines on the forehead, a stripe on the nose, and bands of dots on the cheeks and chin-all added in a red pigment - may be cosmetic lines or tattooing. The faint bluish paint on the

top and back of the head represented hair. Large almond-shaped eyes are preserved as "ghosts," areas that were once painted but are now lighter in color, as well as smoother and slightly raised in comparison to the adjacent marble surface. Although the findspot of the great majority of Cycladic idols is unknown, many of those with known context were found in graves. This has prompted scholars to suggest a ritual function for the idols connected with death and the afterlife. Not all early Cycladic graves contain such figures, however, and some idols have been found in settlement and sanctuary contexts, indicating a more complex and perhaps multi-faceted usage.

STATUETTE OF A HARPIST

Early Cycladic (Cyclades), circa 2500 B.C.

Marble

H: 35.8 cm (14½ in.);

D: 28 cm (11 in.);

W: 9.5 cm (3½ in.)

85.AA.103

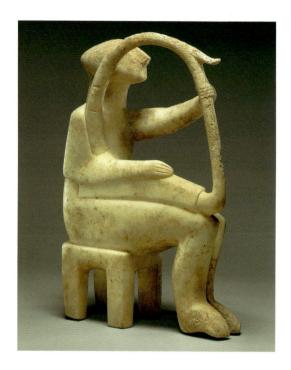

As one of just ten known Cycladic harpists in the world, this figure is unique in the Museum's collection. Sitting erect on a simple four-legged stool, the harpist lifts his head, perhaps in song. His left hand holds the frame of the harp; his right hand rests on its sound box. Originally, the sculpture's visual impact would have been quite different, because the figure's eyes and hair were once added in paint.

The instrument held by the musician, a frame harp, originated in the Near East and is the ancestor of the modern harp. At the top of the harp is an extension in the form of a swan's head, a common feature on ancient stringed instruments. The swan's elongated neck facilitated the projection of sound from the harp.

Because there are no known images of a harp-playing god at this early date, Cycladic statuettes of harpists probably represent humans rather than deities. Musicians were important figures in the preliterate society of the Cyclades; they not only provided entertainment but also transmitted common history, mythology, and folklore through their stories and singing.

FEMALE FIGURE OF THE LATE SPEDOS TYPE

Name-piece of the Steiner Master Early Cycladic (Cyclades), 2500-2400 B.C. Marble H: 59.9 cm (23% in.) 88.AA.80

Sculpture in marble, particularly the figurative so-called idols, constitutes the most distinctive product of the culture that flourished in the archipelago at the center of the Aegean in the third millennium B.C. The figures formed a special class of object that conformed to a strict traditional typology, within which the Spedos type, named after a burial site on the island of Naxos, is one of the most common and longest lived examples of the canonical reclining female figure with folded arms.

Incisions on this figure delineate the arms from the body, separate the thighs, define the abdomen and pubic triangle, and indicate fingers and toes. The breasts are lightly modeled. The nose is the only carved feature on the U-shaped head, though other details may have been enhanced originally with brightly colored pigments. Viewed from the side, the back is straight and continues the line of the neck, the head is slightly

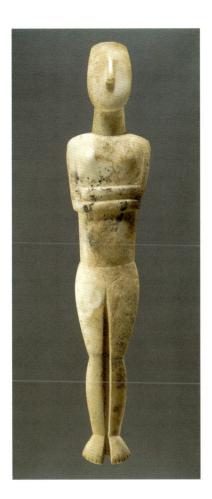

arched, and the knees are gently flexed, so that the thighs and calves do not form a single straight line. The feet are bent forward in such a way that the figure cannot stand. Details of the human form are reduced to a minimum, and the figure is a flattened, schematic representation that approaches pure abstraction. Yet the figure is clearly a female, and male figures are rare in comparison to such canonical female idols. Ranging from delicate miniatures to robust works of impressive size, Cycladic idols often show a striking purity of form, beauty of material, and excellence in their workmanship.

Mycenaean

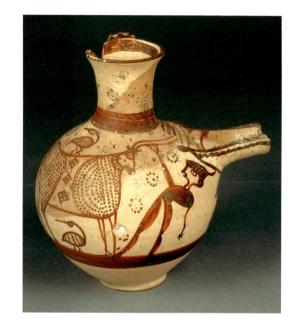

MYCENAEAN SIDE-SPOUTED SIEVE JUG

Attributed to Painter 20
Mycenaean Greek,
1250–1225 B.C.
Terracotta
H: 16.6 cm (6½ in.);
DIAM (body): 13 cm (5½ in.)
85.AE.145

During the final stages of the Aegean Bronze Age, from about 1400 B.C. on, Mycenaean potters developed one of the earliest figurative styles in Greek painted pottery. The inspiration for this new style may have been fresco painting. Referred to as the Pictorial style, this type of pottery became progressively more popular in the fourteenth and thirteenth centuries B.C., but accounted for only a small percentage of Mycenaean pottery production. Although the majority of Pictorial-style vases have been found in Cyprus and the Near East, recent discoveries, along with scientific analysis, suggest that most were made in the Argolid, the broad plain that was home to Mycenae, Tiryns, and other important Mycenaean centers.

Wrapped around the body of this jug are many of the figurative elements that are found on other Pictorial-style vases: either a sphinx or a Centaur holding a pomegranate branch or spray of opium poppies; a bull; four birds; and a man, who grasps one of the bull's horns. The connection between bull and man may allude to the ritual or athletic performance of bull leaping, which had its origins in Minoan Crete, but this is not a typical bull-leaping scene. Based on the way specific details are rendered and repeated, and on the overall drawing style, a number of these vases have been attributed to individual potters. Their names remain anonymous, but their styles have been differentiated and identified by numbers. Although the precise function of this jug is uncertain, the strainer holes suggest that it was designed for a liquid requiring filtering, perhaps beer.

Tartessian

FURNITURE SUPPORT REPRESENTING A WINGED FELINE

Tartessian (Tartessos), 700-575 B.C.
Bronze
H: 61 cm (24 in.);
D: 33 cm (13 in.)
79.AC.140

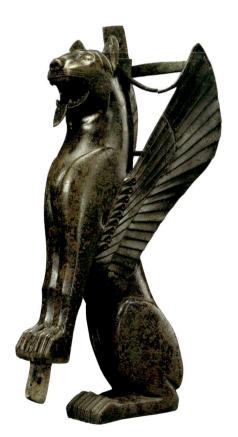

Stylistic details on the wings and head of this fierce, panther-like creature and the general method of its manufacture suggest that it comes from the kingdom of Tartessos on the Atlantic coast outside the Strait of Gibraltar in modern Spain. Due to its rich mineral resources, Tartessos was an important port on Greek, Phoenician, and Etruscan trade routes in the western Mediterranean. The art of Tartessos combines native Iberian elements with influences brought by traders and colonists.

The form of the feline's brow is distinctively Tartessian, as is the triangle design in the creature's ears. Artists of the region were influenced by the animal-style tradition of the Phoenicians who first established colonies there. Felines, in particular, were popular in the art of many Mediterranean and Near Eastern cultures.

This beast was cast in two separate pieces, which are joined with rivets just below the wings. The thin bronze rods between the head and wings could be design features, but more likely they are part of the bronze mold's internal system of tubes, which facilitated the flow of the molten metal. The pierced projections behind the head and below the front paws of the winged creature indicate that it was attached to a larger structure, such as a wooden throne. It was not uncommon in antiquity for ceremonial chairs and thrones constructed of wood to be embellished with elements made of bronze and other metals.

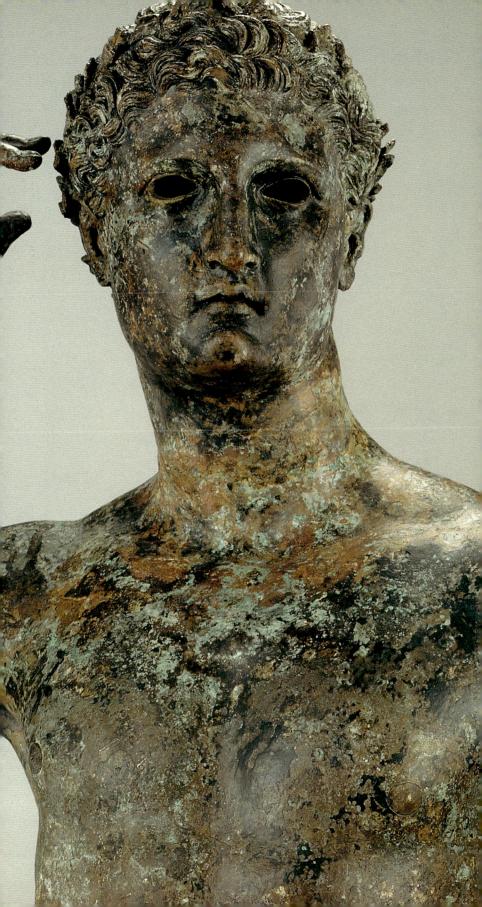

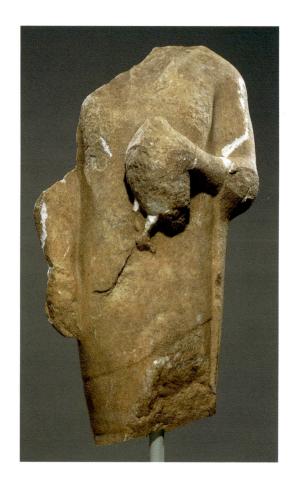

STATUE OF A KOUROS

East Greek (Didyma), 550-525 B.C. Marble H: 51.5 cm (201/4 in.)

In the 500s B.C., the Greeks, in both Greece itself and its colonies, frequently dedicated statues of young men such as this one, called kouroi, as offerings to the gods in religious sanctuaries. Most kouroi were depicted nude, with an emphasis on the figure's youthfulness, athletic build, and vitality. The word kouros means "a youth" in the Greek language. These statues of kouroi embodied an ideal of physical and moral beauty valued in Greek society. Although usually portrayed nude, clothed kouroi were also made. Most kouroi wearing clothes come from Greek colonies that were located east of the Greek mainland in Ionia (the west coast of modern Turkey) and reflect a regional preference. This half-life-size kouros wears a himation, or cloak, over a long tunic. A double incised line decorates the edge of the cloak. In his left hand, he holds a bird (whose head is missing) to his chest as an offering to the gods; his right hand is at his side. The figure stands frontally, with his left leg placed in front of the right. His shoulders are broad, his hips narrow; both buttocks are well defined. Kouroi often had long hair, and here the ends of long locks of hair are preserved on the upper back of the statue. The rounded muscular body of this kouros, his delicately sculpted fingers, and the smooth carving of his clinging garment strongly suggest that the statue was sculpted in the East Greek city of Didyma.

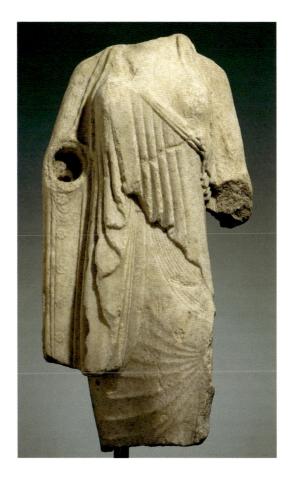

STATUE OF A KORE

Greek (Paros), circa 530 B.C. Marble H: 73 cm (28¾ in.) 93.AA.24

The Greek kore statue, the female equivalent of the kouros, was the embodiment of youthful beauty and grace. Like the kouros, it was a religious dedication. This kore is a beautiful young woman dressed in her finest, ready to perform a dance for the gods at a religious festival. Nearly life size, she wears a long dress of thin fabric under a cloak that is fastened diagonally over her right shoulder. The edges of the cloak are held together by a series of flower-shaped buttons. The young woman's hair is long and arranged at the back in fourteen rippling vertical locks. Long loose ringlets fall over both shoulders in the front and lie alongside her breasts.

With her now-missing left hand she pulls the finely pleated fabric of the dress

across her lower body and her advancing left leg, revealing their forms. This
gesture is so deliberate and stylized that
the pose must be that of a dance movement. The missing right arm and hand,
carved separately and then attached
to the torso, would have held out an
offering to the gods. The iron pin visible
in the socket indicates a later repair to
the statue.

Although missing its head, arms, and legs, this statue's exquisite carving and refinement confirm its original high quality. The visual effect of the kore's costume—originally created by a combination of painted decoration, which has disappeared, and sculpted details—is one of elegance and luxury.

STATUE OF A KOUROS

Greek, circa 530 B.C. or modern forgery Marble H: 206 cm (81 1/8 in.) 85.AA.40

The earliest monumental sculpture in Greece dates to around 650 B.C. and appears to have taken its inspiration from Egypt and the Near East. From this time on, there was an active artistic output of life-size and over-life-size statues throughout Greece. Most consist of standing male and female figureskouroi and korai-and most were carved from marble or limestone that was often brightly painted. The kouros, or standing male figure, was an established type throughout the sixth century B.C. Standing erect with the left foot forward, the arms lowered by the side of the body, and the eyes looking straight ahead, these statues were either dedicated in sanctuaries or stood above tombs as grave monuments. Archaic Greek statues are uniquely interesting because

they show the progression of Greek knowledge about human anatomy. Step by step, Greek sculptors learned to represent in detail the complex structure of the head, torso, arms, legs, and feet. By about 480 B.C., an anatomically accurate human figure was achieved for the first time in the history of Western art.

Neither scientists nor art historians have been able to completely resolve the issue of the Getty Kouros's authenticity. Certain elements of the statue, such as a mixture of earlier and later stylistic traits and the use of marble from the island of Thasos, have led scholars to question its veracity. Yet the apparent anomalies of the Getty Kouros may indicate our limited knowledge of Archaic Greek sculpture rather than be evidence of a forger's mistakes.

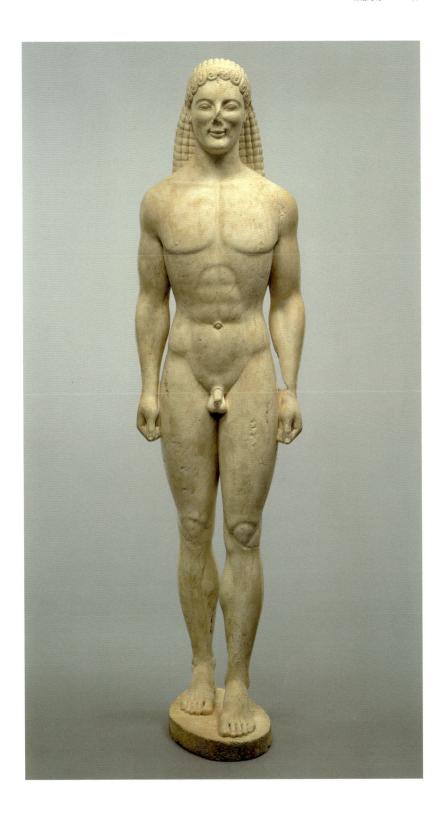

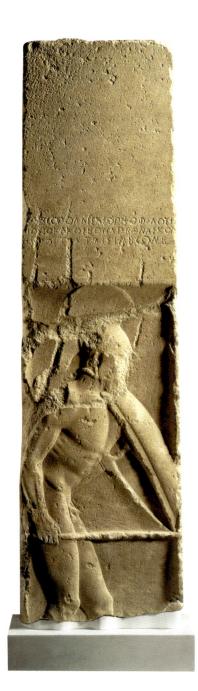

GRAVE STELE OF THE HOPLITE POLLIS

Greek (Megara), circa 480 B.C. Marble H: 153 cm (60¼ in.); W: 45.1 cm (17¼ in.); D: 15.9 cm (6¼ in.)

"I speak, I, Pollis, the dear son of Asopichos, not having died a coward, with the wounds of the tattooers, yes myself," reads the inscription carved on this sculpted stele, a gravestone for the hoplite Pollis. A hoplite was a heavily armed foot soldier, and Pollis here advances into battle helmeted with his shield raised and his spear ready. A sword hangs at his side, suspended from a strap that was originally added in paint, as were other details of the decoration.

Pollis probably was killed while defending Greece from invading Persians. The tattooers, the enemy named in the inscription, were most likely the Thracians, a fierce people who occupied the area to the north of Greece and who fought against the Greeks under the Persian commander Xerxes in 480 B.C.

In form the stele retains the tall narrow shape popular in the Archaic period, yet its decoration looks forward to the early Classical period. Sculptors of the period from about 480 to 450 B.C. displayed a new interest in the representation of space, movement, and human anatomy. Shown mostly in profile view with accurate musculature and a foreshortened shield, the figure of Pollis conveys a sense of three-dimensionality. Given the stele's very shallow carving, this effect is all the more remarkable.

The stele's inscription combines the alphabets of both Athens and Corinth. This kind of writing was typical of Megara, the city-state located between the two, and probably indicates that this gravestone was a Megarian monument.

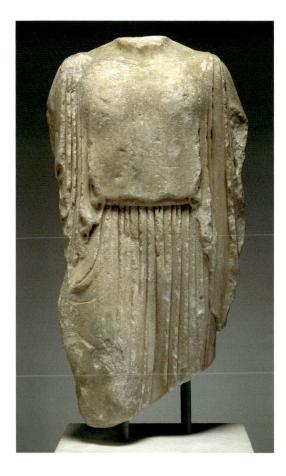

STATUE OF A KORE (THE ELGIN KORE)

Greek, circa 475 B.C. Marble H: 71 cm (28 in.) 70.AA.114

Wearing a peplos, this young woman (kore in Greek) steps forward with her right leg. A peplos was a modest onepiece woolen garment belted at the waist and pinned at the shoulders with long, metal, decorative dress pins. Formed from a rectangular piece of woven cloth, the heavy fabric of the tunic was folded at the neckline to create an overfall on the upper body. Little of the body of this young woman is actually visible, except for the contour of her right thigh, which is revealed as she pulls the peplos to one side with her now-missing right hand. This gesture is typical of the kore statue type, in which one hand was usually extended with an offering to the gods while the other grasped the fabric of the dress below the waist.

Draped statues of women were the norm in the 400s B.C. in Greece, whereas men were often shown nude. Sculptors of korai were interested in capturing the interplay of fabric folds and the body. This statue may have been a gift to the gods in a sanctuary or even used to decorate the pediment of a Greek temple.

This kore was once in the collection of Thomas Bruce, 7th Earl of Elgin.

Lord Elgin, as he is commonly known, was British Ambassador to Constantinople in the late eighteenth century. He is best known as the person responsible for removing most of the sculptural decoration from the Parthenon on the Acropolis in Athens and bringing the pieces to England, where they now are displayed in the British Museum in London.

Incised Grave Stele of Athanias

Greek (Boiotia), circa 400 B.C. Limestone H: 170.2 cm (67 in.); W (bottom): 80 cm (31½ in.); D: 19 cm (7½ in.) 93.AA.47

The young warrior who stands holding his spear and shield, sword hanging by his side, is identified by the inscription at the top of this gravestone as Athanias. Standing calmly, he wears a conical helmet (a *pilos*) with a wreath. The spear is pointing downward and the shield interior is elaborately decorated with a scene of the hero Bellerophon on the winged horse Pegasos, battling the Chimaira, a monster that combines elements of a lion, snake, and goat.

Carved from the local black limestone of Boiotia, this is one of a small and highly distinctive group of engraved tombstones depicting warriors, usually charging into battle. The fact that the names of some of these warriors appear on an inscription listing the casualties of the Battle of Delion in 424 B.C. has prompted scholars to assign all the engraved Boiotian warrior stelai to the local men who fell at that battle, although some may be later. Even though Athanias is not among the surviving names on the casualty list, the name is well known in Boiotia.

The incised lines that now form the image are usually thought to be guidelines for the original painted decoration, which has completely disappeared. The engravings are, however, far more com-

plex than those found on other painted stelai and the fact that no trace of paint survives on any of these tombstones may suggest that the incised lines were intended to be seen and not completely covered with paint. The incised technique on the stelai bears a striking resemblance to ancient engraved metalwork.

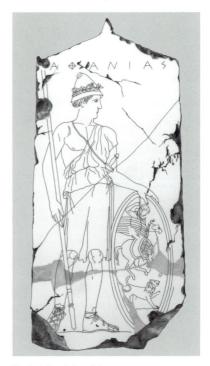

Drawing by Beverly Lazor-Bahr

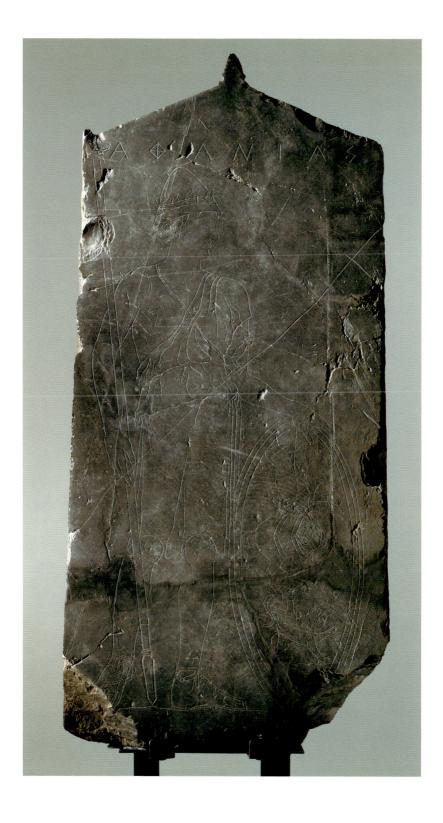

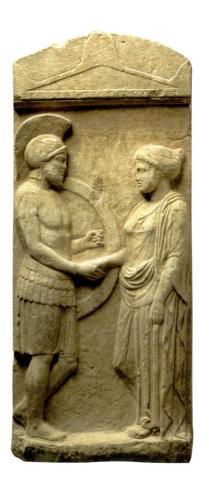

GRAVE STELE OF PHILOXENOS WITH HIS WIFE, PHILOMMENE

Greek (Attika), circa 400 B.C. Marble H: 102.2 cm (40½ in.); W: 44.5 cm (17½ in.); D: 16.5 cm (6½ in.) 83.AA.378

Philoxenos, wearing the armor and shield of a warrior, solemnly shakes hands with his wife, Philoumene, on this stele, or gravestone, from Attika. The names of the couple are carved above their heads, and both figures were originally elaborated with painted details. The handshake was a symbolic and popular gesture on gravestones of the Classical period. It could represent a simple farewell, a reunion in the afterlife, or a continuing connection between the deceased and the living.

The fact that it is often difficult to tell which figure represents the deceased on gravestones further emphasizes the connection between the world of the living and the world of the dead. The living rarely display sorrow or grief on grave markers of about 400 B.C. Instead, their calm, expressionless faces reproduce the idealized features and detachment that prevailed in the sculptural style of Athens and its surrounding region, Attika, at this time.

Philoxenos, here represented as a soldier, probably distinguished himself in combat. The style and the iconography of this gravestone date it to a period just after the end of the Peloponnesian War in 404 B.C. Funerary reliefs of the time reflected a renewed appreciation for family life following that disastrous war with Sparta.

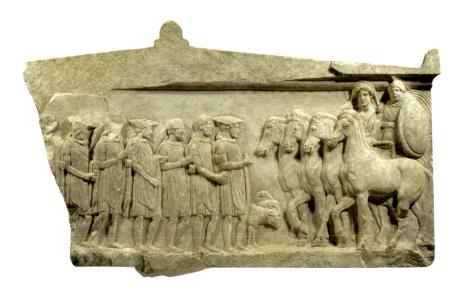

VOTIVE RELIEF TO ACHILLES AND THETIS

Greek (Thessaly), circa 350 B.C.
Marble
H: 78 cm (30½ in.);
W: 132 cm (52 in.);
D: 7.6 cm (3 in.)
78.AA.264

On this relief, the greatest of the Greek heroes of the Trojan War, Achilles, rides with his mother, Thetis, in a chariot. The chariot confronts a procession of votaries, who are dressed as travelers, wearing cloaks and widebrimmed hats. Only seven of these waiting men remain on the broken relief, but originally there must have been about ten.

In Greek religion, many heroes were honored and had religious cults associated with them. It was believed that these heroes could intercede with the gods on behalf of mortals. Achilles was certainly worshiped as a hero, and some scholars believe that in certain places he may even have been worshiped as a god. In this relief, the group of votaries brings three rams to sacrifice to Achilles. The relief is probably from Thessaly, where, according to Greek mythology, Achilles was born and educated. It takes the usual form of a votive monument that was set up as an offering in a religious sanctuary. The dedicators of the votive are named in the partially legible inscription at the bottom of the relief, which gives the names of Lakrates and Gephes and refers to the religious association of the Achilleides, who claimed to be descendants of Achilles. Plaques made of marble and more perishable materials existed as religious dedications before the Classical period in Greece, but only after the completion of the Parthenon in Athens, in 432 B.C., did marble votive reliefs begin to be mass produced.

SIDE PANEL OF A GRAVE NAISKOS WITH THE RELIEF OF A YOUNG HUNTER

Greek (Thessaly or Macedonia), circa 325 B.C. Marble
H: 143.1 cm (56 % in.);
W: 42.7 cm (16 % in.);
D: 10.2 cm (4 in.)
96.AA.48

Carved in a recessed rectangular area on this marble slab, a young hunter wearing a short tunic tied with a belt walks with his spears resting on his shoulder. Indistinct objects are slung from the weapons. The rounded shape at the top seems most appropriate for that of a petasos, a broad-brimmed hat worn by hunters and travelers. The shape at the bottom appears more baglike and is likely a purse net, used in antiquity for catching hares. The boy is probably carrying both suspended from his spears. This relief was originally painted, and colored details would have made it easier to identify the objects.

A curved molding at the top right corner indicates that this relief panel was part of a three-sided *naiskos*, an elaborate funerary monument constructed in the form of a small, open-fronted building. It would have formed the right-hand side of the *naiskos*, with the carving on the interior, and the young hunter looking toward an image of the deceased on the back wall.

Being shown with horse, hound, servant, or hunting gear established the high rank and status of the deceased in society. The style, subject, and type of marble of the panel point to an origin in Macedonia or Thessaly in northern Greece.

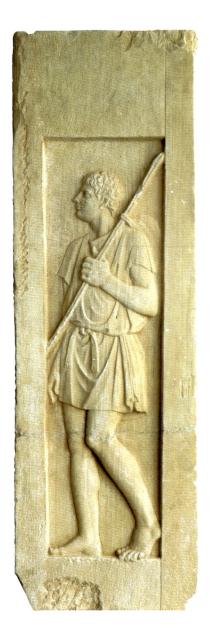

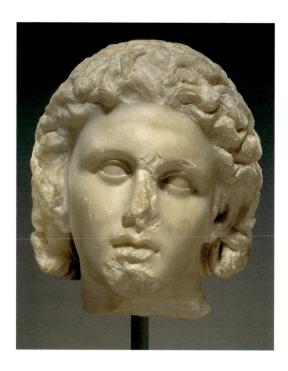

PORTRAIT OF ALEXANDER THE GREAT

Greek, circa 320 B.C. Marble H: 29.1 cm (11½ in.) 73.AA.27

Clearly identified here by his mass of leonine hair, his young idealized face, and his deep-set, upturned eyes, Alexander the Great, king of Macedonia (reigned 336-323 B.C.), was the first Greek ruler to understand and exploit the propagandistic power of portraiture. According to ancient literary sources, he let only one sculptor carve his portrait: Lysippos, who created the standard Alexander portrait type. Ancient writers describe Alexander as handsome, energetic, charismatic, and unconventional. Brave and decisive, he had endurance, delighted in exploration, and was a founder of cities.

Surviving images of the youthful conqueror incorporate characteristics that had been used earlier for the representation of gods and heroes. Claiming descent from the Greek heroes Herakles and Achilles and identifying himself with the gods Zeus Ammon (a divinity combining Zeus, king of the Greek pan-

theon, and Ammon, king of the Egyptian pantheon) and Dionysos, Alexander was treated as divine even before his death. This practice was part of Alexander's adoption of the Egyptian and Near Eastern idea of honoring rulers as if they were gods.

This posthumous portrait of Alexander was part of a multi-figured composition. More than thirty fragments of the group, which might have included sacrificial elements, survive. The participants include Alexander, his companion Hephaistion, a goddess, Herakles, a flute player, and several other figures, as well as animals and birds. The ensemble to which this head belongs probably served as a votive or commemorative monument, possibly even as an elaborate funerary monument for a courtier who wanted to associate himself with the ruler. Alexander became the new ideal ruler, a hero on Earth and an example to follow, even to worship after his death.

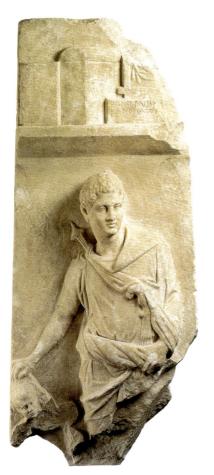

Grave Stele of Phanokrates

East Greek (Smyrna), circa 200 B.C. Marble H: 125.4 cm (49% in.); W: 53.3 cm (21 in.); D: 21.6 cm (8½ in.)

Elements from his life surround the deceased, named Phanokrates, on this grave stele. The implements supplementing his luxurious garments suggest an aristocratic background, commemorating him as a wealthy, learned man. Phanokrates' cloak is fastened on his right shoulder with an unusual pin in the shape of a large ivy leaf, and a short sword with an ornate, eagle's-head hilt is tucked into the roll of fabric at his waist.

The head of a small attendant or slave who stood at the right side of Phanokrates appears just above the broken lower edge of the stele. Phanokrates' right hand rests upon an object, probably a herm, placed behind the servant boy. A shelf above the figures holds objects associated with the life of an educated man: on the left, a closed pair of wax writing tablets; in the middle, a chest with an arched lid that probably held book rolls; and, on the right, a framed tablet with a wreath. The inscription on the low base under the wreath names the deceased and his father: "Phanokrates, son of Phanokrates." A second wreath is on the background below the shelf, next to Phanokrates' head.

The stele was freestanding; it was not a slab from a longer frieze, but it was probably set in an architectural framework. Phanokrates' pose and outfit indicate that the gravestone comes from the area around the ancient city of Smyrna (now Izmir, Turkey).

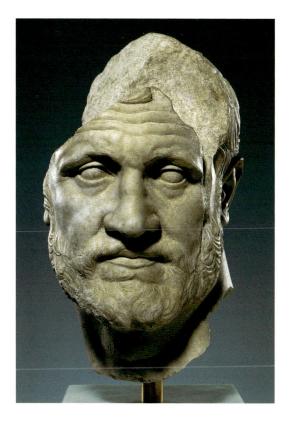

Portrait of a Bearded Man

Greek, circa 160–150 B.C. Marble H: 40.7 cm (16 in.) 91.AA.14

Broken in antiquity into two large fragments, this head is all that remains of a larger-than-life-size, full-length statue. A furrowed brow and an intense gaze distinguish this portrait of an older man, whose face reflects serious determination. The condition and irregular shape of his nose suggest that it has been broken more than once, and one can surmise that the man had endured many rigorous experiences, perhaps as a soldier. The nose, square jaw, and folds between cheeks and mouth capture the man's individual character, but his true identity cannot be determined with certainty.

The head belongs to a category of portraits of Hellenistic rulers that arose in the wake of Alexander the Great (reigned 336–323 B.C.). Designed as propaganda to legitimize that ruler and emphasize dynastic connections, these portraits combined individual traits with dramatic, idealized images of their sub-

jects. Yet this man cannot have been a ruler when the statue was carved, for he does not wear a diadem, a type of headband reserved for kings and gods. Drapery on the back of the neck indicates that he was portrayed as a statesman, not as a warrior. The portrait's scale and the man's regal bearing, however, clearly suggest that he is a member of a royal family—but which one?

Stylistically, the head relates closely to sculpture produced at Pergamon, a Hellenistic kingdom on the west coast of modern Turkey. Sculptors at Pergamon frequently used the type of grayish marble from which this portrait is carved. The subject of this portrait was probably a high-ranking member of the Attalid dynasty, who ruled Peragamon during the Hellenistic period, perhaps even Attalos II (reigned 158–138 B.C.) himself, portrayed shortly before he became king.

STATUE OF TYCHE

Greek, 150–100 B.C. Marble H: 84.5 cm (33¹/₄ in.) 96.AA.49

A crown shaped like the walls of a city identifies this figure as Tyche, goddess of fortune. In addition to embodying the fortune of an individual, Tyche was also seen to represent the fortune of a city. During the Hellenistic period, cities would commission large statues of Tyche to ensure their safety and prosperity. One well-known statue of Tyche was created by the artist Eutychides for the city of Antioch. His statue depicted the goddess seated atop a personification of the Orontes River, which flows through the city. The worship of Tyche eventually blended with that of the Roman goddess Fortuna, who embodied the same protective qualities.

Unlike Eutychides' statue, this figure stands regally with a veil descending from the back of her mural crown. The attributes she once held are missing, but very likely she cradled a cornucopia, a symbol of prosperity, on her left arm and held a ship's rudder with her right hand, signaling her ability to steer events. The bottom of the rudder may once have been attached in the area of loss next to her right foot.

The size of this figure suggests that she was used for private worship within a household. Her stone ears are drilled for the insertion of real earrings, and there are holes on either side of her neck to suspend a necklace.

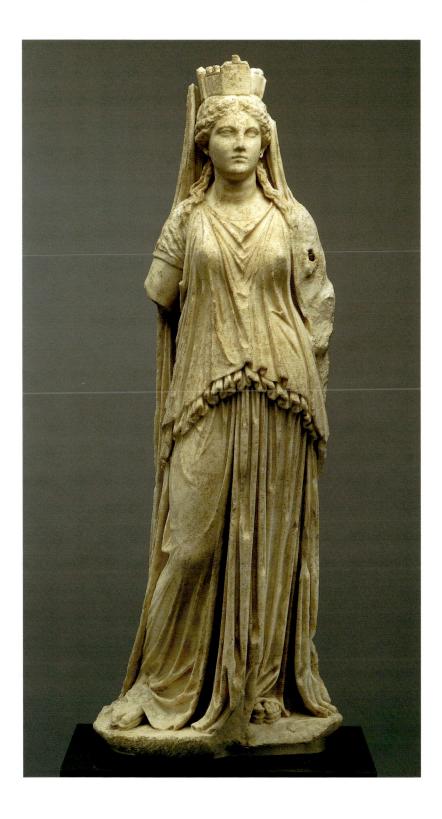

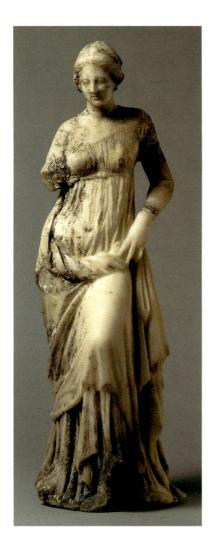

STATUETTE OF A DRAPED FEMALE FIGURE

Greek (Eastern Mediterranean), 100-1 B.C.
Marble
H: 45.1 cm (17³/₄ in.)
96.AA.169

This slender young woman in a graceful undulating pose probably represents Aphrodite, goddess of love, often identified by the fleshy folds on her neck known as "Venus rings," which were considered a sign of beauty in antiquity. She wears a gathered chiton of delicate material belted high under her breasts; with her left hand she holds a voluminous mantle that falls from her right shoulder. Her narrow shoulders, broad hips, elongated proportions, and complex drapery folds are characteristic of the Hellenistic period, as is her hairstyle.

Like many small-scale Hellenistic sculptures, especially those from the island of Delos, this piece employs the technique of piecing small sections, such as the arms, feet, and parts of the head, to the main body of the statuette. Small statues like this one were produced for private use and widely exported all over the ancient world.

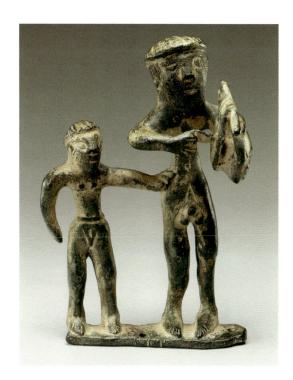

STATUETTE OF A LYRE PLAYER WITH A COMPANION

Greek (perhaps Crete), 690–670 B.C. Bronze H: 11.5 cm (4½ in.) 90.AB.6

Cast in solid bronze, this small statuette of a standing male lyre player and a smaller companion was originally attached by the holes in its base to another object, probably a large bronze vessel. Both figures are male, with oversize heads, fluid limbs, and thin, tapering torsos. Their hair is shaped like a cap, with rows of braids marked with parallel lines radiating from the crown. The larger figure is nude and plays a stringed instrument —perhaps the Homeric phorminx or kithara—evidently with a plektron (pick) held in his right hand. One of his eyes is rendered differently from the other. The smaller figure wears a loincloth and belt, typical male attire for Crete.

Group compositions such as this one are rare in Greek art of the late eighth and seventh centuries B.C., and groups of two or more human figures are rarer still. It is also very unusual to find three-dimensional musicians from this

period. Although certain deities, such as Apollo, are later depicted as musicians, this bronze bard, along with his companion, must be mortal. He is an *aoidos*, or minstrel, like Demodokos, the blind singer at the court of King Alkinoös who was described by Homer in the *Odyssey*. The date of this small bronze is roughly contemporary with that of Homer himself. The fact that Homer was said to be blind, and that the sightless Demodokos was assisted by a herald, suggests that this lyre player is a blind bard, like Homer or Demodokos, assisted by a young companion or apprentice.

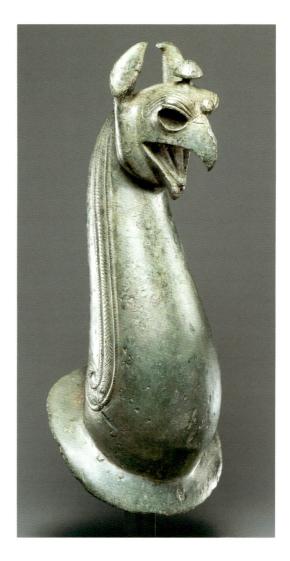

GRIFFIN PROTOME

Greek, circa 650 B.C. Bronze H: 28.5 cm (11½ in.); W: 10.7 cm (4½ in.); D: 9.3 cm (3½ in.) 96.AC.44

Griffins, hybrid creatures combining characteristics of a lion, bird, and snake, were often chosen to decorate the large bronze cauldrons that were popular votive offerings in temples of the early Archaic period. This cast image of a griffin was one of several that would have been attached to the shoulder of such a vessel by means of the holes in its flanged base. The creature is represented with upright ears, a gaping mouth, and wide-open eyes that were once inlaid—an apt visage considering its role as a

sentinel for a valuable vessel. Griffins in general are appropriate guardians of prized possessions because they were the creatures that guarded the god Apollo's gold and were known for their unwavering vigilance. These griffin cauldrons are found in particularly great numbers at the sanctuaries of Zeus at Olympia, Apollo at Delphi, and Hera at Samos. They were placed on tall stands and presented by, among others, victors in athletic games.

SHIELD STRAP FRAGMENT

Signed by Aristodamos of Argos
Greek (Argos), circa 575 B.C.
Bronze
H: 16.2 cm (6¾ in.);
W: 8 cm (3½ in.)
84.AC.11

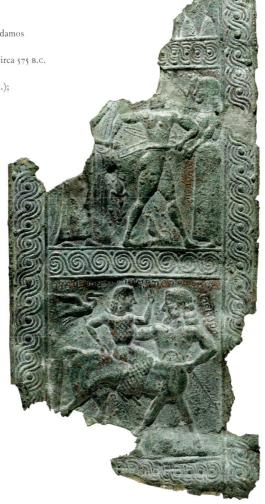

This small bronze relief fragment once decorated an arm strap inside an Argive warrior's shield. It is an especially significant piece because it contains the earliest surviving signature of an ancient Greek metalworker. At the top edge of the lower square, the signature of the bronze-worker, Aristodamos, is written retrograde (from right to left).

Considered by ancient Greeks to be valuable dedications, shield straps are often found in the excavations of sanctuaries, particularly at the Sanctuary of Zeus at Olympia. Because Aristodamos names himself as an inhabitant of Argos, this work can be taken as important evidence for the style and presentation of Argive art in the early Archaic period. Indeed, this strap represents two myths that were favored there. The lower square shows the Centaur Nessos abducting Deianeira, the wife of Herakles. The scene above it represents the recovery of Helen of Troy by her Spartan husband, Menelaos, an Argive king. Athena, protectress of the Greeks, stands watching to the right, her name inscribed beside her.

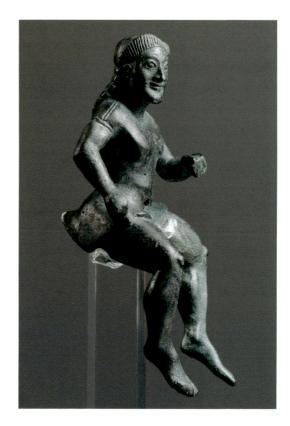

STATUETTE OF A RIDER

Greek (Corinth), circa 550 B.C. Bronze H: 8.3 cm (3½ in.); W: 4 cm (1½ in.); D: 3.4 cm (1½ in.) 96.AB.45

Virtually all ancient Greek bronzes served as devotional gifts to gods and were therefore dedicated in sanctuaries. The valuable material and spirited execution of a youthful, exuberant horseman distinguish this small bronze rider. The matching horse he rode has been lost; horses from similar ensembles are in the collections of the Louvre Museum, in Paris, and the National Archaeological Museum, in Athens. The Getty figure is dressed in a short tunic enlivened by a zigzag pattern around the neck; he probably originally wore a petasos, or rider's hat, atop his flattened head. His leg muscles arch in response to the movement of the horse as he guides the reins to his right.

Details of this work's manufacture may link it to a bronze workshop in

Corinth, but the patina, or surface corrosion, suggests that it was likely found at the Sanctuary of Zeus at Dodona, in northern Greece. This situation reflects the trade movement of art in antiquity, where a popular workshop would produce quantities of figures that could be destined for any number of sanctuaries. Corinth was an important center for bronzeworking in the middle of the sixth century B.C. and was a likely place for an aristocrat to commission a votive piece that would reflect his energy and status as a horseman. The ancient Greeks would have associated horsemen, especially those grouped in pairs, with Kastor and Polydeukes, the twin sons of Zeus and brothers of Helen of Troy, who were known as the Dioskouroi.

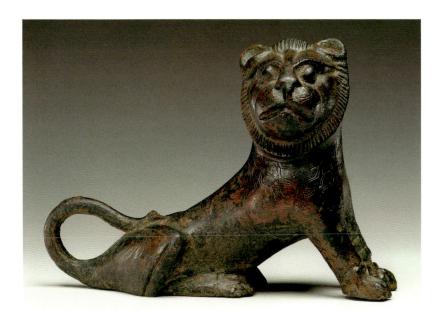

STATUETTE OF A SEATED LION

Greek (Lakonia), circa 550 B.C.
Bronze
H: 9.3 cm (3 1 in.);
W: 5 cm (2 in.);
L: 13.3 cm (5 1 in.)
96.AB.76

In contrast to more common depictions of lions as fierce and menacing, this small whimsical figure seems somewhat bemused. He sits back on his haunches with his front paws outstretched, turning his head to look straight at the viewer. His tail makes a graceful S-curve up the center of his back. The style of the piece indicates that it was made in the region of Lakonia in southern Greece, an area once controlled by the ancient city of Sparta. The treatment of the lion's ruff as short and incised, the flame-like lines incised on the body to indicate the patterns of fur, and the rounded face and ears are all hallmarks of the Lakonian style.

In antiquity lions were seen as guardian beasts. Statues of lions were placed on the corners of funerary plots or atop graves to guard the deceased. They were a popular subject during the Archaic period of Greek art (about 700–480 B.C.) even though they probably no longer existed in Greece at that time.

This statuette was once attached to another object, perhaps the rim of a large metal vessel. The remnants of an attachment pin are preserved on the bottom of the lion's left front paw. The figure was hollow cast, and much of the ancient core material remains inside.

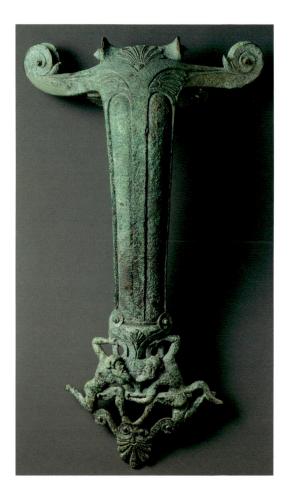

HANDLE OF A VESSEL

Greek, circa 500 B.C. Bronze H: 23.5 cm (91/4 in.) 96.AC.79

This handle once belonged to a large bronze serving vessel. The image of two satyrs holding up a large kantharos at the base of the handle suggests, through its associations with Dionysos, that the now-missing vessel was probably intended to hold wine; the god of wine is often pictured holding this type of cup, accompanied in his revelry by parthuman satyrs. On the Getty handle, these playful creatures balance carefully atop a palmette; they mirror one another across the large cup, striking the same pose, despite its different orientation with respect to the viewer. The satyr on the right is turned so that his back faces toward the viewer, while the one on the

left is shown in frontal perspective, exposing his chest and erect phallos; the long tail he once had is now missing. The remainder of the handle appears to grow out of the kantharos. A double volute rises out of its mouth to form the base of the shaft, and the palmettes and volutes at the top of the handle continue the organic theme. This decoration encompasses the fertility connotations of the satyr's phallos as well as Dionysos's additional role as god of the vine, vegetation, and rebirth.

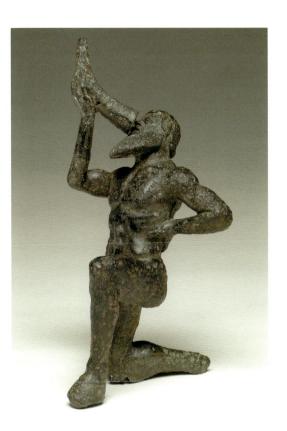

STATUETTE OF A KNEELING SATYR

Greek, 480–460 B.C. Bronze H: 10 cm (3½ in.); W: 4.3 cm (1½ in.); D: 5.6 cm (2½ in.) 88.AB.72

Completely focused on his activity, a kneeling satyr drinks from an upraised keras (drinking horn). His equine hoof, pointed ears, and the remains of a tail in the small of his back identify him as a satyr. The finely incised strands of his hair and beard along with the detailed and anatomically correct musculature mark the statuette as a piece of outstanding quality. The satyr's developed anatomy and projecting, complex pose serve to date the piece to the early Classical period. At this time, artists were breaking away from the rigid confines of earlier styles to make their figures more complicated and three-dimensional. This satyr needs to be seen from all sides to be fully understood and appreciated: he supports himself on one bent and one upraised knee (a pose that also exposes his erect phallos); his left arm braces his

torso as he puts his hand against his hip to balance himself; and his right arm and *keras* extend upward.

Satyrs were the companions of Dionysos, god of wine, and accompanied him on his drunken revels. In keeping with satyrs' part-human, part-animal nature, their behavior is usually bestial and uncouth, and they symbolize man's uncivilized urges. The vessel from which this satyr drinks, the *keras*, was used to imbibe unmixed or undiluted wine, which led quickly to drunkenness.

Appropriate to his pose, this small figure may have decorated a large metal vessel used to mix and serve wine at a banquet. A rough area below his left hoof may be the remains of an attachment pin. Alternatively, the statuette may have been given as a gift to the god at a sanctuary of Dionysos.

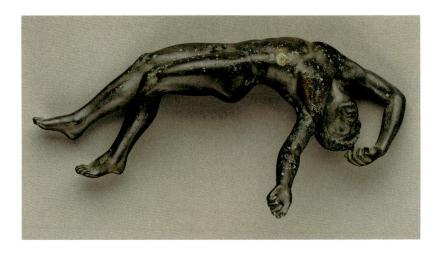

Statuette of a Fallen Youth

Greek, 480-460 B.C. Bronze with copper inlays L: 13.5 cm $(5\frac{1}{4}$ in.); w: 7.3 cm $(2\frac{7}{8}$ in.) 86.AB.530 This figure is unique among surviving bronzes of the early Classical period. The evocative pose is a clue to the figure's identity, for it suggests either sleep or death, which the Greeks thought to be closely related. In this case the figure is posed uncomfortably on his back; the tortuous angle of the chest, combined with lolling head, splayed arms, and dangling legs, completes a pose that evokes death more than sleep. For these reasons, he may be identified as a fallen Niobid. A famous Greek myth tells the story of Niobe, a mortal who boasted of her own seven sons and seven daughters to the goddess Leto. In a jealous rage, Leto's son and daughter, Apollo and Artemis, hunted down and slaughtered all of Niobe's children. The tale was a favorite mode of expressing the dangers of boastful pride (see also Statue of a Collapsing Niobid, p. 154). The Fallen Youth's original context is uncertain, because there are no attachment marks to indicate how it may have been used.

HYDRIA

Greek, circa 460 B.C. Bronze H: 47 cm (18½ in.); DIAM (body): 28.2 cm (11½ in.) 73.AC.12 Hydriae are among the few types of vessels pictured and named in ancient Greek vase-paintings. From images showing their shape and function, it is clear that these three-handled vessels were designed primarily to be water containers—and that they were essential wares in the daily life of the ancient Greeks.

The two horizontal handles on the sides of the vase were used to lift it, while an upright handle on the back made filling it or pouring out its contents easier. The only ornamentation on this vase appears on its handles. Palmette motifs enhance both the attachment plates of the two side handles and the lower plate of the upright

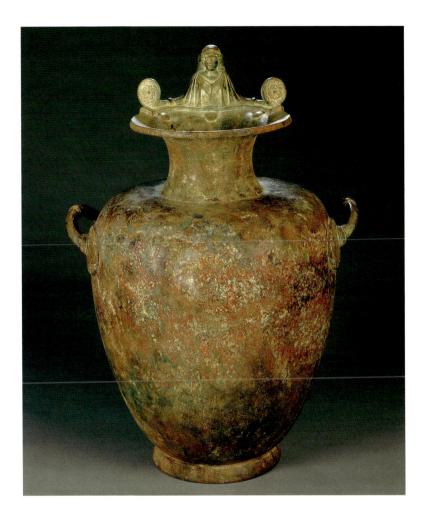

handle. The handle at the rim has a sculptural adjunct in the form of the upper body of a female. Her garment, a peplos, is somewhat altered to cover her outstretched arms and reveal, instead of hands, two *rotellae* (diskshaped ornaments) decorated with floral petals in relief.

Most hydriae were made of terracotta, a relatively inexpensive material that was within the means of ordinary households. In addition to carrying water, these vessels occasionally functioned as ballot boxes or even as cinerary urns. Those made of more costly bronze, which had the color of gold when new, were highly valued and thus were sometimes utilized for special purposes, such as dedicatory offerings to deities or prizes for victors in competitions. The practice of reuse is exemplified by this particular hydria. When found, it contained the skeletal remains of a child who, at death, must have been about two years of age.

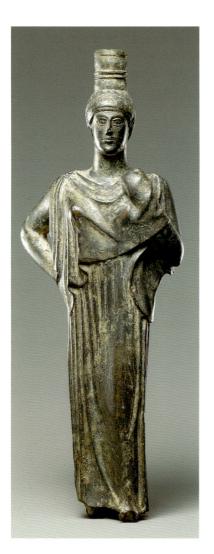

STATUETTE OF A WOMAN WEARING A PEPLOS

Greek (perhaps Argos), 460–450 B.C. Bronze H: 16.1 cm (6 1/8 in.) 96.AB.47

This austere, peplos-clad female probably served as a support for a thymiaterion (incense burner) or a candelabrum, as suggested by the cylindrical attachment on her head, the upper part of which is hollow. Standing in perfect repose, she rests her weight on her right leg and extends her more relaxed left leg slightly forward, breaking the columnar folds of the peplos. Her right hand rests on her hip; her left arm is bent sharply at the elbow and held beneath the overfold of her garment, with the hidden hand raising the fabric near the neckline. Her face is rather somber, with heavy features, a prominent jaw, and a broad neck. The soft fabric of the sakkos, or headdress, that covers her head is patterned with circles and zigzags and forms a series of soft ridges down the back.

This statuette's distinctive pose recalls one of the figures in a famous painting, the *Nekyia* (Descent into the Underworld), by the celebrated Classical painter Polygnotos, who was active around 475–447 B.C. According to the Greek writer Pausanias, Polygnotos showed Eriphyle, an Argive heroine, reaching under her garment to finger the necklace for which she betrayed her husband. The Getty figure's stance, dress, and heavy facial features are associated with larger works created by Argive sculptors and, according to tradition, Eriphyle herself was from Argos.

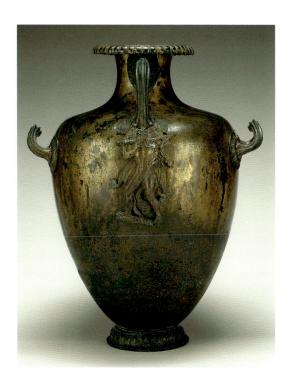

KALPIS

Greek, circa 350 B.C. Bronze H: 48 cm (18¾ in.); DIAM (body): 31.5 cm (12¾ in.) 79.AC.119

Although used to describe a vessel very similar in shape to the hydria, the term kalpis refers more generally to a pitcher. Whereas the hydria (see pp. 38-39) is distinguished by a sharp division at the juncture of the neck and body, the contours of the kalpis are smooth and slightly elongated. From several sources, including inscriptions, we know that kalpides and hydriae were often the prizes in competitions held at different festivals throughout the Greek world. These valued possessions were offered at sanctuaries as dedications, and many of them served as cinerary urns for the ashes of the owner or a member of the family. They could also be used to hold ballots cast in voting. The decoration of bronze hydriae and kalpides was usually limited to the rim, foot, handles, and the relief at the base of the vertical handle.

The body of this kalpis was hammered from a sheet of bronze, while the ornate attachments, such as the handles, were cast and hammered separately and then added. A variety of floral patterns decorate the rim, the foot, and the base of the fluted handles. The separately hammered relief plate below the vertical handle shows the Greek hero Herakles carrying both his club and the infant Eros. The vessel's shape and decoration belong to a class that developed in the course of the fourth century B.C., one characterized by the complex relief plates that replaced the earlier cast finials. Popular figures at this time include Eros, either alone or with another figure; later, the scope of subjects widened to include Dionysos and other deities. The depiction of Herakles carrying the infant Eros in an affectionate manner is the earliest known representation in Greek art of these two figures alone.

KALPIS

Greek, 350-325 B.C. Bronze H: 40.6 cm (16 in.); DIAM (body): 26 cm (101/4 in.) 73.AC.15

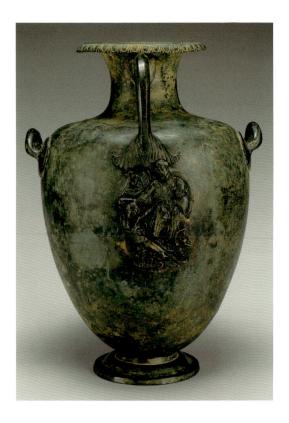

This kalpis displays little ornamentation except for the relief plate and the carefully chased pattern on the rim. The subject of the handle relief is a scene from the battle between the Olympian gods and the Giants. Athena, identified by her aegis, helmet, and shield, defeats a naked Giant who has fallen on his right knee and is being attacked by the snake encircling his body. He tries in vain to ward off the victorious goddess. The terrain on which the combat takes place is stippled and has several flowers seen as if from above. The goddess Athena appears often in Greek art in the battle against the Giants, the earlier divinities of Greek mythology who were defeated and replaced by the Olympian pantheon. The vase's shape, decorative subject, and style suggest that it was produced in the third quarter of the fourth century B.C.

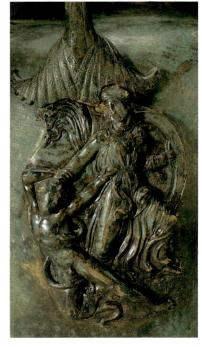

STATUETTE OF THE YOUTHFUL HERAKLES

Greek, 300–200 B.C. Bronze H (with tang): 19.5 cm (7% in.) 96.AB.148

Because the Greek hero Herakles is perhaps more commonly recognized as a bearded and heavily muscled older man carrying a club, this slender figure might be mistaken for an ordinary young man. But what at first glance appears to be only drapery over the left arm is actually the skin of a lion, indicating that the statuette represents the youthful Herakles, who had killed the Nemean Lion as one of his Twelve Labors. It is a small-scale version of a statue created in the fifth century B.C., perhaps by the sculptor Polykleitos.

In his now-missing right hand, Herakles probably held a cup or drinking horn. In Greek art, the hero is often shown in a drunken state or in the company of Dionysos, god of wine, with whom he shared a fondness for wine and engaged in drinking contests. The depiction of Herakles as a drinker, here and in other similar examples, is termed *Bibax* (Latin for "addicted to drinking").

The diadem (a headband associated exclusively with divinities and royalty) and its central lotus leaf crowning this figure's head raise an alternate possibility: that he represents not Herakles but a young ruler in the guise of the hero. Ancient rulers, both Greek and Roman,

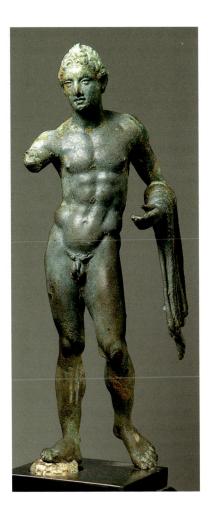

embraced the practice of being portrayed with the attributes of the mighty Herakles. This figure's peaked diadem is a type associated particularly with the Ptolemies, who assumed the rule of Egypt following the death of Alexander the Great in 323 B.C. However, the facial details seem too non-specific to merit consideration as a portrait.

STATUE OF A VICTORIOUS YOUTH

Greek, 300–100 B.C. Bronze with copper inlays H: 151.5 cm (59% in.) 77.AB.30

Standing in a relaxed pose, this nude youth crowns himself with a (mostly now-missing) olive wreath in the traditional gesture of a victorious athlete. This kind of statue is typical of the extravagant votive offerings that victors in athletic games often commissioned and dedicated after a significant success (the bronze Charioteer, in Delphi, is a famous example). The figure's slim proportions, including its relatively small head and modulated torso, indicate youthfulness. The style of the sculpture refers generally to that of Lysippos, the famous fourth-century court sculptor of Alexander the Great. According to the Roman writer Pliny, Lysippos was famous for representing men not as they really were, but as they appeared to be. The phrase well describes this statue, for the polished surface of this bronze was carefully modeled in order to evoke the appearance of well-developed musculature, while naturalistic color contrasts were achieved by inlaying the eyes with colored stone or glass paste and the nip-

ples with copper. The suggestion of circular torsion in the posture that invites the viewer to walk around the statue is characteristic of the Hellenistic period, during which the piece was cast.

Bronze was the favorite medium for sculpture in ancient Greece, particularly in the fifth and fourth centuries B.C. Yet only a fraction of the thousands of votive and commemorative statues that adorned the public and private spaces of cities and sanctuaries have survived, making this bronze especially important. That any original Greek monumental bronzes remain at all is primarily due to the Roman passion for them, for many Greek sculptures were brought to Rome to adorn the Roman forum as well as public and private buildings and gardens. The Victorious Youth was found in an ancient shipwreck off the coast of Italy, incrusted with shells, corals, and mud. It had been taken from a sanctuary, probably Olympia or the hometown of the dedicator, and was no doubt on its way to Rome.

STATUETTE OF A GIANT HURLING A ROCK

Greek, circa 200–175 B.C. Bronze H: 14 cm (5½ in.) 92.AB.9

A muscular Giant, half standing with knees bent and right leg pulled up beneath him, is poised to hurl the rock that he holds over his head. This statuette was most likely part of a larger group composition depicting the Gigatomachy—the battle for control of the Earth between the Olympian gods and the Giants, a mythological race of monsters who ruled before the birth of the gods.

In antiquity, the Gigantomachy was a popular artistic subject for both smalland large-scale compositions. It symbolized the triumph of the Greeks (as represented by the gods) over the barbarians (the uncivilized Giants). The most famous Gigantomachy was carved in marble on the Great Altar of Zeus at Pergamon (now in the Pergamon Museum in Berlin). The only physical indications of this Giant's wild, inhuman nature are his pointed ears and coarse, tufted hair; the rest of the beautifully modeled figure appears quite human. The pose of this statuette is very similar to the pose of a Giant named Klytios carved on the east facade of the Gigantomachy frieze from the Great Altar of Zeus. Like the Getty Giant, Klytios holds a rock over his head.

Groups of mythological figures were frequently used as decorative attachments on candleholders, thrones, large vessels, and ceremonial chariots. A small hole under the Giant's left thigh may indicate the figure's original point of attachment to another object, perhaps a larger rock or landscape setting. Another small statuette of a Giant in the Museum's collection (see p. 192) served a similar function.

HERM OF DIONYSOS

Attributed to the Workshop of Boëthos Greek, 100–50 B.C. Bronze with ivory inlay H: 103.5 cm (40% in.); w (base): 23.5 cm (91/4 in.) 79.AB.138

A herm is a statue in the form of a square pillar surmounted by a bust or head. In antiquity, herms stood at crossroads, served as boundary or distance markers, and were thought to protect travelers. They also guarded the entrances of homes to ward off evil. Herms were used as decorative sculpture in the palaistra (exercise arena) and in gardens. Originally, the head of the herm represented Hermes, god of travelers and commerce (hence the name applied to this kind of sculpture), but herms came to be topped by the heads of other gods and mythological figures, and later by portrait busts of athletes and prominent citizens. Offerings of floral wreaths were draped over the stubby prisms on the herm's sides.

The Getty herm depicts Dionysos, god of wine, wearing a turban. The eyes, only one of which survives, were inlaid with ivory to give a naturalistic impression. This herm is remarkably similar in size and sculptural features to one discovered in an ancient Roman shipwreck off the coast of Tunisia, near the town of Mahdia. The metal content of the bronze used to cast both herms is also the same; they were likely made in the same workshop at the same time. The signature of Boëthos of Chalkedon (a city in modern Turkey) appears on the right prism of the Mahdia herm; this same prism, which might have once held a similar signature, is missing from the Getty piece. If the Getty herm was not made by Boëthos himself, it was probably the work of one of his apprentices.

HANDLE OF AN

Greek, 100–50 B.C. Silver with gilding L: 27 cm (10% in.); w: 9.5 cm (3¼ in.) 85.AM.163

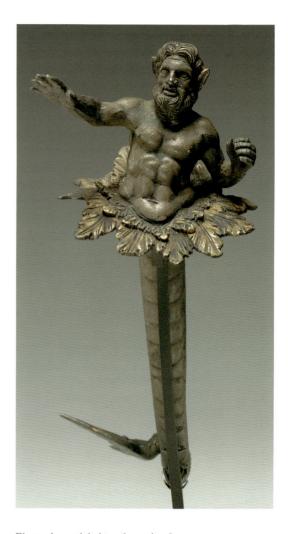

Elegantly modeled in silver, this figure represents a triton, a mythological hybrid of a human and a sea serpent. Originally, this triton served as the handle of a silver or gold oinochoe, a pouring vessel; as a sea deity, his powers were well suited to protecting a container's liquid contents. The figure reaches out with his right hand, perhaps to ward off evil; his other hand presumably once held a trident. This creature's large eyes, swirling, shaggy beard and hair, and horselike ears all recall his untamed nature.

As is typical in much fine Greek metalwork, the unusual aspects of the subject are used to great advantage in the design. While the tail itself arcs to serve as the handle, its end is delicately curled to distract the viewer from its practical function as an attachment to the body of the oinochoe.

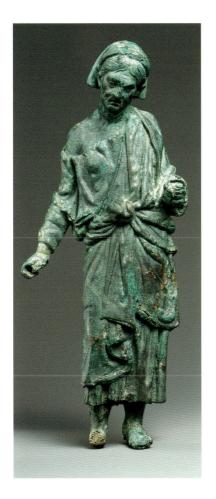

STATUETTE OF AN OLD WOMAN

Greek or Roman, 100–1 B.C. Bronze H: 12.6 cm (5 in.) 96.AB.175

This statuette of an elderly woman poignantly depicts old age. Her sagging cheeks, sunken eyes, and wrinkled neck with visible tendons attest to a long, hard life. The garments she wears and the scarf on her head indicate that she is most likely a household servant, and her fatigue is evident in the tilt of her head and her drooping shoulders. The objects she held in her hands are now missing, thus we can only guess at her occupation. But the positioning of her hands and her downward gaze have led some scholars to propose that she may have been spinning thread. She would have held the unworked distaff of wool in her left hand and the spindle of spun thread in her lowered right hand. It has also been suggested that she is Klotho, one of the three Fates, who spins the thread of life.

A number of other similar images of domestic servants involved in household activities exist, including one that is essentially a replica of this figure in the Kunsthistorisches Museum in Vienna. Depictions of the elderly, along with an interest in portraying people with physical deformities, came into fashion during the late Hellenistic period, from the second century B.C. on.

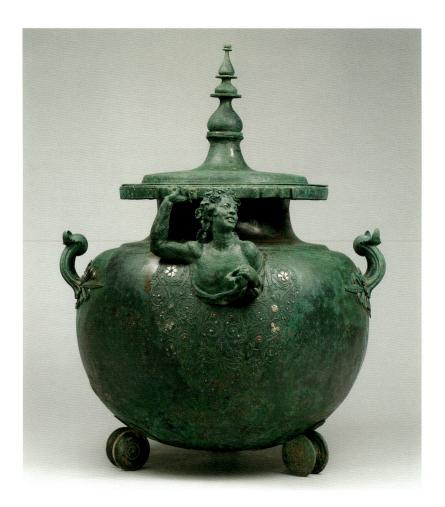

LEBES

Greek, 50-1 B.C. Bronze with silver inlays H: 58 cm (227/8 in.) 96.AC.51 Springing from a pattern of flowers, leaves, and spiraling tendrils on the front of this lebes (cauldron), an intoxicated satyr exuberantly denotes this vessel's purpose. Throwing back his ivy-wreathed head, flashing a roguish grin, and gesturing backward to the lebes with one hand while gripping a drinking cup in the other, he invites the spectator to share in the delights of the contents, strong wine that, in the custom of the Greeks, had been diluted with water. As a follower of Dionysos, who not only was the god of wine but also represented the regenerative powers of nature, the satyr's presence here, together with the vegetative motifs, indicates that the lebes may have been used in cult rituals or festivals honoring the god.

LION PROTOME

Greek (Crete), circa 650 B.C. Terracotta H: 7.6 cm (3 in.); DIAM: 7 cm (2½ in.) 91.AD.24

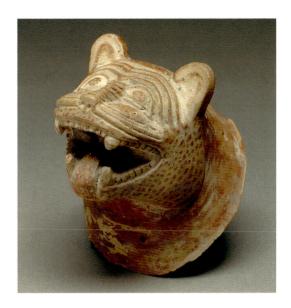

With its open, roaring mouth filled with sharp teeth, this lion appears ready to attack. Six holes around the base of the neck were used to attach the protome to another object, probably a terracotta shield. In Crete in the 700s and early 600s B.C., bronze shields decorated with elaborate three-dimensional animal heads were dedicated in sanctuaries as gifts to the gods. During this period, new artistic ideas flowed into Greece from the Near East. The bronze votive shields copied real shields used for battle in the Near East. Artists on the island of Crete took a leading role in synthesizing native and Near Eastern elements to create a new Greek style. This protome appears to have been part of a terracotta reproduction of such a votive offering.

The protome was made by pressing wet clay into a two-piece mold and then joining the two halves of the figure while the clay was still slightly damp. Next, details of the face were carved with a cutting tool. Interestingly, the same mold that was used to make this lion was used to produce two other surviving lion's heads: one a protome like this and the other an attachment added to a vessel. Although the craftsman of this lion protome is unknown, he left his fingerprints behind in the clay on the inside of the object and in the red paint behind the lion's left ear.

Оіноснов

East Greek (Miletos,
Asia Minor), circa 625 B.C.
Terracotta
H: 35.7 cm (14 in.);
DIAM (body): 26.5 cm
(10% in.)
81.AE.83

Herds of wild goats and spotted deer are arranged single file in discrete registers around this oinochoe. The trefoil mouth of the vase perfectly suits its use as a pitcher for wine. On the shoulder of the vase, pairs of dogs, enormous water birds, and sphinxes flank a floral ornament. The cream-colored background is neatly filled with various patterns, including rosettes, some of which are brought to life by small birds perched on their petals. In whimsical touches, the painter placed a bird on the tail of a sphinx and broke the monotony of the lower frieze by having a deer turn its head.

The goats have given their name to this kind of pottery decoration: the Wild Goat style. It was popular in the Greek settlements on the west coast and offshore islands of Ionia (modern Turkey) in the seventh and sixth centuries B.C. The island of Rhodes was once thought to have been the main producer of Wild Goat pottery, but excavation and clay analysis have since

PROTOCORINTHIAN ARYBALLOS IN THE SHAPE OF A RECUMBENT RAM

Greek (Corinth), 640–625 B.C. Terracotta H: 9.1 cm (3½ in.); L: 14 cm (5½ in.) 86.AE.696

Plastic vases (molded vessels made in the form of human, animal, or mythological beings) first appear in the eastern regions of the Greek-speaking world during the late eighth century B.C. and were popular from about 650 B.C. on. Among the many Greek places that produced such vases, Corinth and Rhodes were the leading manufacturing centers. This Protocorinthian aryballos is a combination wheel-thrown and moldmade vessel fashioned in the shape of a mature ram resting on legs tucked up under its body. Large horns curve behind the ears and frame a carefully detailed face, with stylized locks of fleece falling between the eyes and curling around both corners of the mouth. Dots scattered randomly

over the body represent the fleece, perhaps cut short, and black is used to highlight the hooves and the thick, stubby tail. The vessel's comparatively large body is surmounted by a short neck and rim, with a narrow opening.

Plastic vases such as this appear to have been used for the export of specific precious liquid commodities, whether cosmetic or medicinal. The value of such vessels derived in part from the commodities they held, which were themselves enhanced by the figural container. Widely distributed throughout the Mediterranean, perhaps through intermediaries like the Phoenicians, such vases provide important insights into the economic relationships of the period.

established the importance of workshops based in the ancient city of Miletos. How did files of grazing quadrupeds come to be the pot-painters' favorite? Animals arranged in friezes appear frequently in Greek art of the Orientalizing period. At this time, Greeks came into closer contact with their neighbors in the Near East, where repetitive bands of animal decoration were common. The highly ornate Wild Goat style is thought to have been patterned after textile designs, but ivory and bronze objects may also have provided sources of inspiration; the floral disks applied to the rim of this oinochoe are clearly derived from bronzework.

CORINTHIAN

Name-vase of the
Painter of Malibu 85.AE.89
Greek (Corinth),
650–625 B.C.
Terracotta
H (with rotellae): 32.8 cm
(127/s in.);
DIAM (body): 17 cm (6% in.)
85.AE.89

The body of this elegant pouring vessel is decorated in the manner most frequently used on Corinthian vases, a combination of floral and animal designs in neatly defined friezes or registers. This was a style strongly influenced by the ancient Near East. The four superimposed friezes repeat many of the animals that form the Corinthian vasepainter's standard repertoire: lions, panthers, goats, deer, bulls, boars, swans. Dot-rosettes surround and separate the animals. Both the creatures and the filling ornaments are carefully laid out and meticulously drawn. Individual animals are depicted as if slowly moving forward in their distinct rows. Certain details, such as the animals' manes and underbellies, or the birds' wings, are highlighted with the use of added red paint. The close-set nature of the animals

and rosettes, combined with the superimposed rows, suggests that the overall design may imitate textiles, which, according to ancient literary sources, were highly valued.

This olpe was made so early in the Corinthian period that it displays stylistic traits often called "transitional" by scholars. The neck, lip, and handle of the vase are painted in solid black, while dot-rosettes in added white enhance each of the two roundels that flank the tall handle and encircle the neck. A slightly raised collar-ring, highlighted in added red, separates body from neck, and the characteristic ray pattern encircles the lower body above the foot. The olpe, the aryballos, the pyxis, and a number of other Corinthian shapes were widely distributed throughout the Mediterranean.

CORINTHIAN ARYBALLOS

Greek (Corinth), 600–575 B.C. Terracotta H: 11.2 cm (4½ in.); DIAM: 11.7 cm (4½ in.) 92.AE.4

The black-figure technique was invented in Corinth and from there it spread to Athens, Sparta, and other Greek centers. Corinthian potters exploited the technique to produce some of the earliest narrative scenes in Archaic Greek art. They excelled, in particular, in mastering the miniature picture frieze, where complex mythological stories were artfully rendered in great detail on the surface of small vessels. Here, the greatest of all Greek heroes, Herakles, battles the Lernean Hydra, a monster whose multiple heads took the form of snakes. Required to destroy the fierce creature as the second of the Twelve Labors assigned by King Eurystheus, Herakles grasps one of the snaky heads while stabbing the creature with his sword. On the side of the vase shown here, one of the Hydra's heads is about to bite Herakles' shoulder,

and a crab, sent to help the Hydra, approaches the hero's ankle from behind. Herakles' protectress, the goddess Athena, stands behind him, gesturing her support. On the other side of the vase, inscriptions in the distinctive Doric alphabet of Corinth identify Iolaos, Herakles' nephew and faithful companion, and Iphikles (written as Wiphikledas), Herakles' twin brother. One holds the Hydra; the other (under the handle) is shown as a charioteer, head turned back to face the action while keeping the four-horse chariot at bay, ready to carry off the victorious hero. The handle itself is decorated with a female head resembling that of Athena. Although aryballoi, small jars for perfumed oils, were mass produced and widely distributed, few are as elaborately decorated or as well made as this example.

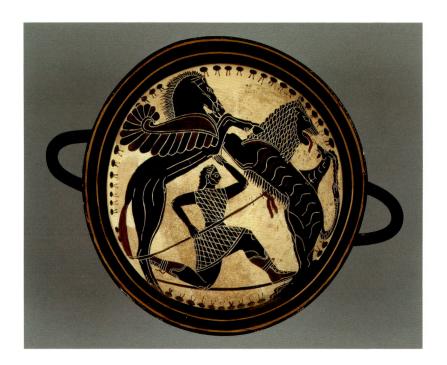

Lakonian Black-Figured Kylix

Attributed to the Boreads Painter Greek (Sparta), 570–565 B.C.
Terracotta
H: 12.5 cm (4½ in.);
DIAM: 18.5 cm (7½ in.)
85.AE.121

In the sixth century B.C., several regions of ancient Greece followed the Corinthian model and decorated vases in the black-figure technique, with details rendered in incision and added red paint. Stemmed drinking cups like this one were a specialty of Lakonia, the region around Sparta, from whence they were exported to a number of centers in the Mediterranean.

Lakonian vase-painters developed different ways of adapting narrative scenes to the circular space of a cup's interior. Here, the triangular composition almost seems to burst the frame, and the groundline bends under the hero Bellerophon. With his right hand, he thrusts a spear into the chest of the Chimaira; with his left, he holds the reigns of the winged horse Pegasos rearing behind him. Bellerophon, who has dismounted to attack the monster, is shown in the kneeling pose used to characterize quick movement in Greek art of the Archaic period. Squeezed against the border of the cup, the Chimaira cannot fully display its terrifying features: the snarling lion's face, the fire-breathing goat's head growing from its back, and the tail turned into a snake. The painter of this cup has been identified as one of two influential masters of the first generation of Lakonian vase-painters. He has been nicknamed the Boreads Painter after one of his tondo designs, which shows the Boreads, the sons of the North Wind.

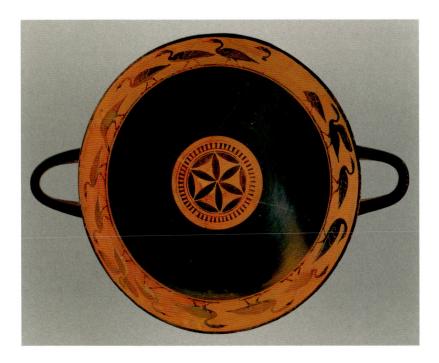

BLACK-FIGURED LIP CUP

Attributed to the Osborne House Painter East Greek (Samos), circa 550 B.C.
Terracotta
H (as restored): 9 cm (3½ in.);
DIAM: 14.2 cm (5% in.)
86.AE.57

Fine miniaturist drawing matches the delicate potting of this wine cup. It was made around the middle of the sixth century B.C., most probably on the Greek island of Samos, situated in the Mediterranean off the coast of modern Turkey. In antiquity, this coastal area was settled by Greeks, now generally referred to as East Greeks.

The shape of the cup is similar to that of the socalled Little Master cups made in Athens, but most of the decoration is East Greek. Typically East Greek are the ivy vine on the outer lip and the rosette in the center of the cup, derived from a compass-drawn net pattern of Near Eastern origin. Apart from the tondo, the inside of the bowl is glazed black, with the lip reserved. In this space march several waterfowl, a common motif on pottery from East Greece: here, two birds flap their wings, another turns its neck, and vet another reaches down with its beak to the black surface below. When the cup was filled to the lower edge of the lip, the birds would have appeared to be wading in shallow liquid as if on the shores of the sea or a lake. In a similar play with design and contents, other cups show dolphins instead of birds. The idea of a sea of wine inside a cup or bowl was also taken up by pot-painters in Athens, who depicted fleets of ships inside the rims of kraters and dinoi (see, for example, the dinos on p. 63).

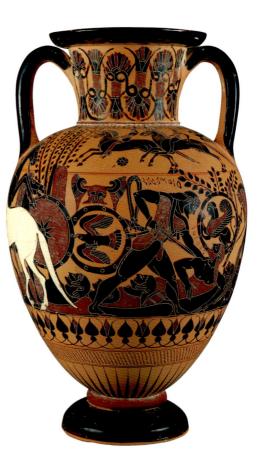

CHALKIDIAN BLACK-FIGURED NECK-AMPHORA

Attributed to the Inscription Painter Greek (Rhegion, South Italy), circa 540 B.C.
Terracotta
H: 39.6 cm (15% in.);
DIAM (body): 24.9 cm (9% in.)
96.AE.1

The Thracian king Rhesos and his troops came to Troy to fight on the side of the Trojans against the Greeks. Arriving late at night and exhausted from the journey, they had to camp outside the city walls. In the middle of the night they were attacked by the Greek heroes Odysseus and Diomedes, who coveted their immortal horses. Odysseus and Diomedes killed twelve of the sleeping Thracians and their king, Rhesos, before they led the horses away. So we are told by Homer in his epic poem the Iliad. Remarkably, many details of the epic version recur in the colorful painting on this amphora. The Thracians are depicted wrapped in their robes and with their armor and weapons hanging in the landscape around them. In the primary scene, Odysseus and Diomedes

are identified by inscriptions, as is King Rhesos, who is about to be stabbed by Diomedes. Under the handles of the vase, the horses that Homer described as "fast as the wind and white as snow" are shown rearing in panic, with a striking white stallion in the foreground.

Bold use of red and white added paint highlights the skillful composition. This has been attributed to the so-called Inscription Painter, who had the habit of labeling the figures in his drawings. The variant of the Greek alphabet used in these inscriptions is one of the features suggesting that his home was Rhegion (modern Reggio) in South Italy, a colony of the Greek city of Chalkis. There he appears to have set up a workshop producing the type of black-figured pottery that we call Chalkidian.

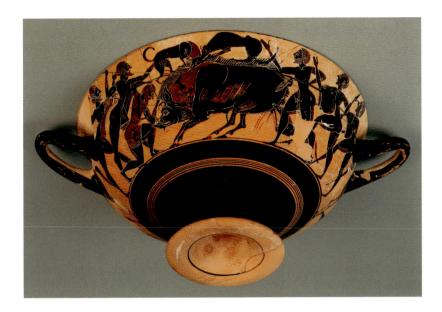

ATTIC BLACK-FIGURED SIANA CUP

Attributed to the Painter of Boston C.A. Greek (Athens), circa 560 B.C. Terracotta
H: 12.9 cm (5% in.);
DIAM: 26.2 cm (10% in.)
86.AE.154

The Siana cup was one of the most popular blackfigured cup shapes from early in the sixth century B.C. until about 540 B.C. It was named for a cemetery on the island of Rhodes, where two examples of the shape were found. These cups are distinguished by their offset lip, which could be either decorated separately from or, as in this case, painted in unison with the composition on the body. Heroic and mythical exploits decorate the exterior of this vase. The Calydonian boar hunt, one of the favorite adventures of the early Archaic age, is on Side B (pictured here), where six men and three dogs are shown energetically attacking the enormous boar sent by Artemis to ravage Peloponnesian Calydon. According to myth, several notable heroes took part in this hunt, among them Peleus, Meleager, and the huntress Atalanta. Though the figures are not identified by inscription, a Greek viewer would no doubt have interpreted the men as representations of these heroes. Side A represents an episode from the Battle of Lapiths and Centaurs. The interior of a Siana cup is typically black, with a simply designed tondo. This cup's tondo depicts a mounted rider of the aristocratic Athenian class, the type of man who would have purchased and drunk from a cup like this.

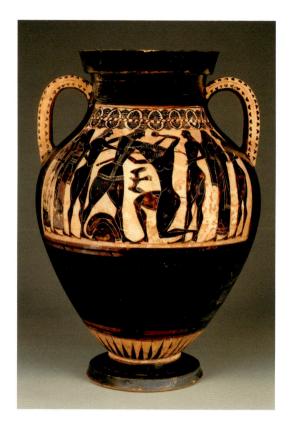

ATTIC BLACK-FIGURED AMPHORA, TYPE A

Attributed to Lydos
(as painter) or a painter
close to him
Greek (Athens), 550-540 B.C.
Terracotta
H: 45.5 cm (17% in.);
DIAM (body): 32.6 cm (12% in.)
86.AE.60

In two examples, Lydos signed his work "the Lydian," so, though he may have been born in Athens and spent a long career there, he considered his origin to be Lydia in Asia Minor (modern Turkey). One of the masters of Athenian vasepainting, Lydos took part in the development and elaboration of tales and legends that first began to be painted on vases in the middle of the sixth century B.C. Among these tales were Herakles' fight with the triple-bodied Geryon, many of the Trojan War episodes, and the Battle of Theseus and the Minotaur. This was a favorite because it represented the most heroic exploit of the first great hero of Athens. On Side A of this amphora (shown here), the Athenian youths and maidens whom Theseus saved from the Minotaur watch the bat-

tle. Lydos's style is typified by robust male forms with beefy thighs and articulated musculature that resemble the sculpted Archaic kouroi (see the Museum's kouroi on pp. 14, 16–17). Many black-figured neck-amphorae have necks set off sharply from the bodies (see, for example, p. 61). In contrast, on Type A amphorae (also called belly-amphorae), that transition is smooth. This shape is also distinguished by its flared mouth and flanged handles, usually painted with an ivy design; the decoration is generally restricted to panels, as here.

Attic Black-Figured Neck-Amphora

Name-vase of the Bareiss Painter
Greek (Athens), 530–520 B.C.
Terracotta
H: 32.8 cm (12% in.);
DIAM (body): 21.9 cm (8% in.)
86.AE.85

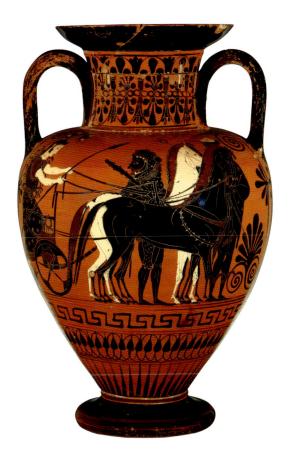

One of this vase's most interesting features is its physical condition. Not long after it was completed, the entire mouth and upper area of the neck were damaged so seriously that they had to be replaced. The broken edge was leveled, and a neck from a different amphora of slightly later date but almost exactly the same dimensions was substituted for the first neck. The still-evident drill-holes would originally have received bronze pins (and, later, lead clamps) to hold the two pieces together. The skillful ancient repairwork is nearly seamless.

This vase has been identified as the name-piece of the Bareiss Painter, an artist who worked within a group of painters of similar style called the Medea Group. Because so few Greek vasepainters signed their work, scholars assign a nickname to a painter based on a noteworthy feature of one of his vases. In this case, the modern collector's name was used.

The scenes on this vase are typical of favorite subjects on pots of the last third of the sixth century B.C. The Apotheosis of Herakles is represented on Side A (seen here), which shows him about to join Athena in a four-horse chariot that will take them to Mount Olympos. Side B shows mounted hoplites in combat over a fallen warrior. To the vase's ancient owner, this unidentified scene would have recalled heroic battle scenes such as those Homer described in the *Iliad*.

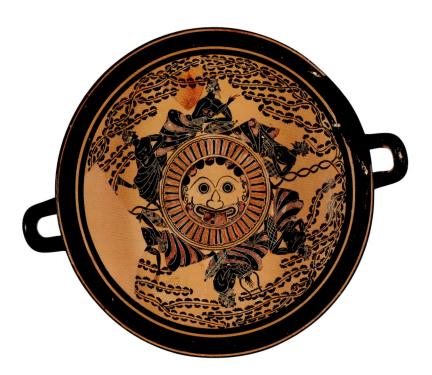

ATTIC BLACK-FIGURED ZONE CUP, TYPE A

Attributed to the manner of the Lysippides Painter and to Andokides (as potter)
Greek (Athens), circa 520 B.C.
Terracotta
H: 13.6 cm (5% in.);
DIAM: 36.4 cm (14% in.)
87.AE.22

The name *zone cup* refers to the circular frieze in the interior of this vessel. In this case, it depicts a *symposion*, the all-male drinking party at which such cups were used. Six men of different ages with ivy wreaths around their heads recline under twisting vines. One of them plays the lyre, while the others hold drinking vessels and engage in conversation. This surrounds a central medallion decorated with the face of the Gorgon Medusa, whose gaze was said to turn people to stone.

When raised to the mouth and tilted, this cup turns into a mask: big eyes painted on the exterior stare at the drinker's companions. It has been suggested that these are the eyes of satyrs and nymphs (followers of the wine god, Dionysos) or of the god himself, or even of his companion animal, the panther, for ancient Greeks believed that through the consumption of wine they became part of the Dionysiac world. The eyes may also have been meant to ward off evil by magically protecting the drinker when the tilted cup obscured his view.

When filled, this large cup would have been very heavy and difficult to drink from, so it was perhaps intended mainly as a showpiece. An ancient repair indicates that it was a cherished possession: a fragment of another cup was inserted into a break on the rim and fixed with three metal clamps. While the cup's painter remains anonymous, the potter was probably Andokides, whose signature has survived on a similar vase.

ATTIC BLACK-FIGURED DINOS

Attributed to the Circle of the Antimenes Painter Greek (Athens), 520–510 B.C. Terracotta
H: 35.5 cm (14 in.);
DIAM (rim): 33 cm (13 in.)
92.AE.88

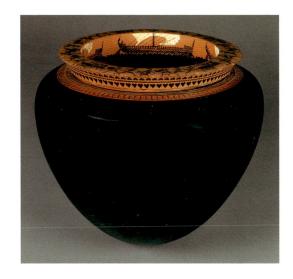

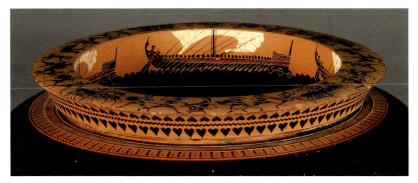

During the sixth century B.C. and before the advent of the red-figured krater shape, the black-figured dinos was the centerpiece of the men's wine-drinking ritual called the *symposion*. This vase was originally made to fit on a separate stand. Its mouth is wide to accommodate a variety of functions: at times another vessel was placed inside it to chill the wine; the dinos could also serve as a mixing vessel for wine and water. Small pitchers were dipped into the wine, which was then poured into drinking cups (such as the zone cup on the facing page).

The strong influence of the Antimenes Painter, the most prolific of the late-sixthcentury black-figure painters, is evident in this vase's clean and uncluttered style of painting, as well as its legible, straightforward narrative. The top of the rim is decorated with battles of hoplites, or foot soldiers, interspersed with four quadrigae (four-horse chariots) in one continuous battle frieze that has been carefully, but not mathematically, calculated to fill the circular space. Four large ships are under sail on the rim's interior. Ranks of oarsmen and a helmsman are visible on each ship, which have swan's heads carved on their sterns and battering rams shaped like boar's heads. In a wittily designed and executed comment on Homer's "wine-dark sea," these ships would have seemed to those who peered inside to be sailing directly on the surface of the wine itself.

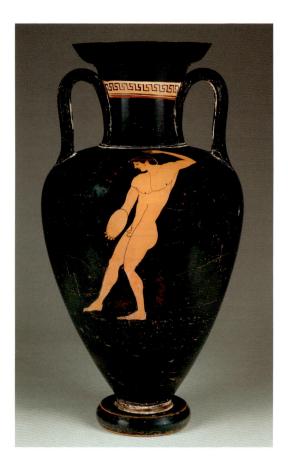

Attic Red-Figured Neck-Amphora

Attributed to Euthymides (as painter)
Greek (Athens), 520–510 B.C.
Terracotta
H: 43.5 cm (17% in.);
DIAM (body): 25.7 cm (10% in.)
84.AE.63

The technique of red-figure vase-painting came into use around 530 B.C., and the first group of painters to explore the potential of the technique has been termed the Pioneers. Chief among them were Euphronios, who was also a potter in later life (see the kantharos on p. 76), and Euthymides, the painter of this vase. These painters worked in different workshops and competed for clients, but they seem to have known each other and clearly shared a fascination with the technical possibilities inherent in the new technique. Shifting from black-figure to red-figure painting was comparable to modifying one's style from etching to drafting—it allowed artists to shade and twist lines. Red-figure artists had the freedom to portray subjects illusionistically, which had been impossible in

black-figure painting. These artists often focused on the single figure and its movement in space. Athletes were good subjects for such experiments. Their many unusual poses gave the painters ample opportunity to experiment with foreshortening while providing a favorite theme for clients.

On this vase, Euthymides painted a javelin thrower on one side and a discus thrower on the other. The latter is labeled Phayllos, who also appears on two other vases by Euthymides. He is probably Phayllos of Kroton, a famous athlete from the Greek colony of Kroton in South Italy. If so, this is a highly unusual example of a specific historical figure in vase-painting. The mouth of this vase was damaged and cut away in antiquity; the present mouth is a restoration.

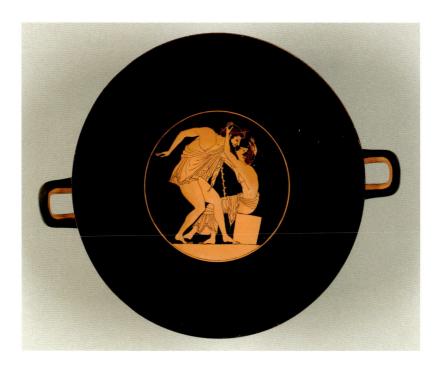

ATTIC RED-FIGURED KYLIX, TYPE C

Attributed to the Carpenter Painter Greek (Athens), 510–500 B.C. Terracotta
H: 11 cm (4% in.);
DIAM: 33.5 cm (13% in.)
85.AE.25

Drinking cups intended for banquets were frequently decorated with scenes depicting their users' favorite activities, such as athletics, feasting, entertainment, and amorous adventures. In the interior of this cup, a seated youth, with his long chiton lowered to his hips and draped across his legs, draws his older friend toward him for a kiss. Dressed in a short chlamys, the man leans forward somewhat tentatively on his toes, his left arm reaching behind the youth's head. Among the upper classes in Athens during the time when this kylix was painted, the erotic aspect of relationships between older and younger men was considered fundamental to the preparation of adolescents for adult status in Greek society. It is interesting to note that the painter neglected to complete a minor element: he shows the older man leaning on his walking stick, but forgot to draw it all the way down to the ground behind the legs of the seated youth.

Gymnastic activities decorate the exterior of the cup (with youths and older men practicing discus hurling, javelin throwing, and the long jump to the musical accompaniment of a flute), illustrating another important component of the socialization of Athenian youth. Near the handle, an altar completes the picture; religion and the gods were central to all facets of life, including the outcome of any athletic contest.

ATTIC RED-FIGURED KYLIX, Type B

Greek (Athens),
circa \$10 - 500 B.C.
Terracotta
H: 11.2 cm (4% in.);
DIAM: 27.5 cm (10% in.)
86.AE.280

This drinking cup is decorated entirely with figures of dancing revelers. One, shown here, is framed in the tondo of the cup's interior, while ten more stretch and pose around its exterior. This cup's most remarkable feature is the rich red color used to glaze the interior. Most Athenian vases were produced in either the redfigure technique, as the exterior and tondo of this cup were, or the black-figure technique (for example, see the neck-amphora on p. 61). Some workshops produced a coral-red glaze, named for the red sea-coral it resembles, also known as intentional red. When ocher was added to the black glaze that covered the body of the vessel, it turned red in the firing process. It was first and most often practiced on cups like this, from around 510 B.C., where the red color would richly combine with the wine they held. Later, coral-red was used on larger vessels (see the volute-krater on p. 73), but it never achieved wide production. Though extraordinary in effect, the technique was gradually abandoned because the reddish glaze was fragile and easily flaked off from the surface of the clay. Today, less than one hundred examples of the technique remain.

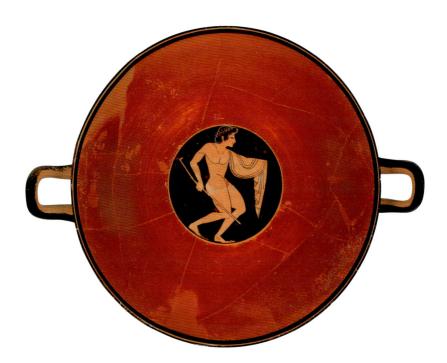

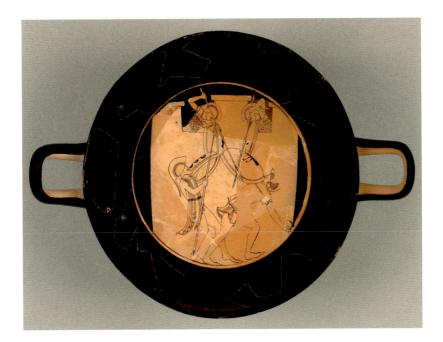

ATTIC RED-FIGURED KYLIX, Type C

Attributed to Apollodoros (as painter)
Greek (Athens), circa 500 B.C.
Terracotta
H: 7.7 cm (3 in.);
DIAM: 18.8 cm (7 1/4 in.)
84.AE.38

Cityscapes are extremely rare in Greek art. While the exterior of this cup was left black, the interior tondo shows one of the very few extant representations of late Archaic city walls. The scene is a city under siege, succinctly represented by two attacking and two defending warriors. Interestingly, no one hits his mark; this is a picture of an anonymous battle, not a conquest. The artist demonstrates an understanding of spatial extension in the way the walls disappear behind the frame of the tondo. Paradoxically, the attacking warriors are solidly balanced on the curve of the tondo frame itself. To combine a fictional space with the viewer's own physical space in this way is a characteristic approach of Greek Archaic art. The swallow-tailed folds of the chiton worn by the warrior on the left, which move in response to his action, are also typical. The holes visible on the left side of the cup are evidence of an ancient repair employing lead clamps to hold the fragments together.

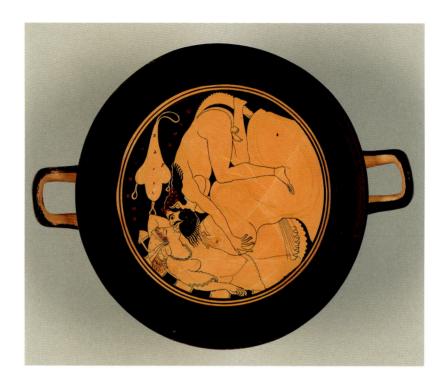

ATTIC RED-FIGURED KYLIX, TYPE B

Attributed to Onesimos (as painter)
Greek (Athens), 500–490 B.C.
Terracotta
H (restored): 8.3 cm (3½ in.);
DIAM: 23.5 cm (9½ in.)
86.AE.607

The antics of satyrs, companions of Dionysos, were a popular subject for the drinking cups of Athenians. In the tondo of this kylix, a satyr creeps up on a nymph who naps on a large striped cushion beneath a rocky outcropping. The Greek inscription above them tells why the satyr is so smitten: "the girl is beautiful." The cup's painter, Onesimos, seems to take particular delight in juxtaposing the lovely profile of the sleeping girl with the brutish, pug-nosed face of the satyr about to steal a kiss. Contemporary philosophical and poetic interests in sleep and wakefulness, beauty and ugliness, and tamed and untamed nature are expressed with clarity and sensitive understanding in this scene, which is meant to both amuse and arouse. On each side of the exterior a single satyr dances. The figures' robust physicality combined with the use of short groundlines helps to identify this kylix as an early work by Onesimos, a pupil of Euphronios and possibly the greatest of all red-figure cup-painters.

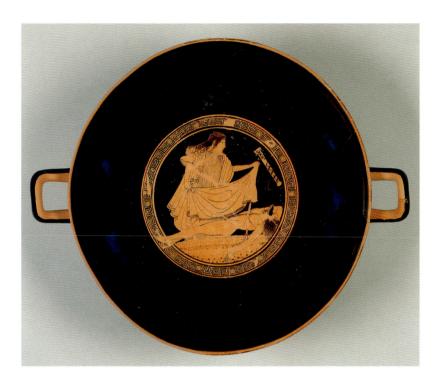

ATTIC RED-FIGURED KYLIX, Type B

Attributed to the Brygos Painter Greek (Athens), circa 490 B.C. Terracotta
H: 11.2 cm (4% in.);
DIAM: 31.4 cm (12% in.)
86.AE.286

On this cup, the Brygos Painter tells the tragic story of Ajax, one of the greatest Greek heroes at Troy. The three painted areas of the cup have been skillfully separated to represent the essential parts of the narrative. On Side B, the Greeks cast their votes to award the arms of Achilles to either Odysseus or Ajax. When Odysseus wins by a single vote, a fight breaks out between the opponents (Side A). Finally, driven to despair by the madness that had come over him, Ajax commits suicide on the beach by throwing himself onto his sword. On the cup's interior (shown here), the painter has chosen to represent not the moment of death (a popular scene in Greek art) but the tenderness of Ajax's companion, Tekmessa, who rushes to cover the body and restore to it the respect due a great hero. With striking artistic virtuosity, the Brygos Painter has emphasized the event and the figure of Ajax by draping the hero's feet over the border of the tondo and placing him on his back, so that he looks as if he has been stabbed from behind. Ajax's story was a particularly sad one, for he had risked his own life to save the body of Achilles from the Trojans. The rightful inheritor of Achilles' arms, he had been tricked out of them by Odysseus's skillful tongue.

The second se

ATTIC WHITE-GROUND LEKYTHOS

Attributed to Douris (as painter) Greek (Athens), circa 500 B.C. Terracotta H: 33.4 cm (13½ in.); DIAM (shoulder): 12.6 cm (5 in.) 84.AE.770

Two young Athenian aristocrats arm themselves in the presence of a boy and a woman on this lekythos painted by Douris, one of the most skilled and productive artists of late Archaic Athens. Dressed in short chitons, one of the youths puts on his greaves, while the other proudly holds out his helmet and shield. *Kalos* (meaning "beautiful" in Greek) inscriptions painted in the field between the figures praise the beauty of two youths, Nikodromos and Panaitios.

Though primarily a cup-painter (see facing page), some of Douris's best draftsmanship appears on white-ground lekythoi. The application of a white slip to the outside of the red-clay body enabled the artist to draw his figures with a very precise, clean outline while using a dilute glaze to delineate the interior lines of muscles and drapery folds. The lekythos was a good shape for holding precious oils; its slender neck and sharply rimmed mouth were especially suited to controlling the flow of the expensive material inside. This lekythos is well compared to the one on p. 79, for it was painted in a developmental phase, before the shape became exclusively used for funerary purposes. Clues to its dating are the Panaitios inscription, which places it early in the artist's career, the encircling figural frieze, and the running maenad on the shoulder. The latter two features are inherited from the black-figure technique, which Douris may also have practiced.

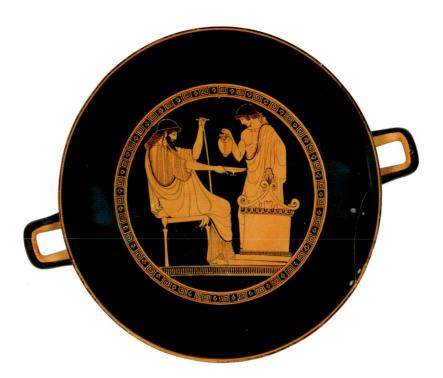

ATTIC RED-FIGURED KYLIX, Type B

Signed by Douris (as painter); attributed to Python (as potter)
Greek (Athens), circa 480 B.C.
Terracotta
H: 13.3 cm (5½ in.);
DIAM: 32.4 cm (12½ in.)
84.AE.569

This is one of over forty vases signed by Douris, one of the most prolific of all Athenian vase-painters. On it, he has combined scenes of mythical erotic pursuits with portraits of Athenian kings. In the tondo, the sacredness of the scene is symbolized by the altar, behind which a youth, standing, pours a libation into a cup held by a dignified bearded man, who is seated. This man may perhaps be Kekrops, a legendary king of Athens, for, on one exterior side, Kekrops is identified by inscription together with Pandion, another king, as they watch the goddess Eos pursuing Kephalos. On the other side of the vase, Zeus himself pursues the Trojan prince, Ganymede (identified by a hoop). Because Zeus would take Ganymede to Mount Olympos to be his cupbearer, the scene on the interior of the vase could also be interpreted as Ganymede serving Zeus there. The strongly composed interior scene is evidence of Douris's mastery of foreshortening and composition within a circular frame. An interesting clue to the value placed on the vase by its owner is also preserved here, for the cup was repaired in ancient times with a fragment from another cup that featured marine motifs for its decoration. The fragment has been attributed to one of the other great cup-painting masters of the time, Makron.

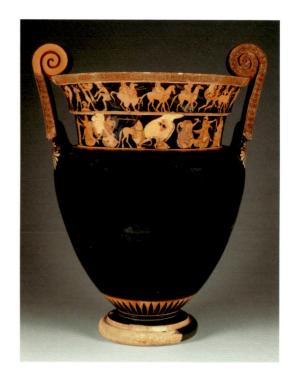

ATTIC RED-FIGURED VOLUTE-KRATER

Greek (Athens), circa 490 B.C.
Attributed to the
Kleophrades Painter
Terracotta
H (as restored): 56.9 cm
(22 in.);
DIAM (rim): 41.1 cm (16% in.)
77.AE.11

The volute-krater is named for the shape of the decorative handles that rise in spirals, similar to architectural Ionic volutes, over the rim of the vase. As large vessels used for chilling and mixing wine and water, red-figured kraters served the same function in the fifth century B.C. that black-figured dinoi (see p. 63) served in the sixth century B.C., becoming more popular than dinoi around 500 B.C. This one, from the same workshop as the volute-krater on the facing page, was decorated with a double-frieze design that provided the Kleophrades Painter enough space to accommodate his prodigious interest in painting myth and legend. Here he communicates his gift for narrative (seen also on the kalpis on p. 74) by using actively striding figures in energetic poses. The

entire upper rim of this krater is painted with an Amazonomachy, a battle between the Greeks (here aided by Herakles) and the fierce female warriors we know from Herodotos's Histories, written in the fifth century B.C. The lower frieze on Side A (shown here) shows the Capture of Thetis by Peleus, watched at left by her parents, Doris and Nereus, and by the wise Centaur Cheiron, who would later tutor their son Achilles, On Side B, the lower frieze is filled with three of the Labors of Herakles: the Battle with the Lernean Hydra; the fight with the triple-bodied monster Geryon (whose double-headed dog lies already dispatched behind Herakles); and the last Labor, in which Herakles picks the Apples of the Hesperides while Atlas supports the Earth.

ATTIC RED-FIGURED VOLUTE-KRATER

Attributed to the Kleophrades Painter (as painter and potter) and a pupil (as painter) Greek (Athens), 480–470 B.C. Terracotta
H (to top of volutes): 56. 9 cm (22½ in.);
DIAM (rim): 41.1 cm (16½ in.)
84.AE.974

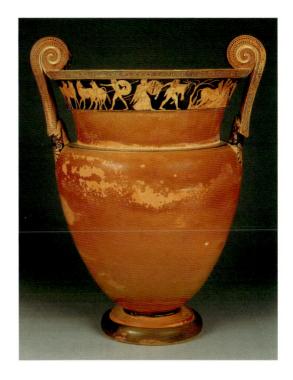

This volute-krater was potted and painted in the same workshop as the pots on pp. 72 and 74, and Side A appears to be the work of the same artist, the Kleophrades Painter. The body of the krater was decorated with the earliest known use of the coral-red technique on the exterior of a large vessel (see also p. 66). Four of the Labors of Herakles have been represented around the rim. On Side A (shown here), Herakles, with assistance from his patron goddess, Athena, creeps up on the sleeping Giant Alkyoneus, who had stolen the magic cattle of Helios. The Giant's deep slumber is represented by a tiny winged personification of sleep (Hypnos) crouching on his chest. As Herakles prepares to engage Alkyoneus in battle, his nephew Iolaos drives off the cattle. The complexity of this narrative composition and the stylistic inventiveness of the foreshortened cattle point to the hand of the Kleophrades Painter, while the more straightforward representations of three Labors on Side B (the battles with the Keryneian Hind, the Hydra of Lerna, and the Nemean Lion, with Athena seated regally amid them) suggest a pupil's work.

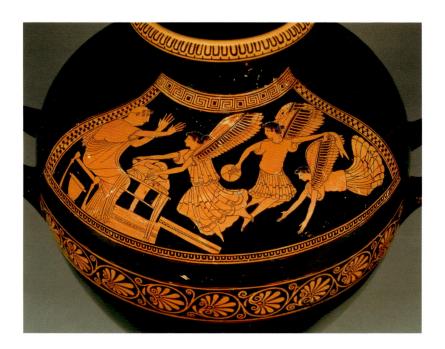

ATTIC RED-FIGURED KALPIS

Attributed to the Kleophrades Painter Greek (Athens), circa 480 B.C. Terracotta H: 39 cm (15% in.); DIAM (body): 32.5 cm (12% in.) 85.AE.316

The Kleophrades Painter has been called the greatest pot-painter of the late Archaic period. The scene on the shoulder of this vase is a fine example of his mature style (for examples of his earlier work, see the kraters on pp. 72 and 73). Like the hydria, the kalpis was a three-handled vessel used to transport water. The shape's design left a large uninterrupted field at the front, where the viewer could best take in the painting. Wider at the bottom than the top, the trapezoidal area required particular compositional skill, and the Kleophrades Painter was unusually adept at filling it with lively scenes from heroic myth and legend.

The scene on this kalpis reflects the myth of Phineus, a blind Thracian king and prophet who, according to the Hellenistic poet Apollonius of Rhodes, had been punished by the gods for revealing their plans against their wishes. He was doomed to have all his food either stolen or spoiled by the monstrous Harpies, until Jason and the Argonauts rescued him in return for his prophecy of their adventures. In an unusually sympathetic depiction of old age and blindness, this scene shows poor Phineus prior to his salvation, futilely gesticulating while the winged Harpies steal loaves of bread and chunks of meat off a fully laden table in front of him. Though Harpies were evil female demons related to Sirens and Furies, the Kleophrades Painter shows them in typically serene Archaic style.

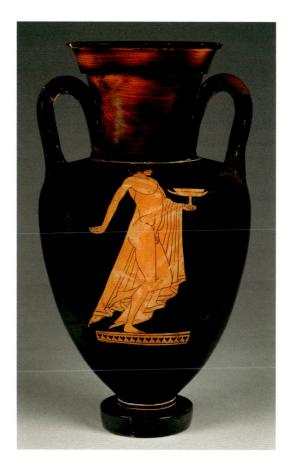

ATTIC RED-FIGURED NECK-AMPHORA WITH DOUBLE HANDLES

Attributed to the Berlin Painter
Greek (Athens), circa 480 B.C.
Terracotta
H: 30.6 cm (12 in.);
DIAM (body): 17.2 cm (6% in.)
86.AE.187

The Berlin Painter was the foremost draftsman in late Archaic Athens. Profiting from the work of the Pioneers (see also p. 64) and their experiments, he was able to take full advantage of the possibilities for anatomical rendering and expression that the red-figure technique offered. He did not paint cups, preferring larger closed shapes, such as the amphora, and at times open shapes, like the calyx-krater (a vessel used for mixing water and wine). His style is immediately recognizable by its exquisitely drawn single figures or small groups on a groundline, silhouetted

against a black expanse of clay. This amphora is a classic example. Crowned with an ivy wreath and holding a drinking cup by the foot, the youthful dancer seen here on the front of the vase moves in a similar way to the old, foreign-looking man on the reverse, yet the contrast between them is striking. The Berlin Painter has juxtaposed youth and old age, beauty and ugliness, but there is also a contrast of class, for the pug-nosed man on the reverse is probably a slave accompanying his master, the youth, at an initiation ritual.

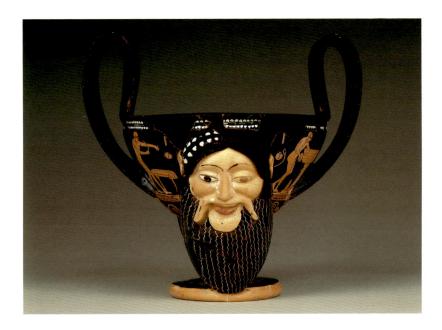

ATTIC RED-FIGURED KANTHAROS WITH MASKS

Attributed to the Foundry Painter (as painter) and to Euphronios (as potter) Greek (Athens), circa 480 B.C. Terracotta
H (to top of handles): 21.1 cm (8½ in.);
DIAM (bowl): 17.4 cm (6¾ in.)
85.AE.263

This stemmed cup with two high, vertical handles is called a kantharos. The kantharos was not very common as a drinking vessel in Classical Athens, but it was closely associated with the wine god, Dionysos, who is shown holding one in many ancient depictions. On this kantharos, two molded clay masks made separately and attached to the wheelthrown bowl point directly to the world of Dionysos: on Side A (seen here), a serene, bearded face represents the deity himself; on Side B, one of his companions, a snub-nosed satyr, grins broadly. Traces of vermillion indicate

the original color of the flesh. Ivy garlands drawn in white around the heads and the kantharos's rim also refer to Dionysos. The masks were inspired by theater masks or by mask-idols used in the cult of the wine god.

The vessel would have been awkward to handle, but it made an appropriate offering for a sanctuary or grave. It was probably shaped by Euphronios, a vasepainter and potter whose long career spanned the decades around 500 B.C. and who belonged to the group of artisans now called the Pioneers. The figural decoration is by the Foundry Painter, a younger colleague named after the representation of a bronze workshop on one of his vases. Scenes from everyday life were popular in the red-figure technique, and this kantharos shows young athletes cleaning their bodies after exercise. Two scrape off oil and dirt with the curved implement called a strigil, one washes at a basin, another is getting dressed. Round oil flasks are depicted next to each figure, and nonsensical letters written in red paint are strewn in the field.

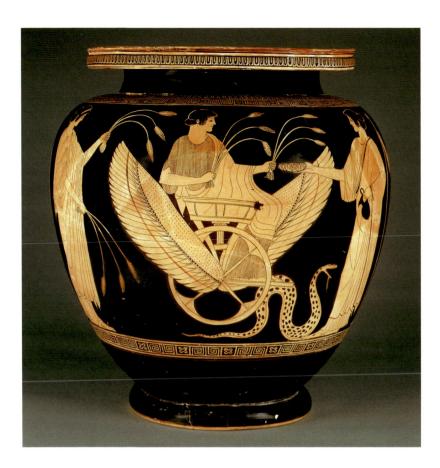

ATTIC RED-FIGURED FOOTED DINOS

Attributed to the Syleus Painter Greek (Athens), circa 470 B.C. Terracotta H: 36.8 cm (14½ in.); DIAM (body): 35.7 cm (14 in.) 89.AE.73

Demeter and Kore flank Triptolemos on this red-figured dinos (a mixing bowl for wine and water) from the early Classical period. The scene presents the heroes and deities of Eleusis (a city just outside of Athens), the site of the highly secretive cult of Demeter, goddess of agriculture. Triptolemos first appears as an Eleusinian hero in Greek art around 500 B.C. Demeter, who stands behind him holding stalks of grain, gave him a fabulous winged chariot so that he could spread the knowledge of grain cultivation across the world. This vase shows him departing on that journey. The Syleus Painter probably chose the bulbous shape of the dinos so that he could give full amplification to the chariot wings upon which he has lavished so much attention. To wish him good fortune, Kore, Demeter's daughter (inscribed Pheraphatta), offers him a libation bowl that she has just filled from the jug in her left hand. Other figures on the vase include Theos (Hades), god of the Underworld, his wife, Thea, and the personification of the city of Eleusis itself, all identified by inscription.

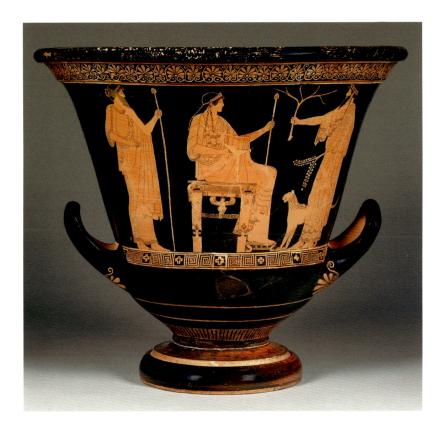

ATTIC RED-FIGURED CALYX-KRATER

Signed by Syriskos (otherwise known as the Copenhagen Painter) (as painter)
Greek (Athens), 470–460 B.C.
Terracotta
H: 43 cm (17 in.);
DIAM: 54 cm (21½ in.)
92.AE.6

This krater, used in the Athenian symposion to mix water with wine before serving, is one of the most esoteric works in the Museum's vase collection. On the side of the vase shown here, the goddess Ge Pantaleia (allgiving Earth) is seated on an elaborate throne between her son, the Titan Okeanos (Ocean), on the left, and the god of wine, Dionysos, on the right. Accompanied by a leopard, Dionysos extends a sacred branch toward Ge.

Signatures and marks on the vase tell us a great deal about its production. Just visible over the handle to the right of Dionysos is the first signature of the painter Syriskos (known otherwise as a potter and stylistically identified as the Copenhagen Painter), whose name can be literally translated as "the Little Syrian," suggesting that he was a foreign slave working in Athens. The same artist later changed his signature to Pistoxenos, probably upon gaining his freedom. A graffito on the underside of the foot gives the price of the vase as one Greek stater, approximately two day's wages for an Athenian foot soldier.

ATTIC WHITE-GROUND LEKYTHOS

Attributed to the Painter of Athens 1826
Greek (Athens), 470–460 B.C.
Terracotta
H: 24.7 cm (9½ in.);
DIAM (shoulder): 8.9 cm (3½ in.)
86.AE.253

Intended as a tomb offering, this Athenian white-ground lekythos depicts family members visiting a loved one's burial site. The grave is shown as a high earthen mound marked by a tall, thin stele, or gravestone, similar to the one on p. 18. A youth, standing at the left, ties fillets, or ribbons, around the stele as a sign of respect and commemoration. On the right, a girl, her hair cut short as a gesture of mourning, holds an alabastron (a small oil vessel) and a flower. The oil in the alabastron was used to anoint the gravestone, with the container itself and the flower left as offerings. The two visitors conducting these grave rituals are presumably the children of the individual buried under the mound, whose name would have been inscribed on the stele above.

Many white lekythoi were made specifically as containers for the oil that was used in funerary rituals, and for burial with the deceased. The scenes most frequently depicted on them are visitations to a tomb or the preparations for such a

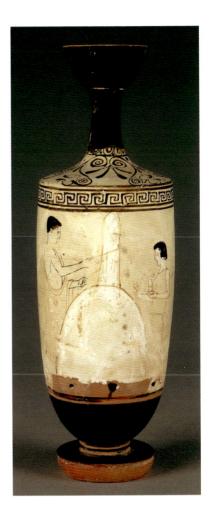

visit. In actual practice in ancient Greece, care of tombs began when all the rituals of burial were completed and continued frequently and indefinitely. It was an important responsibility usually performed by the women of the family.

The Painter of Athens 1826 decorated vases in the white-ground technique in Athens around 470 to 460 B.C. He painted primarily lekythoi and was one of the earliest artists to focus on their production. The true name of the Painter of Athens 1826 is unknown; scholars named him for a vase of that inventory number in the National Archaeological Museum in Athens.

ATTIC RED-FIGURED LEKYTHOS

Attributed to the Painter of the Frankfort Acorn Greek (Athens), 420–400 B.C. Terracotta
H: 18.4 cm (7½ in.);
DIAM (body): 10.6 cm (4½ in.)
91.AE.10

The setting of this dramatic encounter is the palace of Menelaos at Sparta, indicated by the doors at the left. The visiting Trojan prince, Paris, has come upon Helen gazing at herself in her mirror, and, as she turns, their eyes meet in a locked gaze that will seal the fate of a generation of Greeks and Trojans. Aphrodite, her work accomplished, flies above them in a tiny chariot drawn by two tiny erotes (companions of Eros). To the left, one of Helen's attendants reacts in astonishment as she watches the chariot fly by, her startled response predicting the unhappy events this union will cause. The opulent painting style, with its applied gilding, added white pigment, and attention to sumptuous fabrics and jewelry, was popular during the late Classical period. It follows in the manner of the Meidias Painter, whose work typifies the tastes of the age. This vase, like all lekythoi, contained precious perfumed oil. In contrast to vases used by their owners, this one's extremely fine state of preservation indicates that it was most likely a funerary gift.

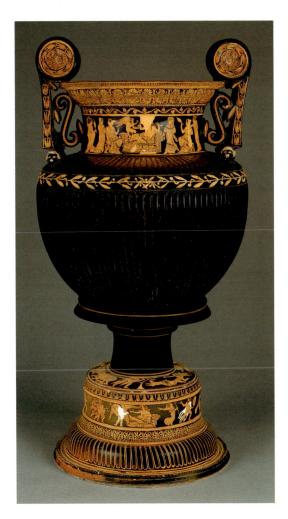

ATTIC RED-FIGURED DINOID VOLUTE-KRATER AND STAND

Attributed to the Meleager Painter Greek (Athens), 390–380 B.C. Terracotta H (krater): 54 cm (21½ in.); DIAM (krater): 40 cm (15½ in.); H (stand): 16.5 cm (6½ in.) 87.AE.93

This vase assemblage is a sumptuous combination of late Classical relief decoration, gilding, and splendid red-figure painting. That it was produced to intentionally imitate metal vessels is partly indicated by the fluted body, gilded olive wreath around the shoulder, and floral and figural decoration limited to the neck and base. On the front of the krater's neck (shown here), Adonis, the consort of Aphrodite, goddess of love, lies on a couch covered with elaborately embroidered textiles. As Adonis binds a fillet around his head, Eros offers him a plate

of food. Because Adonis spent part of each year living with Aphrodite on Mount Olympos and part with Persephone in Hades, the goddesses are placed with their attendants on either side of him. The *symposion* scene on the reverse side of the neck shows a mortal (and less luxurious) version of this scene. Each couple engages in the pleasures of the revel. A youth has put down his lyre to play *kottabos*, a game often enjoyed at *symposia*; participants fling the dregs of wine from the bottom of their cup toward a target.

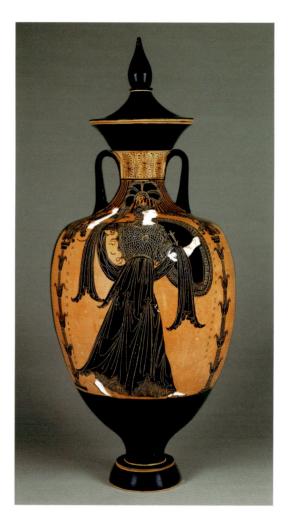

ATTIC PANATHENAIC PRIZE AMPHORA AND LID

Attributed to the Painter of the Wedding Procession; signed by Nikodemos (as potter)
Greek (Athens), 363–362 B.C.
Terracotta
H (with lid): 89.5 cm (35½ in.);
DIAM (body): 38.3 cm (15½ in.)
93.AE.55

Every four years the Athenians celebrated the Panathenaic festival in honor of Athena, goddess of war and patron deity of Athens, in a grand way. The Great Panathenaia included a procession, sacrifices, and games similar to the Olympics. The winners of the athletic contests were rewarded with olive oil in two-handled pottery jars, the so-called Panathenaic amphorae. Like other such amphorae (see also p. 84), this one is decorated with an armed Athena and identified as "(one) of the prizes from Athens" by an inscription running along a column flanking the goddess, here decorated with acanthus leaves.

The back of the vase, which shows Nike, winged personification of victory, crowning a victor, indicates the sport: the long ribbons held by the contestants were wrapped around their hands and wrists to serve as boxing gloves. The vase's imagery is unusual in illustrating the victory ceremony rather than the boxing match itself.

This example, which was made to hold more than 37 liters of oil, proclaims in Greek next to the left column on the front: "Nikodemos has made (me)." It can be dated to a specific Panathenaic festival by the figures of Nike that crown the columns.

ATTIC RED-FIGURED PELIKE OF KERCH STYLE

Attributed to the Painter of the Wedding Procession Greek (Athens), circa 360 B.C. Terracotta H: 48.3 cm (19 in.); DIAM (body): 27.2 cm (10½ in.) 83.AE.10

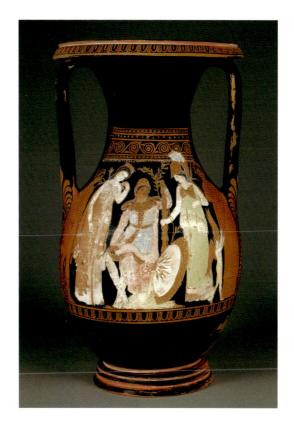

The front of this tall pelike, a storage jar for olive oil, shows the Judgment of Paris. Dressed in rich oriental attire, Paris, the young prince of Troy, sits on a rock and looks toward Athena, goddess of war. Behind Athena, Aphrodite, goddess of love, holds a veil to her face in feigned modesty, while Eros tugs at her himation. To Paris's right stands Hera, queen of the Greek deities, followed by Hermes, the messenger god, who has escorted the goddesses to Paris so he can decide which is the most beautiful. Bribed by all three goddesses, Paris chose Aphrodite because she had promised him the love of the world's most beautiful woman, Helen. The Trojan War would be precipitated by Paris's abduction of Helen; thus this Judgment is considered to be its cause.

The colorful dress, white female skin, and golden highlights create an air of luxury and beauty typical of the so-called Kerch vases of the later fourth century B.C. These vessels represent a late stage of Attic redfigure vase-painting named after Kerch in the Crimea, the site of an ancient Greek colony where many examples have been found.

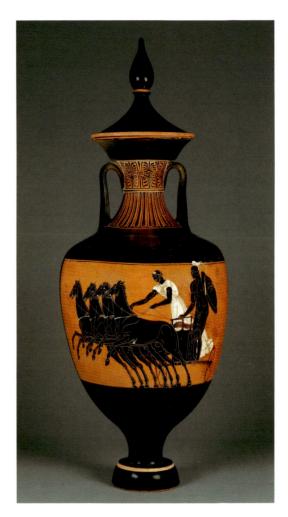

ATTIC PANATHENAIC PRIZE AMPHORA AND LID

Attributed to the Marsyas Painter Greek (Athens), 340–339 B.C. Terracotta H (with lid): 99.5 cm (39% in.);
DIAM (body): 39.2 cm (15% in.)
79.AE.147

Like the vase on p. 82, this amphora was made as a container for high-quality olive oil from Athens, to be awarded to one of the winners of the Panathenaic games. The goddess Athena is depicted on the front of the vase. The back (seen here) shows the contest for which it served as a prize. A charioteer in a long white garment stands next to a naked man with a helmet and a shield. This is a scene from the race of the apobates, literally, "the dismounters": the warrior is about to leap from the chariot and continue running on foot. Few surviving amphorae represent this discipline, which also appears on the Parthenon frieze.

The inscription "Theophrastos" on the front of the vase names the magistrate responsible for collecting the olive oil. Because that official was appointed annually, this amphora can be dated precisely to the year 340 or 339 B.C. The amphorae, with their traditional decoration, had over generations become specifically associated with the Athenian games. To underscore the venerable history of the Panathenaic tradition, Athena is deliberately rendered in an old-fashioned manner, wearing a garment with swaying, swallowtail folds that echo Archaic dress styles.

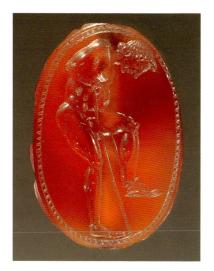

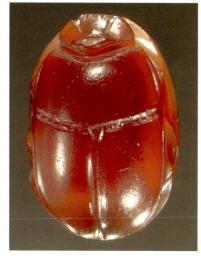

Engraved Scarab

Attributed to Epimenes Greek (carved in the Cyclades), circa 500 B.C. Carnelian H: 1.6 cm (½ in.); W: 1.1 cm (½ in.); D: .8 cm (½ in.) 81.AN.76.22

dramatically in form, materials, and technique. The scarab, with its convex back carved, like this one, in the shape of a beetle (top right) and its flat surface decorated with an intaglio scene, was introduced. The scarab form ultimately derives from Egypt, where it had been used as seals and amulets for centuries. Certain features of Greek scarabs, however, show the influence of Phoenician models, which the Greek gem carvers probably saw on Cyprus. Scarabs were pierced and generally worn as rings or pendants. When attached to a metal hoop and worn as a ring, the beetle side faced out and the intaglio surface rested against the finger. When serving as a seal, the ring was removed, the scarab could be swiveled, and the intaglio design was pressed into soft clay or wax placed on an object to identify its sender or owner and to secure it.

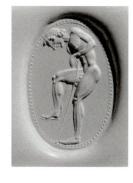

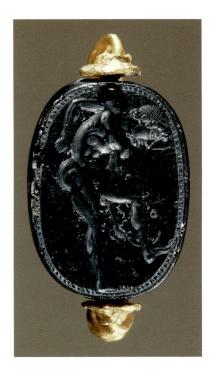

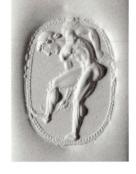

Engraved Scaraboid

Attributed to Epimenes
Greek (carved in the Cyclades),
circa 500 B.C.
Obsidian
H: 1.62 cm (½ in.);
W: 1.29 cm (½ in.);
D: .7 cm (¼ in.)
85.AN.370.6

A youth bends over to scrape his shin with a curved blade called a strigil. After training, Greek athletes coated themselves with oil and used a strigil to scrape off the sweat, oil, and dirt. The pose of this figure, bending over in an activity, was a favorite for carved gems in the late 5008 B.C., in part because it fills the oval space well. However, the difficult three-quarter view of the youth, the rendering of the musculature, and details such as the duck's head decorating

the end of the strigil display the unique skills of the artist Epimenes. Epimenes worked in the period about 500 B.C. in the Cyclades, the group of islands in the Aegean Sea between Greece and Turkey that surround the island of Delos. He carved both scarabs and scaraboids in a distinctive manner. His gems are decorated with nude youths with the musculature clearly defined and naturalistically rendered. A scaraboid is a simplified scarab, ultimately influenced by Egyptian prototypes. Although many oval gems were carved on their reverse side to resemble convex beetles, on this gem the reverse is plain while the flat side is decorated with an intaglio design. In the 400s B.C., the scaraboid form gradually replaced the scarab in Greece. Scaraboid gems were pierced, worn as rings or pendants, and used in the same manner as scarabs (see p. 85). This scaraboid is set in a modern ring.

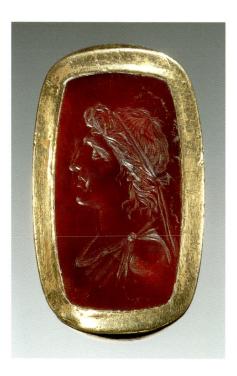

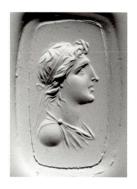

Engraved Gem Inset into a Hollow Ring

Greek, 100–1 B.C.
Carnelian and gold
H (gem): 2.2 cm (% in.);
W (gem): 1.3 cm (½ in.);
D (gem): .3 cm (½ in.);
DIAM (hoop): 2.82 cm (1% in.)
85.AN.124

Engraved on the gem is the draped bust of a young man wearing a diadem. His long hair flows in a manner often ascribed to Alexander the Great; the diadem in his hair indicates his royal status, and the upward curl of the locks of hair on the forehead resembles Alexander's well-known anastole. It is possible that the charismatic young ruler is depicted here. According to Pliny the Elder (Natural History 7.37.125), Pyrgoteles was the only engraver that Alexander would allow to carve his image into gems during his lifetime. Gem portraits like this were popular after Alexander's death in 323 B.C., however, and were used by other late Hellenistic rulers, most notably Mithradates VI (reigned 120-63 B.C.) and other Pontic kings. Mithradates VI formed a famous collection of gems, which was taken to Rome after his defeat at the hands of Pompey the Great. The popularity of gems engraved with portrait busts continued into the Roman period.

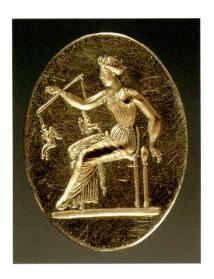

GOLD RING

Greek, circa 350 B.C.
Gold

H (bezel): 2.23 cm (½ in.);

W (bezel): 1.76 cm (½ in.);

DIAM (hoop): 2.07 cm (½ in.)

85.AM.277

An elegantly clad woman sits on a stool, delicately balancing a scale with two erotes. This is the erotostasia, or weighing of love, which also appears on Athenian and South Italian vases and as a subject in sculpture. It was later copied by eighteenth-century Neoclassical painters, who specialized in scenes of love derived from the models of antiquity. Although the true meaning of the scene is unclear, it may symbolize some aspect of love related to the Homeric weighing of souls, the psychostasia. Because the only woman capable of judging weight in the realm of love is the goddess Aphrodite, her identity in this context is fairly certain.

Funerary Wreath

Greek, circa 320–300 B.C. Gold, with blue and green glass-paste inlays DIAM: 30 cm (11½ in.) 93.AM:30 This elaborate wreath is adorned with a lush array of gold leaves and flowers, some of which are embellished with blue and green glass paste. Because of the artist's remarkable mastery of metalworking and his great attention to detail, it is possible to identify the leaves and blossoms as bellflowers mixed with myrtle, apple, and pear blossoms, plants that grow profusely in northern Greece. These leaves and flowers are attached to a hollow gold circlet that is hinged in the front with a type of square knot known as a Herakles knot (see also the bracelet on pp. 90-91 and the diadem on pp. 92-93). A popular motif in Hellenistic jewelry, the Herakles knot was believed to have beneficent magical qualities. Despite their very fragile nature, wreaths like this one, which shows signs of repair and wear, may have been worn in ceremonies. They were usually buried with the dead along with other precious offerings.

PAIR OF DISK EARRINGS WITH NIKAI PENDANTS

Greek, circa 225–175 B.C. Gold H (.1): 9.7 cm (3½ in.); H (.2): 9. 3 cm (3½ in.) 96.AM.159.1–.2

Tiny golden sculptures for the ears, these Nikai earrings are prime examples of the flamboyant taste for jewelry that is characteristic of the Hellenistic age. Erotes and Nikai were popular images for earrings because they would appear to be flying when suspended from the wearer's ear. Their billowing garments and slightly twisted torsos are reminiscent of the famous Nike of Samothrace (now in the Louvre Museum, in Paris) to which they are stylistically related. Like that monumental statue, these miniature Nikai seem about to touch the ground. Their torches (a common attribute for Nike, goddess of victory) and wings were added separately and are

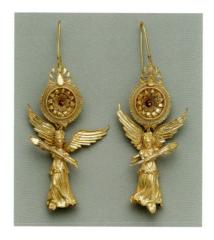

articulated by filigree. The feathers and flames were originally filled with colored enamel. The Nikai are suspended from elaborate disk rosettes punctuated by a petal-within-petal design constructed from dense granulation. The rosettes themselves dangle from flame-shaped palmettes, the hearts of which were probably originally inlaid with garnets.

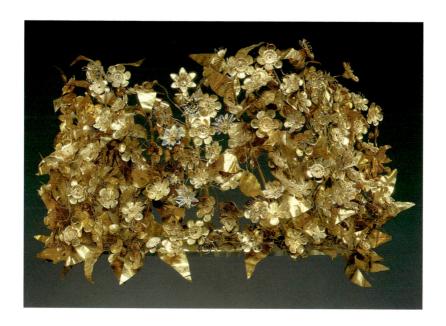

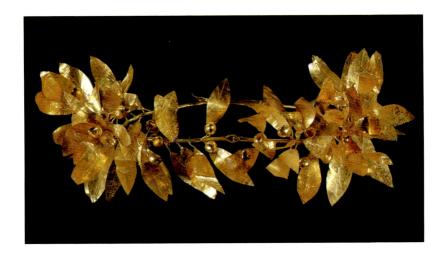

Funerary Wreath

Greek, 300–100 B.C. Gold DIAM: 21.7 cm (8½ in.) 92.AM.89 Ancient authors describe the various uses of wreaths, both those made from natural leaves as well as ones made from materials imitating nature. The laurel leaves comprising this wreath are specifically associated with the god Apollo. Wreaths were given as rewards in artistic and athletic contests, offered as prizes at festivals (including the Panathenaia), presented as engagement gifts or gifts to war heroes, dedicated at temples, worn at banquets, and used as funerary gifts. The fragility of this wreath suggests that it was not worn frequently. More likely, it was part of the grave contents of a wealthy individual.

BRACELET WITH BULL'S-HEAD TERMINALS

Greek, circa 250–200 B.C. Gold DIAM: 8.5 cm (3¹/₈ in.) 96.AM.158 The hoop of this solid-gold bracelet was made by fluting a sheet-gold tube and curving it to connect two bull's heads with a gold Herakles knot. The Herakles knot was never intended to be loosened, as it was a magical knot with amuletic significance (see also the wreath on pp. 88 – 89 and the diadem in the ensemble on pp. 92 – 93), and it cannot be detached from the bracelet. For this reason, and because of the ornament's ample diameter, this piece of jewelry may have been designed to be worn on the upper arm rather than on the wrist. The repoussé gold bull's heads were worked in fine detail from both the interior and exterior. The eyes were recessed to hold enamel filling, which has been lost. The tiny horns and ears were made separately and soldered into small holes punched in the heads.

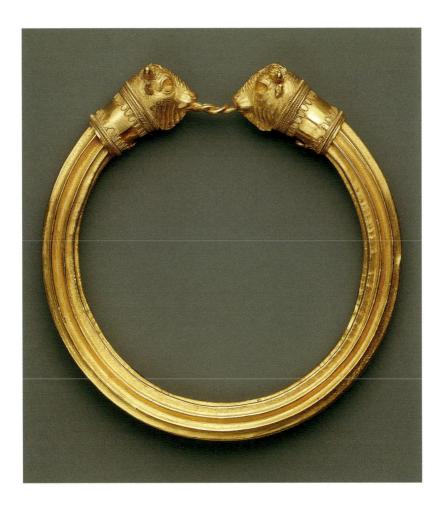

Despite its apparent simplicity when compared to other Hellenistic ornaments, this bracelet contains more than one hundred separate items fashioned together. The assembly of many parts is typical of Hellenistic jewelry, distinguishing it from other styles of ancient ornament. Early on, the Greeks borrowed the popular fashion of wearing bracelets with animal- and bull's-head terminals from the Near East; bracelets such as these can be seen on Assyrian reliefs and are one example of the influence on jewelry styles that resulted from eastern contact even before the campaigns of Alexander the Great. Bull'shead terminals, however, are somewhat rare. Generally symbolic of raw power, bulls were associated with Apis in Egypt and specifically connected to the realm of the god Dionysos in Greece, where they were considered the most prestigious form of sacrifice.

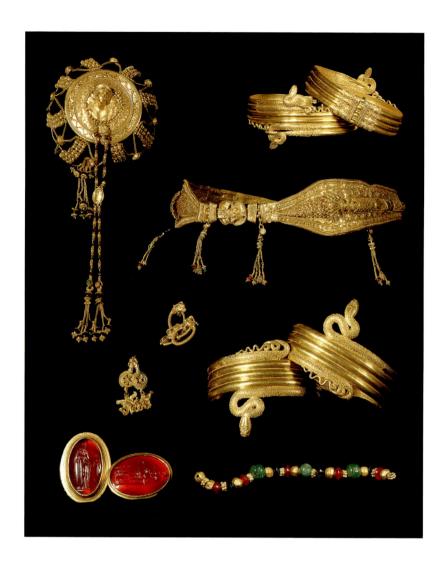

Ensemble of Ptolemaic lewelry

Greek (possibly Alexandria), 220–100 B.C. Gold with various inlaid and attached stones, including garnet, carnelian, pearl, and glass paste 92.AM.8.1–11

This spectacular collection of gold jewelry was likely the prized possession of a Greek woman of high social rank. Signs of ancient repair show that the jewelry had been worn and was therefore not made specifically as a funerary offering. The style and iconography of the pieces indicate that they were probably made in Alexandria, Egypt, by Greek goldsmiths during the reign of the Ptolemies, the rulers of Egypt descended from Ptolemy I Soter, one of the Macedonian generals of Alexander the Great. The imagery conveys the importance of magic and ritual at the Ptolemaic court.

The group's centerpieces are a hairnet (upper left) and a diadem (center right). On the hairnet, one of the few surviving from antiquity, a central medallion displays an image of Aphrodite, goddess of love, with a tiny Eros tugging at her neck. The Ptolemaic queens often presented themselves as descendants of Aphrodite; here the goddess's features and hairstyle are similar to those of Queen Arsinoë II. At the front of the diadem, a magical Herakles knot (once inlaid with garnets or red glass) marks the hinge. A torch motif, with flames made of twisted ribbons of gold wire, adorns the diadem's sides. The

torches may refer to Nike, Greek goddess of victory (see the earrings on p. 89), or to Eros, for whom they symbolize passion. Erotes also appear on the disk earrings that are part of this ensemble (below the hairnet).

Wearing arm ornaments like the ones in this ensemble (above and below the diadem), which are fashioned in the shape of snakes, was not an Egyptian custom; rather, it was a trend that Ptolemaic women brought to Egypt from their classical Greek heritage. Cobras, in particular, indicated power over death. When worn on the arms, a snake motif was intended to communicate a magical control over life and fertility.

The style of the two massive gold and carnelian rings (lower left) is characteristic of Hellenistic Egypt. The ring on the far left has a gem carved with a figure of Tyche, goddess of good fortune. Tyche's attribute, the cornucopia, symbolizes her function as a provider of abundance, fertility, and wealth. On this gem, Tyche holds a double cornucopia, a symbol created specifically for Queen Arsinoë II by her husband and brother, Ptolemy II. The scepter Tyche holds is also significant, for it was widely used on coinage of the Ptolemies to indicate the divine status of the dynasty.

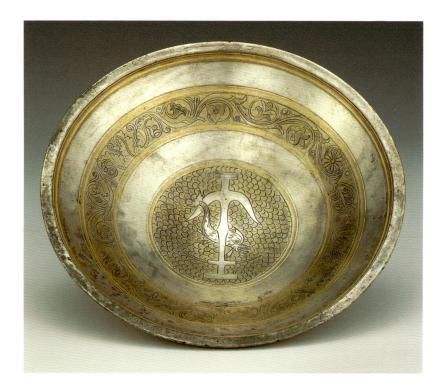

Bowl with Anchor and Dolphin Medallion

Parthian
(Eastern Empire),
200–100 B.C.
Silver
H: 4.3 cm (1½ in.);
DIAM: 18.6 cm (7½ in.)
81.AM.84.1

This elegant silver vessel is one of twenty-five bowls, ranging in height from 2.9 to 8.4 cm (1½ to 3½ in.), that together offer evidence for the kinds of luxury objects produced in the Parthian Empire. In about 238 B.C., the Parni, a nomadic or seminomadic people later known as the Parthians, took control of the area from Asia Minor and Syria to the border of India (modern Iran). Their cultural influences were derived from both the Achaemenid (Persian) and Hellenistic Greek traditions.

The silver bowls that make up this treasure are for the most part the widely distributed calotte type, a hemispherical shape with no foot that resembles earlier Achaemenid or Persian bowls. Only the interiors are decorated, usually with a small ornamental motif in the center framed by decorative friezes. The inverted anchor on this bowl is also found on coins minted by Seleucus (358–281 B.C.), Alexander the Great's general, who had previously ruled this territory.

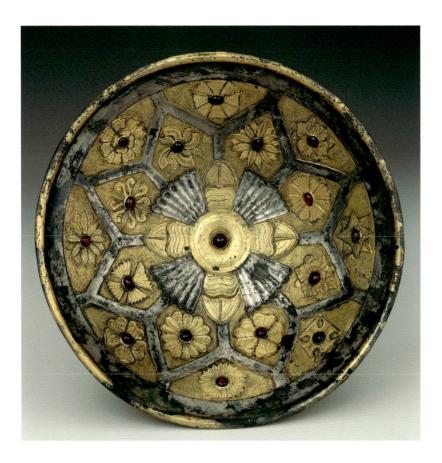

Net-Pattern Bowl

Parthian (Eastern Empire), 100–1 B.C. Gilded silver with garnets DIAM: 20 cm ($7\frac{1}{4}$ in.) 86.AM.752.3

Since the time of Alexander the Great's conquest of parts of the Near East and India in the fourth century B.C., the Greek world had become increasingly familiar with and fond of exotic materials and ornate patterning. This bowl is a rare and beautiful example of the type of elaborately decorated vessel that an affluent and sophisticated collector of the first century B.C. would obtain to enrich his set of table silver.

The net pattern decorating the bowl's interior is composed of sixteen staggered pentagons, a design typically seen in Greek Hellenistic pieces. Within each pentagon, a different type of gilded flower is inset with a garnet. In the center of the bowl, a single garnet forms the heart of a floral calyx. Although the floral-calyx motif was often incorporated into Near Eastern pieces, its use in Greek work is quite rare and adds to the bowl's value.

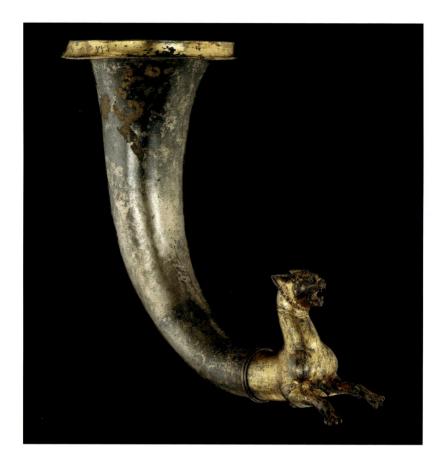

LYNX RHYTON

Parthian (Eastern Empire), 50–1 B.C.
Gilded silver
H: 24.5 cm (9% in.);
L: 41.9 cm (16½ in.);
DIAM (rim): 12.2 cm (4¾ in.)
86.AM.752.1

The protome of a snarling lynx forms the terminal of this elegantly shaped rhyton, one of two that are so close in manufacture that they must have been made as a set. Each animal is dynamically represented with outstretched paws, open mouth, bared teeth, and laid-back ears, all of which ferociously emphasize its wild nature. Rhyta were used to pour wine into a cup or directly into the drinker's mouth, in this case through a spout between the forelegs of the lynx. The vessels are raised from single sheets of silver with only the legs of the animal cast separately. An Aramaic inscription on the lip of each cup states that an Iranian silversmith (whose name is not decipherable) made it. Also incised on the lip is zwzyn (a unit of weight corresponding most likely to the Parthian drachma); the inscription indicates the amount of silver used to manufacture the vessel.

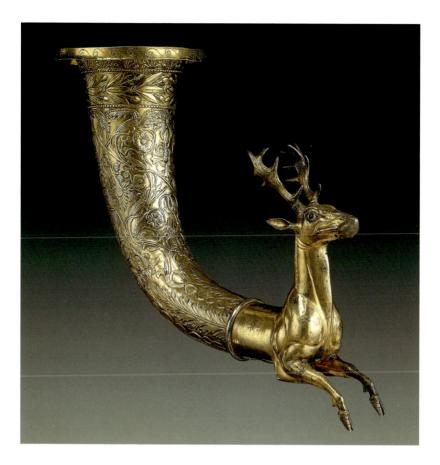

STAG RHYTON

Eastern Mediterranean, circa 50 B.C.—A.D. 50 Gilded silver, garnet, glass H: 27.4 cm (10¾ in.); L: 46 cm (18¼ in.); DIAM (rim): 12.6 cm (5 in.) 86.AM.753 The horn of this gilded-silver rhyton, or drinking vessel, is elegantly decorated with floral patterns and ends in a protome of a stag. The artist captures the animal's natural grace and power by carefully rendering its taut muscles, its protruding veins, and the gentle sweep of its antlers and legs. The spirited nature and alertness associated with a stag are expressed in the wide-open eyes, which are inlaid with glass paste and black stones, and the way the animal holds his head upright. These expressive features of the animal's spirit were intended to convey the potency of the rhyton's contents.

A spout, now lost, was once attached to the hole between the stag's legs. Wine could be poured through the spout into a drinking cup or directly into the mouth of the drinker. An inscription in finely dotted Aramaic letters, found on the underside of the stag, may be a dedicatory inscription to Artemis, goddess of the hunt.

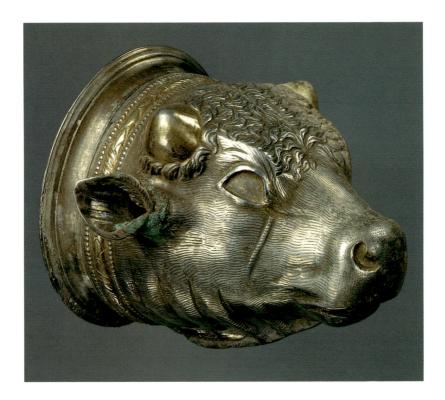

BULL'S-HEAD CUP

East Greek, 100 B.C.—A.D. 100 Silver with leaf gilding H (head): 12.1 cm (4¾ in.); W (head): 9.1 cm (3¾ in.); DIAM (head): 7.8 cm (3⅓ in.);

H (bowl): 5.9 cm ($2\frac{3}{8}$ in.); DIAM (bowl): 9.5 cm ($3\frac{3}{4}$ in.) 87.AM.58 This unique Hellenistic drinking cup in the form of a bull's head is a superb example of the type of luxurious metalwork created for pious occasions. Small budding horns and vigorous curls with a prominent whorl of fur on the forehead indicate the young age of this calf. The horns, mouth, garland, and tear ducts are gilded, adding opulence to the piece and further suggesting that it represents a sacrificial animal. The cup itself may have been used for drinking ceremonial wine or for pouring libations to the gods when a bull was sacrificed. The cup was hammered into a mold from a single sheet of silver. Naturalistically rendered with repoussé designs and stamped details, the calf has ears that were made separately and inserted and wide-open eyes that were once inlaid with glass paste to give a lively expression. A Greek inscription on the rim of the cup gives the weight of the piece as 67 drachmas. This indicates that, though the artistry of this cup is flawless, a greater measure of the cup's value was the weight of the bullion, 276.71 grams, used to make it.

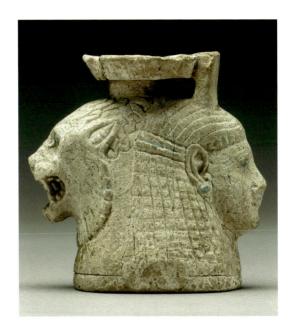

DOUBLE-HEADED ARYBALLOS

East Greek (Rhodes), circa 550 B.C.
Faience
H: 5.6 cm (2½ in.);
DIAM: 6 cm (2½ in.)

Two heads placed back to back form this delicate vessel, which was used to hold perfumed oil. One head is that of a woman; the other is a snarling lion. The style of the piece indicates that it was most likely made on the island of Rhodes. Because of its location in the Mediterranean. Rhodes was a crossroads for commercial travelers. The so-called East Greek style prevalent in this region shows the influence of a variety of artistic sources: Egypt, the Mesopotamian kingdoms, and Greece. The woman's head, in particular, shows a strong influence from Egyptian art, especially in the treatment of her hair as a solid mass, parted at the center of the head. Incised lines emphasize strands of hair, and the "checkerboard" pattern of the lower locks may be an indication that she wears a wig. The style of the lion, with its incised, flame-like locks and laid-back ears, is closer to the arts of the eastern Mediterranean.

The aryballos is made of a composite material known as faience, whose primary component is crushed quartz or some other silicate material. This is combined with lime and natron (plant ash) and mixed with water to form a claylike paste that can be pressed into a mold or thrown on a wheel. Once the piece is formed, it is allowed to air dry prior to firing. Faience was a material used for centuries, primarily in Egypt but also in Mesopotamia; it came later to Greece.

The body of this aryballos was constructed by pressing the damp faience into a mold. The mouth and handle were added after the body was removed from the mold, and finer details were incised into the faience before firing. This method of combining separately made pieces is a typical technique used to construct objects made of faience.

ALABASTRON

Eastern Mediterranean, 200–100 B.C. Faience H: 23 cm (9 in.) 88.AI.135

The name given to this shape of vessel, alabastron, originates from vessels of the same shape made first in Egypt using precious alabaster. An alabastron contained perfumed oil, and the vessel's flat rim may have aided in the application of oil to the skin. This alabastron is made of a composite material called faience, which consists of crushed quartz (or a similar silicate material), lime, and natron (plant ash). These ingredients are combined with water to make a claylike paste that is then formed into the desired shape. The Museum's alabastron was made in three parts: the base, the body, and the neck and rim. These parts were formed in separate molds and then attached to one another.

Various ornamental patterns decorate all parts of the vessel. Rosettes line the edge of the rim and petals descend down the throat of the vessel. The rim's base color is blue, and the rosettes are alternately yellow and brown, with white edges. The shaft of the body contains eight brown or blue ornamental patterns intermixed with solid bands of blue, all on a white ground. The base is deco-

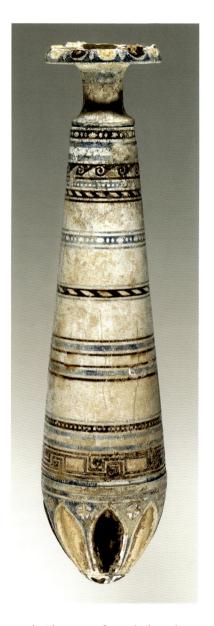

rated with a rosette from which petals ascend to the body of the vessel. The patterns help to date the vessel to the Seleucid or Ptolemaic empire of the second century B.C. The predominantly white color of this alabastron suggests that it was designed to imitate more costly alabaster or ivory.

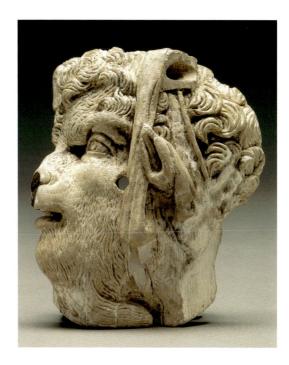

Appliqué Depicting the Head of Pan

Greek, circa 100 B.C. Ivory H: 8.6 cm (3¾ in.); w: 6.9 cm (2¾ in.) 87.AI.18

This disk is carved in low relief with the head of the god Pan. A woodland god native to the region of Arcadia in Greece, Pan is associated with fertility, particularly the fecundity of animal herds. He is half-human and half-goat in appearance. In myth, he often joins the wine god, Dionysos, in his drunken escapades. Pan accompanies the revelry by playing music on his syrinx (panpipes).

The animal qualities of the god are evident in this relief profile portrait. Here, Pan is nearly all goat, with a flattened nose, his facial hair and goatee tucked under his chin, and curling locks resembling fleece on top of his head. His alert ear is also goatlike and follows the direction of his piercing gaze. The god's mouth is slightly open and a row of small, short teeth is visible below his upper lip. In his hair he wears a flat ribbon, or fillet, an item associated with revelry. The ribbon's knot is missing, and one loose end hangs in front of his

ear. His profile goat's horn is also missing, but a hole carved at the top of the head behind the flap of the fillet's loose end indicates its placement; it was probably carved from a separate piece of ivory and attached with a pin or adhesive. The hole in the god's cheekbone indicates that the relief roundel was once attached to another object, perhaps a piece of furniture. The circular shape of the appliqué suggests that it may have been an inlay used to decorate the fulcrum (armrest) of a banqueting couch. Ancient literary sources describe luxurious couches that were inlaid with ivory and other precious materials. The ivory used for this piece came from an elephant's tusk; ivory from both African and Indian elephants was imported into the ancient Mediterranean at this time.

South Italian

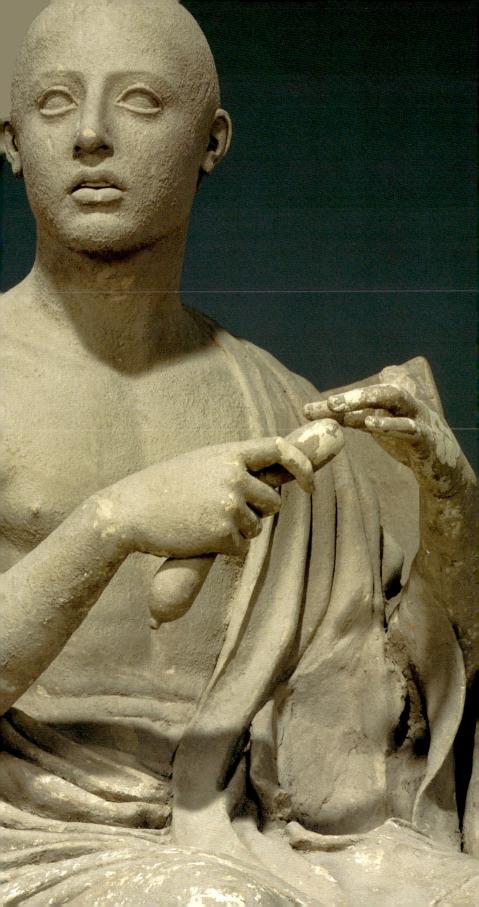

CULT STATUE
OF A GODDESS,
PERHAPS
APHRODITE

Greek (South Italy), 425–400 B.C. Limestone and marble with polychromy H: 220 cm (86% in.); W: 67 cm (26% in.) 88.AA.76

The imposing size and powerful body of this female figure imply that the sculpture represents a deity. But which goddess is she? Lacking the identifying attributes that she once held in her hands, she could be Demeter, Hera, or Aphrodite. The voluptuous proportions of the figure and the windblown garments make it most likely that she is Aphrodite, goddess of love and sexuality.

The statue's excellent state of preservation, including traces of its original paint, indicates that it stood indoors. Unfortunately, parts of the statue, such as the hair, the cloak that was pulled up over the goddess's head, and one arm and foot, have been damaged or lost. Given its larger-than-life-size scale, the statue was undoubtedly a cult image in a temple. Ancient Greeks built temples to honor a particular god or goddess and to house an image of the divinity. These

physical embodiments of a deity served as a focus for rites and rituals in their worship, thereby becoming cult images.

The statue is made from a combination of materials. The clothed part of the figure was carved from limestone, which still bears traces of its original red, blue, and pink paint. The parts of the body showing exposed flesh—her head, arms, and feet—were carved in marble from the island of Paros. This combined technique, called acrolithic sculpture, is unusual on mainland Greece; it was more commonly used for sculpture produced in the Greek colonies in South Italy and Sicily, where scholars think this statue was carved. Although the technique is a regional variation, the figure's swirling, clinging clothing closely follows the sculptural style current in Athens on the mainland of Greece in the late 400s B.C.

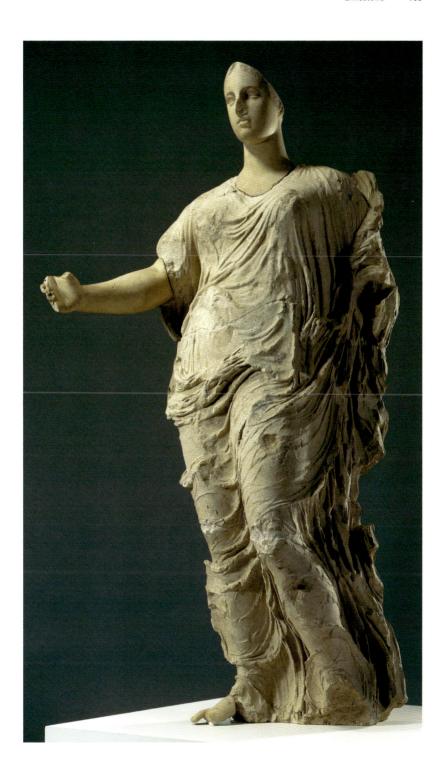

LEKANIS

Greek (South Italy), circa 325–300 B.C.

Marble with polychromy
H: 30.8 cm (12½ in.);
w (with handles): 67 cm
(26½ in.)
85.AA.107

The vivid polychromy on the interior of this unique ceremonial basin illustrates a crucial episode from Homer's *Iliad*. During the Trojan War, the Greek hero Achilles, overcome with anger at the loss of his mistress to Agamemnon, withdrew from the conflict and refused to fight. When his best friend, Patroklos, borrowed his armor and was killed in battle, Achilles was finally stirred to rejoin the fight. He needed a new set of armor, however, because his own had been stripped as booty from Patroklos's body. Achilles' mother, Thetis, a Nereid (sea nymph), arranged for another set to be made for her son by the blacksmith of the gods and, together with her sister Nereids, delivered it to him.

Here, Thetis and two of her sisters ride to the left, one on a sea horse and the other two on sea monsters, while carrying the new cuirass, shield, and helmet.

When the lekanis was filled with water, the dolphins in the composition completed the illusion that the Nereids were riding through the sea. Owing to the painted decoration's fragility, the basin must have been reserved for ceremonies and rituals rather than used every day.

Although painting was a popular and highly regarded art form in ancient Greece, because of its transient nature almost none of it has survived. The scene preserved here can only hint at the original appearance of monumental Greek wall and panel paintings.

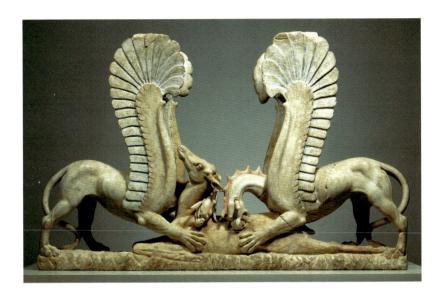

SCULPTURAL GROUP OF TWO GRIFFINS ATTACKING A FALLEN DOE

Greek (South Italy), 325–300 B.C. Marble with polychromy H: 95 cm (37 ½ in.); W: 148 cm (58 ½ in.) 85.AA.106 A doe lies fallen, savagely attacked by two griffins with upraised wings. Masterfully juxtaposing the sinuous forms of the griffins with the brutality of their assault, the carver of this sculpture has embodied in marble the concept of deadly beauty.

Combining the features of an eagle, lion, and snake, griffins were ferocious mythical beasts of eastern origin. In Greece, they signified the power of the sun and were sacred to Apollo, who rode one; exemplifying stalwart vigilance and turning her wheel of fortune, they were adjuncts to Nemesis, goddess of retribution; as stronger animals subduing the weaker, they came to represent the supremacy of the civilized world over the barbaric; and symbolizing the conflict between the forces of life and death, they were appropriate to funerary purposes. By the fourth century B.C., griffins had become commonly recognized and widely used subjects in Greek art.

Cuttings between the raised wings suggest that this piece served as a support for a ceremonial table that most probably was set and utilized in a significant religious context. The considerable traces of original pigment—blue, red, green, and brown—are a striking reminder that all ancient marble sculptures were once richly painted.

FRAGMENT OF A
RELIEF OF A
HORSEMAN AND

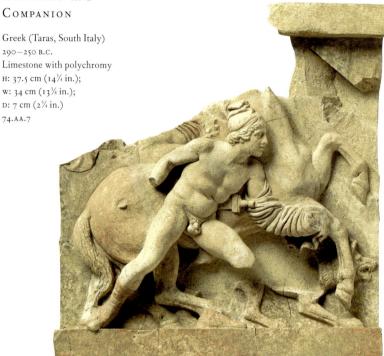

A cloaked horseman pulls back his rearing mount while his companion on foot, naked except for boots, a soft peaked cap, and a cloak wrapped around his left arm, leans forward to attack with a spear (now missing) in his right hand. Although only the chest and parts of the animated cloak of the horseman remain. they reveal his muscled physique, and two creases indicate that his torso turns at the waist. The man on foot is heardless with long, curly hair. There is a sword at his left side, suspended from a strap that was originally added in paint. From beneath the horse, a snarling dog menaces the foe. The dog indicates that the unseen opponent is actually prey and that this is a hunting scene.

At Taras, a Greek colony in South Italy, the dead were honored with small but ornate funerary monuments, often decorated with sculpture carved from soft local limestone. This fragment of relief sculpture probably comes from a funerary monument made in the shape of a small temple; it was cut from a long frieze that ran across its front. The missing sections would have shown the hunter's quarry, probably a boar or a lion. Used on a funerary relief, the theme of hunting refers to the pleasures of the afterlife. Traces of preserved paint hint at the originally vibrant appearance of the relief: red on the cloaks, the hilt of the sword, the horse, and the hunter's boots; brown on the dog; blue on the background.

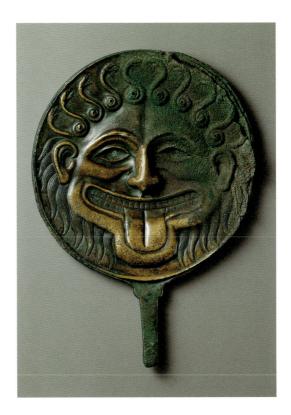

HAND MIRROR

Greek (South Italy), 500 – 480 B.C. Bronze H: 20.2 cm (8 in.); DIAM (disk): 15 cm (5 % in.) 96.AC.109

In antiquity, modest utilitarian objects, whether household or personal, were often treated by craftsmen with the same creative attention and skill as monumental art. The reflective side of this hand mirror was initially highly polished and protected by a raised beaded flange around it. The tondo itself is edged by a simple decorative pattern bordering two incised concentric circles. A support for the now-missing handle has an Aeolic capital with simple incised volutes. But it was the cover over the back of the disk on which the artisan lavished his special care. It is a separately made repoussé relief of the head of Medusa, the dreaded Gorgon whose face could turn anyone who gazed upon it into stone.

Because Medusa's head could unnerve and paralyze an enemy with fear, the Greeks deployed its image on everything from military armor and public architecture to household furnishings and personal amulets, believing that its apotropaic power would safeguard them from their adversaries and any potential threat. Thus, while the user was busy viewing her own reflection on the interior of the mirror, any onlooker would be confronted by the protecting head of Medusa on the outside. Despite the typical Gorgon features—the locks of spiraling snakes capping her head, the wide, grinning mouth with its long rows of teeth, the protruding tongue, and the flame-like beard—this decorative Medusa lacks the fangs of most of her predecessors and seems more benign than sinister.

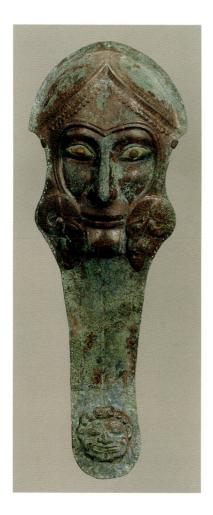

HEADPIECE FOR A HORSE

Greek (South Italy), circa 480 B.C. Bronze; ivory and amber inlay H: 45 cm (17½ in.); W: 17.2 cm (6½ in.) 83.AC.7.1

Although equine armor commonly was used to protect the chest and forehead of a horse in battle, the precious amber and ivory materials embellishing the beautiful decorative work on this elaborately detailed headpiece (prometopidion) distinguish it as ceremonial armor. It is decorated at the top with the face of a warrior, symbolizing the armor's ability to protect its wearer, and at the bottom with the head of a Gorgon, a symbolic device used to ward off evil. The warrior wears a helmet with ram'shead cheekpieces, which, like most of the details of his face, is delineated with elaborate incision; his eyes are inlaid with ivory for the whites and amber for the irises.

Two equine breastplates and a second headpiece were found together with this one. The breastplates are incised with a frontal view of a quadriga, or four-horse chariot, and flying figures of Nike, goddess of victory, who carry wreaths for the charioteer standing in the chariot box. This motif suggests that the trappings had perhaps been made for a champion chariot team that had brought glory to its owner.

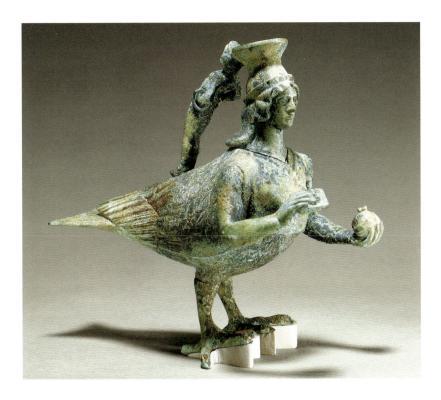

Askos in the Shape of a Siren

Greek (South Italy), circa 480–450 B.C.
Bronze
H: 15.9 cm (6½ in.);
L: 19.4 cm (7½ in.)
92.AC.5

This exceptional bronze askos (a word meaning wineskin) was cast in the shape of a Siren with the stout but finely feathered body of a bird and the head and arms of a woman. The vessel probably served as a container for expensive scented oil that could be dispensed from the top of the Siren's head. The now-missing stopper was attached by a chain to the ring, still extant, which encircles the left arm of the nude youth that forms the handle.

Known most commonly for their irresistibly beautiful voices and the songs that enticed sailors to their deaths,

the bird-bodied Sirens also had a strong association with the afterlife. In fact, they were regarded as the Muses of the Underworld and thus often appear in funerary contexts to mourn the dead and help fulfill the promise of life after death.

Those chthonic and funerary connotations are emphasized by the pomegranate this Siren offers with her left hand. It is a fruit clearly linked to the Underworld through the myth of Persephone, who had eaten its seeds and was consequently doomed to spend half the year there as wife of the king of Hades. The Siren's right hand holds panpipes, a pastoral wind instrument that, in contrast to her deceitfully innocuous appearance and modest dress, subtly alludes to the fatal lure of her music. Symbolic of both the inevitability of death and the hope of an afterlife, the Siren would have been an appropriate image for a tomb offering, which this askos most likely was.

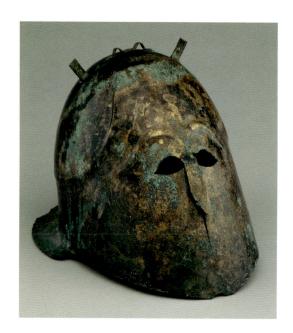

Негмет

Greek, Apulo-Corinthian (South Italy), 400–375 B.C. Bronze H: 19.3 cm (7½ in.); W: 22.5 cm (8½ in.) 92.AC.7.1

Of the numerous forms of military headgear used throughout the Greek world, the so-called Corinthian helmet covered almost the entire head and had openings for only the eyes, nose, and mouth. When not used in battle, it could be pushed up and worn on top of the head like a cap. In Greek art, both warriors and Athena Promachos (the goddess in her guise as protectress of Athens) are often shown wearing the helmet that way. Although the Corinthian helmet eventually fell into disuse in Greece, it survived in the Greek colonies in South Italy where, in time, the openings in the face of the helmet grew so small in size that they no longer served any real function. As it evolved in Apulia and other parts of Italy, the Apulo-Corinthian helmet became a decorative piece of armor worn atop the head in the style of Athena herself and intended only for ceremonial purposes or as a dedication in the tomb.

This helmet is ornamented with incised patterns representing curling locks of hair across the forehead and, between the repoussé brows, a lotus bud. Chevrons border the nose and eyes, and seated heraldic sphinxes decorate the cheekpieces. The attachments on the crown originally held either horsehair crests or feathers.

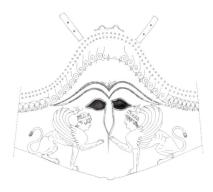

Drawing by Beverly Lazor-Bahr

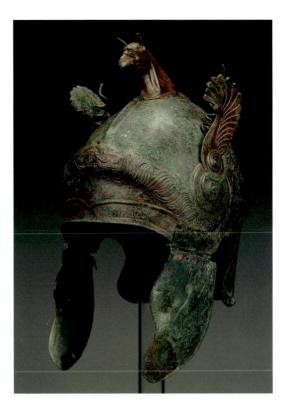

HELMET OF CHALKIDIAN SHAPE

Greek (South Italy), 350–300 B.C. Bronze H (without cheek flaps): 27.9 cm (11 in.); w: 16.2 cm (6% in.) 93.AC.27

Like the Apulo-Corinthian helmet (see previous entry), this type of helmet derived from the kind that originally was developed in Corinth on mainland Greece. It slid completely over the warrior's head, with openings for the eves and mouth and a protective guard for the nose. In Chalkis, a city on the island of Euboia off the east coast of Greece that was well known for its metalwork, a significant improvement was made by opening up the areas over the ears, enabling wearers to hear what was going on around them. It was this varianthinged cheekpieces but no protection for the nose—that came to be widely used throughout Italy and beyond. It remained a common part of the military panoply even in the time of the Roman Empire.

In relief on the front of this helmet, above the embossed lines mimicking eyebrows and as if set over the wearer's hair, there is a diadem with a central rosette and surrounding spiraling tendrils. Carefully arranged locks of hair curl up and over it from beneath. The cheekpieces are embellished with the side-whiskers of a beard, through which a quadruped climbs as if scrambling up a mountainside. Ornamental attachments include the protome of a griffin on the crest and stylized griffin wings concealing the coils that once held feathers. These were meant to make the wearer appear particularly imposing and frightening and to impart some of the mythological creature's potency.

Because helmets with griffin protomes are almost always appropriate to gods and heroes alone, this helmet probably served not for actual battle but for ceremonial rites, perhaps funereal in heroizing a dead mortal warrior.

THYMIATERION SUPPORTED BY A STATUETTE OF NIKE

Greek (Taras, South Italy), 500–480 B.C. Terracotta with polychromy H: 44.6 cm (17½ in.) 86.AD.681

This figure of Nike, winged goddess of victory, conveys an impression of monumentality. She is, in fact, a statuette functioning as a caryatid, or support, for the shallow bowl of an incense burner and its egg-shaped openwork lid, on which a dove perches. This thymiaterion may have been intended for use in the performance of religious rituals. However, because it preserves traces of its original vibrant pink, purple, red, and blue pigments and the incense bowl shows no evidence of use, it more likely was placed in a tomb as a grave offering.

The exquisitely detailed features of this terracotta statuette—the crimped hair that frames the forehead and falls gracefully over the shoulders, the finely pleated chiton beneath the heavier folds of the himation, and the pose, in which the goddess stands with her left leg advanced while she draws the fabric of her garments to one side revealing the contours of her limbs—all find parallels among the large-scale marble korai (maidens) of the late Archaic period found on the Acropolis in Athens (see

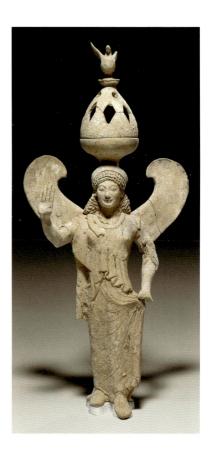

the korai on pp. 15 and 19 and the statuette on p. 40, which may have supported a thymiaterion). That sensitivity, exercised by ancient artisans as they embellished even the most modest and utilitarian objects of daily life with beautiful figures and ornamental patterns, is one of the most compelling aspects of Greek art. Distinguished from the korai only by her outspread wings, this goddess of victory underscores the humanistic nature of Greek religion that is intrinsic to Greek art. At the same time, the incense bowl and openwork lid betray the functional nature of the statuette, reminding us that most Greek art served a purpose beyond artistic expression.

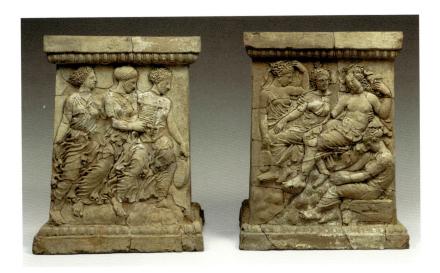

PAIR OF ALTARS

Greek (probably Taras, South Italy), 400–375 B.C. Terracotta H: 41.8 (16½ in.); w (top): 31.5 cm (12½ in.); D (top): 27 cm (10½ in.) 86.AD.598.1

H: 41.8 cm (16½ in.); W: (top): 31.5 cm (12½ in.); D (top): 27.8 cm (11 in.) 86.AD.598.2 The scenes on these two altars form a single composition in which the altar on the right provides the primary element. In the rocky landscape at its center, Aphrodite, goddess of love and sexuality, sits embraced by her lover Adonis. A beautiful youth associated with vegetation and fertility, Adonis was also the lover of Persephone, queen of the Underworld. To appease both deities, Zeus decreed that Adonis spend half the year with one goddess and half with the other.

While most of the other figures, including the dancing figures on the left altar, are most likely the nymphs who are common to the mythology of both Aphrodite and Adonis, the identity of the dejected figure seated at the bottom right is unclear. Although she does not carry a musical instrument, she too may be a nymph, one whose attitude of mourning foretells the doomed nature of the relationship. Alternatively, she may be Persephone, without her usual attributes, mourning her loss, even if only temporary, of Adonis to Aphrodite. In either case, the altars could have served for the burning of offerings or incense in a private shrine dedicated to these deities. The third, and least likely, possibility is that the seated woman represents a deceased mortal bride who, unlike Aphrodite and Adonis, will never again enjoy the companionship and love of her husband. In such an instance, the altars could have been made as funerary offerings to be deposited in the bride's grave.

SEATED POET AND SIRENS

Greek
(probably Taras,
South Italy),
350-300 B.C.
Terracotta
with polychromy
H (poet): 104 cm (41 in.)
H (sirens): 140 cm (55% in.)
76.AD.11

Once brightly painted, these large clay figures, often identified as the mythological characters Orpheus and the Sirens, are unique among South Italian terracottas in both size and iconography. According to the myths, the half-human, half-bird Sirens used their sweet, seductive songs to lure sailors to their deaths upon a rocky shore somewhere in the south of Italy. They met their match in Orpheus, however, the mythical musician and singer. He saved Jason and the Argonauts during their quest for the Golden Fleece by singing so beautifully that the Sirens not only stopped their own singing to listen but threw themselves into the sea, allowing the ship to pass safely. Orpheus charmed even Hades, the king of the Underworld, when he ventured there to rescue his wife, Eurydice.

Here, the seated man is singing, as shown by his open mouth. He uses the object in his right hand, the plektron (pick) to strike the strings of his now-missing kithara (harp), which once rested on his lap. Each Siren stands on a small, rocklike base. With her chin resting on her hand, one appears to listen attentively while the other sings, lips parted and one arm outstretched.

The fact that the man is singing and playing the kithara suggests that he may be Orpheus, whose cult was widespread in South Italy. Yet, because Sirens are often found in funerary contexts as figures who sing to mourn the dead and help fulfill the promise of life after death, the seated man may be a mortal who in life had been a poet and thus, for his funerary monument, is depicted as Orpheus.

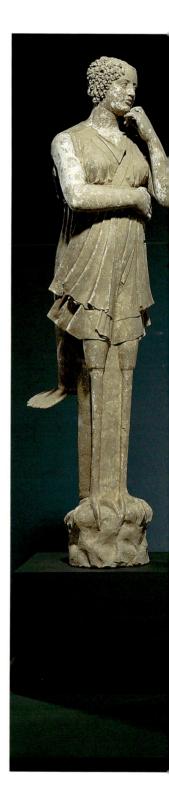

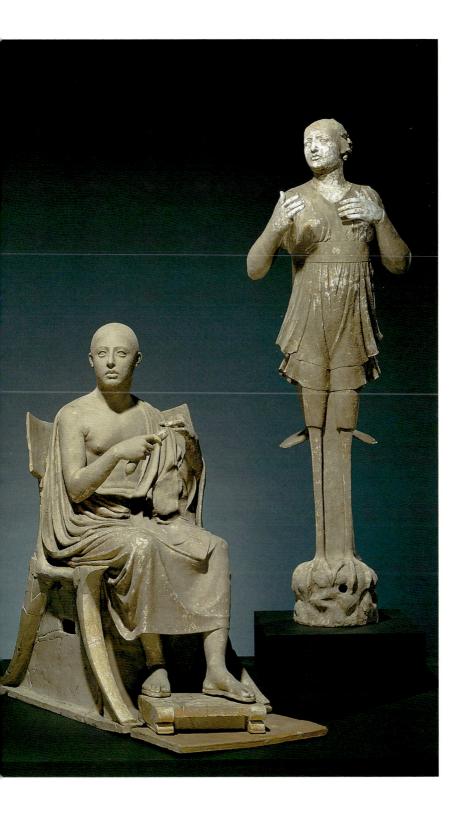

Apulian Red-Figured Volute-Krater

Attributed to the Sisyphus Group Greek (Apulia, South Italy), 410–400 B.C.
Terracotta
H: 63.3 cm (24½ in.);
DIAM (body): 38 cm (15 in.)
85.AE.102

The balanced composition and the often sculptural character of the figures on early red-figured vases from South Italy reveal the traditions of Classical Attic vase-painting that were followed by those painters. Many had emigrated from Athens around the last third of the fifth century B.C. to practice their trade in their new homes, the Greek colonies in South Italy. The pottery produced there preserves a wide variety of subjects from classical mythology.

The story of Andromeda and Perseus enjoyed enormous popularity in antiquity. Andromeda was the daughter of Cepheus, king of Ethiopia, and his wife, Cassiopeia, who bragged that she was more beautiful than the Nereids, the fifty sea-nymph daughters of a sea god. As punishment for such vanity, Poseidon sent a flood and a *ketos* (sea monster) to devastate the land. When Cepheus

learned that he could save his country only by offering his daughter as a sacrifice to the monster, his subjects demanded that he do so. Flying past on his return from slaying Medusa, the hero Perseus spotted the princess bound to a rock and promised Cepheus he would destroy the sea monster in exchange for Andromeda's hand.

On this krater, the Ethiopian princess is being readied as a sacrifice to appease the sea monster. The youth at the left ties Andromeda between two tree stumps while, at the right, Perseus and Andromeda's father, King Cepheus, make the pact that the princess will be the hero's bride if he slays the monster. The chest and *kalathos* (basket for holding wool) by Andromeda's feet are traditionally associated with the household tasks of a wife.

APULIAN RED-FIGURED BELL-KRATER

Name-vase of the Choregos Painter Greek (Apulia, South Italy), circa 380 B.C. Terracotta H: 37 cm (14% in.); DIAM (rim): 45 cm (17% in.) 96.AE.29

Even though it had deep roots in mainland Greece, South Italian vase-painting evolved its own, often flamboyant, style through innovations in vase shapes, the use of added color, and the choice of subject matter. Among the subjects most favored were those inspired by so-called phlyax plays, extremely popular farces and slapstick comedies that parodied everything from mythological tales and figures to the absurdities of daily life. These plays derive their name from the phlyakes, the actors who toured the countryside performing them in distinctive costume - mask, tights, padded tunic, and large fake phallos. Likewise, vases with scenes from these farces are known as phlyax vases.

The picture on this krater depicts a theatrical company and the staging of a play. At the far left is the very basic set, consisting of a pair of doors through which a character, wearing a costume associated with tragedy, has probably just made his entrance. The name Aigisthos is inscribed over his head. The white-haired figure facing him and the man at the far right are each labeled Choregos (theatrical producer). Standing between them, in the pose of an orator on an overturned basket that serves as his platform, is another stock figure from comedy. He is identifed as Pyrrias, meaning "red-head," to indicate his role as a typically red-haired slave from Thrace. The scene suggests a lampoon of a disagreement about producing a show, with the two choregoi arguing about whether to back a comedy, represented by the fellow between them, or a tragedy, denoted by the character on the left. It also offers an important document for our knowledge of ancient stage construction, especially the simple temporary stages and sets used by traveling theatrical troupes.

Paestan Squat Lekythos

Attributed to Asteas
(as painter)
Greek (Paestum, South Italy),
350–340 B.C.
Terracotta
H: 45.5 cm (17% in.);
DIAM (base): 18.3 cm (7% in.)
96.AE.119

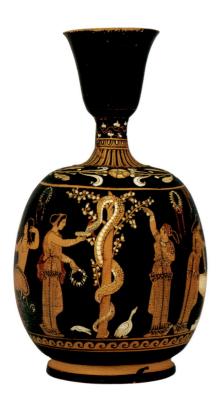

Diminutive squat lekythoi, with surface enough for only a single female head or small figure, are common in Greek vase-painting of South Italy. However, sizeable examples like this one, which are better suited to decoration with narrative scenes, are quite rare. The scene on this very large lekythos shows the Garden of the Hesperides, an idyllic but remote mythical haven generally considered in antiquity to be in North Africa, the outermost reaches of the western Mediterranean, or the far north. There, on a tree protected by the Hesperides (nymphs) and the terrible hundredheaded snake, Ladon, grew the golden apples of immortality. The tree, with its highly coveted fruit, had been given to Hera upon her marriage to Zeus and entrusted to the Hesperides for safekeeping.

The Hesperides are rarely depicted without Herakles because the tale of his acquiring some of the golden apples, one of the most complex and difficult of his Twelve Labors, is so primary to any association with the garden. In this scene, however, Herakles has been omitted and, instead, the focus is on the tree and its guardians. Entwined around the tree and represented here as singleheaded, the snake drinks innocuously from a shallow bowl offered by one of the Hesperides as apples are plucked from a branch by another. The picture is framed by two other Hesperides, one sitting upon a palmette fan and the other leaning over a washbasin. Attributed to the vase-painter Asteas, this vase makes a notable counterpart to his signed lekythos in Naples, on which he painted a very similar picture that includes Herakles.

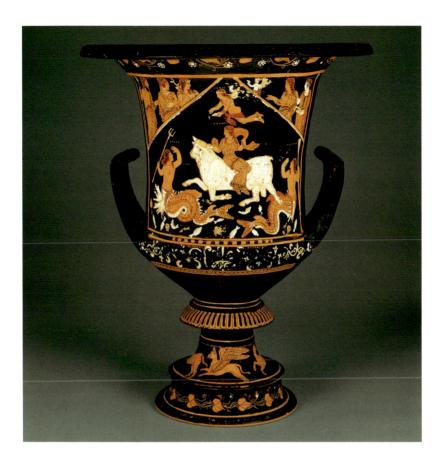

Paestan Red-Figured Calyx-Krater

Signed by Asteas (as painter)
Greek (Paestum, South Italy),
circa 340 B.C.
Terracotta
H: 71.2 cm (28 in.);
DIAM (body): 59.6 cm
(23½ in.)
81.AE.78

This large vase is called a calyx-krater because its shape recalls the form of a blooming flower. It functioned exactly as did other Greek kraters, as a mixing bowl for wine and water at what must have been exceptionally sumptuous banquets. The primary scene is the famous Greek myth of Europa and the Bull. According to one popular version of the myth, Zeus fell in love with Europa, the daughter of the king of Tyre (in Lycia, modern Turkey). In order to seduce her, he sent a sweet-natured sea bull swimming to the shore where she was playing. The bull enticed Europa to climb upon its back and quickly swept her off to Crete (according to tradition, the birthplace of Zeus). There she bore Zeus three sons, one of them Minos, the legendary king of the Minoans. On the vase, Pothos, the winged personification of Zeus's amorous longing, hovers above Europa, while other gods observe from the left and right upper corners. The marine setting is conveyed by the fish scattered across the bottom of the frame, as well as the sea monster Skylla, in the lower left corner, and the sea god Triton, in the lower right corner.

Campanian Red-Figured Neck-Amphora

Attributed to the Caivano Painter Greek (Campania, South Italy), circa 340 B.C. Terracotta
H: 63.5 cm (25 in.);
DIAM (body): 25 cm (9 1/8 in.)
92.AE.86

In the Seven Against Thebes, Aeschylus's tragedy set at the walls of the great city, the warrior Kapaneus was the only one of the seven attacking leaders to reach the wall in an effort to reinstate the rightful king on the throne. His hubris in boasting that he did not require the help of the gods in this undertaking led to his downfall. Zeus could no longer endure the warrior's arrogant claims and destroyed him with a lightning bolt.

Inspired by that tale, the vase-painter, whose larger vases are often decorated with subjects drawn from drama, has transferred the essential elements of the tragedy to this amphora. Holding a firebrand and shield, Kapaneus climbs a ladder toward the top of the battlements. Two defenders and a bearded, whitehaired man holding a scepter, probably Kreon, the usurping ruler of Thebes, watch him. Just as the doomed Kapaneus reaches the top, the fatal lightning bolt flashes down. On the right side of the city gate, a winged figure of Nike, holding a wreath and fillet, hovers over a four-horse chariot. The vase documents a highly dramatic event rarely shown in ancient art, particularly in vase-painting.

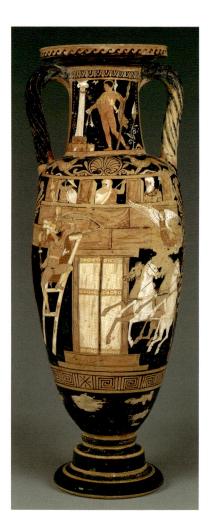

The depiction of the city wall and gate, detailing the grain of the wood and metal attachments, most likely copies a stage set for the play. The way in which Kapaneus climbs the ladder suggests that he wants to face the audience in order to be heard when he speaks.

The local Oscan-style helmet with an upright feather on either side, as worn here by Kapaneus, is characteristic of the painter's warriors. This vase-painter also makes extensive use of added white, yellow, and purplish red, giving his vessels a bright and colorful aspect.

Apulian Red-Figured Loutrophoros

Attributed to the Metope Group Greek (Apulia, South Italy), 340–330 B.C.
Terracotta
H: 87 cm (34½ in.);
DIAM (rim): 26.9 cm (10½ in.)
84.AE.996

The front of the vase (shown here) depicts an episode from one of the most celebrated tales in antiquity, the story of Perseus and Andromeda (see p. 118 for a summary of the myth). The princess Andromeda, who is being sacrificed to placate the sea monster that had been ravaging her father's kingdom, stands bound to a rock or entrance to a seashore grotto that most probably reflects a theatrical set upon which a drama derived from the myth had been staged. The aged King Cepheus, holding a staff, watches from the right. In the lower register, Perseus in his winged hat and sandals is about to kill the monster, on whose back kneels a small Eros, symbol of love.

Around the time this vase was painted, Alexander the Great had been campaigning in Persia and the East. His exploits were well known, even in South Italy, and their influence is evident here in the male figures' Persian-style clothing.

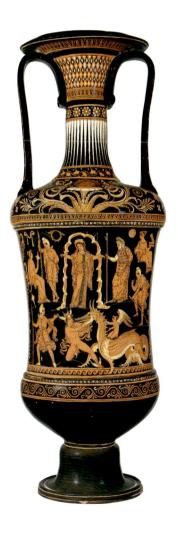

APULIAN RED-FIGURED LOUTROPHOROS

Attributed to the Painter of Louvre MNB 1148
Greek (Apulia, South Italy), circa 330 B.C.
Terracotta
H: 90.1 cm (35½ in.);
DIAM (rim): 26 cm
(10½ in.)
86.AE.680

Even though Greek-speaking vasepainters of the fifth century B.C. in South Italy at first imitated the shapes, subjects, and style of the Attic pottery of mainland Greece, they soon developed an independent style and expanded their repertoire with novel shapes and subjects. By virtue of the large number of vases he painted and his innovative treatment of their subject matter, the artist of this loutrophoros with spiraling handles, a uniquely Apulian shape, is considered to be an important South Italian vase-painter. Here, on two different levels, the painter has shown two scenes relevant to the myth of Leda and the Swan (see also the Roman statue on pp. 152-153). The upper register depicts Zeus, Aphrodite, and Eros inside an Ionic building. The king of the gods may be asking for Aphrodite's help in seducing Leda and using Eros to help plead his case. At the bottom of the vase, in one of his guises adopted while seducing mortal women, Zeus appears as a white swan leaping into Leda's embrace, while Hypnos, a personification of sleep, showers them with drowsiness. One of the results of this union was Helen, the cause of the Trojan War. Other mythological figures, also identified by their incised names—Astrape, a personifica-

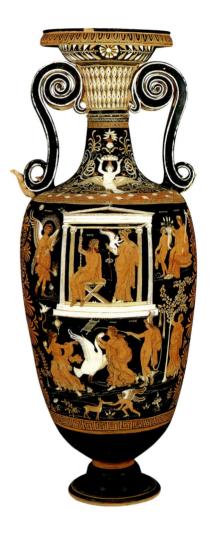

tion of lightening; Eniautos, the personification of the calendar year; and Eleusis, the personification of an important sanctuary—are not clearly connected to this tale. The depiction of the story in two registers, the dual appearance of Zeus as both god and bird, and the inclusion of inscribed names and secondary figures suggest that this painter's representation of the myth may have been inspired by a theatrical performance.

APULIAN RED-FIGURED LOUTROPHOROS

Attributed to the Painter of Louvre MNB 1148 and Circle of the Darius Painter
Greek (Apulia, South Italy), circa 330 B.C.
Terracotta
H: 98 cm (38% in.);
DIAM (rim): 21.9 cm (8% in.)
82.AE.16

According to ancient sources, vases of this shape were used for carrying water to nuptial baths and also as funerary offerings for those who had died unwed. Thus their painted scenes are usually relevant to marriages and funerals. The main scene on this vase depicts the conclusion of the story of Niobe. Although there are differing accounts of the tale, the most common relates that, as the mother of six (or seven, as some legends have it) sons and an equal number of daughters, she was excessively proud, mocking Leto, the mother of Artemis and Apollo, for having only two children. To avenge this insult, Leto directed Apollo and Artemis to slay all of Niobe's children, although in some versions two survive (for a sculpture of one of the stricken sons, see p. 154). Grief stricken, Niobe lamented for nine days and nine nights at the tomb, imploring Zeus to change her into stone.

Here, her wish granted, Niobe stands inside a *naiskos*, or small shrine, with her head covered and in an attitude of mourning. The added white paint on the lower part of her garment indicates her forthcoming petrification. The two loutrophoroi shown within the shrine as well as the women making offerings outside it serve to emphasize the vase's funerary significance. The loutrophoroi

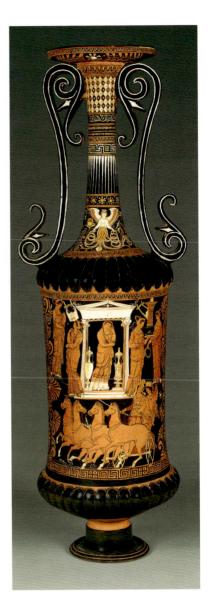

are painted in white, perhaps in imitation of marble originals. One may represent an offering to Niobe's slain sons and the other to her daughters. In the scene below, Pelops and his bride, Hippodamia, appear in a four-horse chariot. Because he was Niobe's brother, Pelops may be arriving at the tomb in order to plead with her to desist.

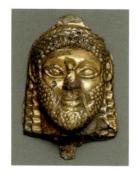

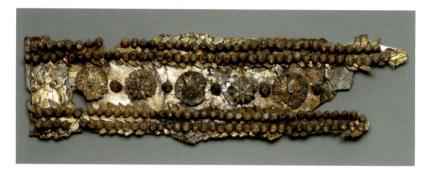

Three Appliqués and One Band with Foliate Ornament

Greek (South Italy), 525–500 B.C. Gilded silver and bronze Various dimensions 96.AM.110.4, .7, .11, and .21 These objects are representative of a larger set of ornaments once used for personal adornment. The three heads pictured here are part of a group of eleven, which were formed by hammering thin sheets of silver into molds. Details were picked out with gilding. The kore (left), her hair falling onto her shoulders, wears a diadem and necklace. A wreath of pointed leaves crowns the bearded male (center). The monstrous Gorgon Medusa (right) has the furrowed brow, broad nose, protruding tongue, and fangs that typify her portrayal in the Archaic period. Because there are no traces of holes for either sewing or nailing the heads to a background, it is likely that an adhesive fastened them to whatever that background may have been.

Most impressive is a broad band of gilded silver preserving an elaborate decoration of schematized floral forms. The background sheet is plain except for a tongue pattern along the top and bottom edges. Applied over this is a triple row of overlapping cutouts in the shape of laurel leaves. On each laurel garland is a superimposed double line of small buds or acorn-shaped finials. Against the plain background of the middle zone, large bud-shaped finials alternate with stylized blossoms made in two layers. Too fragile to be worn, the band

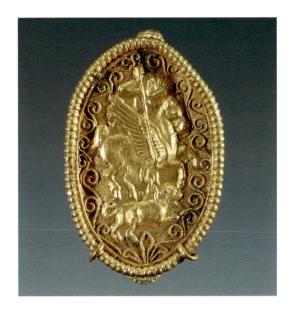

Box-Bezel Ring

Attributed to the Santa Eufemia Master Greek (South Italy), circa 300 B.C. Gold

H (bezel): 2.04 cm (11/16 in.);

W (bezel): 1.42 cm (1/16 in.);

D (bezel): .77 cm (1/16 in.);

DIAM (hoop): 2.31 cm (11/16 in.)

88.AM.104

Elaborate ornamentation is the distinguishing feature of this ring, one of the few ancient rings that can be attributed to a known goldsmith. It is called a box-bezel ring because the bezel is formed in the shape of an oval box. On the top, the Greek hero Bellerophon, mounted on his winged horse Pegasos, kills the Chimaira, a polymorphous lion-goat that breathed fire and had the tail of a serpent. This legend often had funerary associations and was beloved by the Archaic Greeks, and by the Greeks of South Italy, where this ring was made.

The figural group is embossed on a thin gold sheet, which was then cut around the edges and fixed as an appliqué to the surface. Filigree spirals and floral devices surround it. Though it is not visible when the ring is being worn, the underside of the box is elaborated with filigreed back-to-back palmettes with a tendril spiral and a bellflower. The manufacture of these motifs is a clue to the artist, for one of his stylistic traits was the use of a corkscrew coil of gold wire that lies flat on the surface of the object. This method has been observed on other pieces of jewelry found in a female burial cache in southern Italy and given the name of the Santa Eufemia Treasure (now in the British Museum in London); hence the artist who made them is now referred to as the Santa Eufemia Master.

was probably part of a belt or a ceremonial crown that may have adorned a cult statue or the garments of a deceased woman.

The group also includes four pairs of pins, the head of another pin that may have been used as a perfume dipper, a D-shaped object (perhaps part of a belt), and four finials.

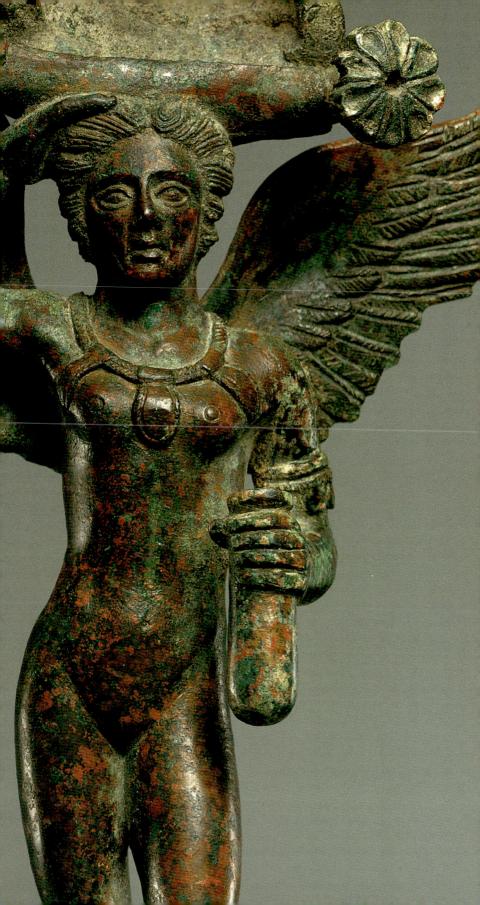

STATUETTE OF AN ARCHER, PERHAPS A HERO OR DIVINITY

Etruscan, 510-490 B.C. Bronze H (with base): 11.5 cm (4½ in.) 96.AC.12.4

This lively statuette of a young archer, cast solid together with its base, once topped a candelabrum like the one on pp. 134-135. His body type is that of the Greek kouros (youthful male), often used as a model by Etruscan sculptors at this time (see the statuette on the facing page). Typically, a kouros stands with one leg advanced; in this early example, however, the weight is distributed evenly between the figure's legs. This archer once held his bow in his upraised right hand; his bow case (gorytos) is slung beneath his left arm. His distinctively pointed archer's helmet is decorated all over with a zigzag pattern and lined with a soft material that hangs free in two lappets, one in front of each ear. He wears pointed boots, tight leggings with incised patterns, and a close-fitting upper garment also completely covered with rows of zigzags. This is the typical costume of a Scythian archer, and is also worn by Amazons, but with a significant variation: The archer has draped a doeskin over his traditional costume. Its forelegs are knotted on the archer's left shoulder, and its head hangs protectively over his groin. The doeskin is dappled with incised almond-shaped

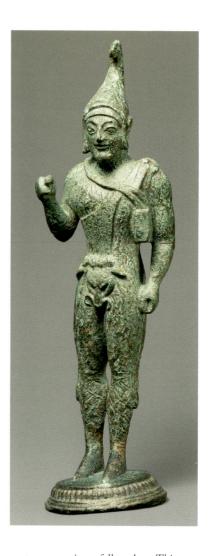

spots, suggesting a fallow deer. This type of deerskin identifies the wearer as a hunter (which not all archers were). Given the doeskin's elaborate details, this archer may be an Italic divinity or hero connected with the chase. The figure is similar in style to statuettes found at Vulci, the famous Etruscan bronze-casting center, from whence he is said to have come. He shares with them large almond-shaped eyes, a short nose, a gently smiling mouth, and a heavy chin.

STATUETTE OF A KOUROS

Etruscan, circa 490 B.C. Bronze H: 22.5 cm (8 % in.) 85.AB.104

This statuette of a kouros, or young male, is based on a type widely known in sixth-century-B.C. Greece. In its form and intention it is very similar to the bronze statuette on p. 133. Like that work and its Greek prototype, this statuette was originally intended to serve as a votive offering in a sanctuary. The extremely high level of craftsmanship indicates that the original patron valued it very highly and intended it to be devoted to an important god, in this case most likely Apollo. In imitation of its Greek model, this Etruscan statuette stands in an erect posture, with his left leg projecting slightly forward. Unlike the Greek kouros, however, this one is clothed in the Etruscan costume of status, the tebenna, a precursor to the Roman toga. Wrapped around the figure's right hip, one end of the long garment is pulled over his left shoulder from behind, and the other end is thrown over his left forearm. The decorative patterns at the edges of the cloth made by diagonal and dotted incisions indicate areas that would have been embroidered if this cloth were real. He holds the remains of a now-missing staff in his lowered left hand. The authentic-

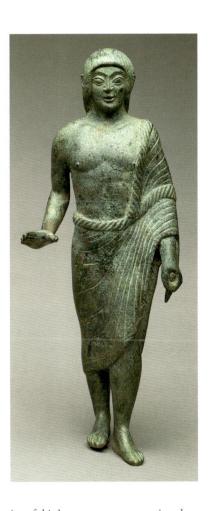

ity of this kouros was once questioned because the drapery's arrangement and thickness is inconsistent with other examples. However, extensive analysis of the statuette's patina, or surface corrosion, proved that it is authentic. The uncharacteristically thick band at the edge of the *tebenna* therefore probably reflects a misunderstanding on the part of the Etruscan artist.

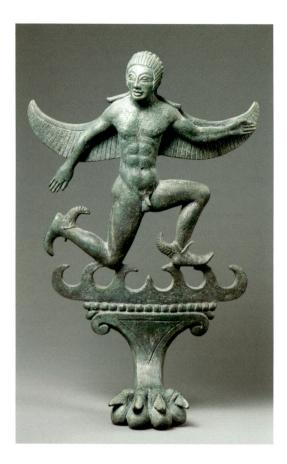

FOOT OF A CISTA IN THE FORM OF A WINGED YOUTH

Etruscan, circa 490 B.C. Bronze H (with base): 15.2 cm (6 in.); W: 10.3 cm (4 in.) 96.AC.127

The overall impression conveyed by this work is of swiftness and flight. From the youth's outstretched arms and wings and his twisted torso to the undulating waves below his feet, every element of this carefully detailed sculpture is calculated to reinforce the idea of movement. For example, the position of the legs is a convention used throughout the Archaic period to represent running or rapid motion, while the strain of the muscles is evident in both the arms and legs. Such liveliness of pose characterizes images of the Etruscan sun god Usil, identified with the Greek Helios, who was believed to traverse the course of the heavens every day as he brought light to the Earth. Images of Usil were considered to

be appropriate decorations for women's toiletry objects, on which winged deities of both sexes often appeared (see also the Etruscan patera handle, p. 136).

This piece once belonged to a *cista*, or round cosmetic box. The slightly curved back of the figure and the outstretched wings indicate that it was attached to the side of the box, while the feline paw below functioned as one of the *cista*'s three feet. It has been suggested that this type of figural foot was an invention of the bronze-casting workshops in the city of Vulci, located in southwestern Etruria; significantly, this piece is said to have been found at Vulci.

STATUETTE OF A BEARDED MAN, PROBABLY TINIA

Etruscan (Piombino), circa 480 B.C.
Bronze
H: 17.2 cm (6¾ in.)
55.AB.12

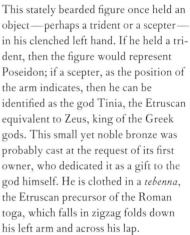

The rigid frontality of his pose and his advanced left leg are vestiges of the Archaic sculptural style, recalling the pose of a typical Greek kouros. Yet the relatively naturalistic treatment of the torso and face place this work stylistically in the early Classical period. This apparently odd juxtaposition of stylistic traits taken from the Greeks is in fact characteristic of Etruscan art in general. The figure may have come from the region of Piombino, in Tuscany; its hairstyle, musculature, and drapery closely resemble statues of male figures found there. It can be well contrasted to the Statuette of an Archer (see p. 130), which carries traits associated with Vulci, an even more prominent Etruscan bronze-casting center.

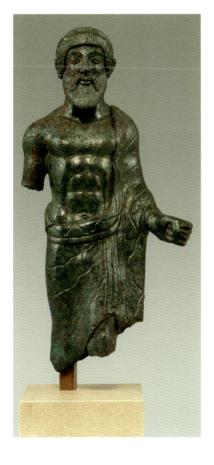

Candelabrum

Etruscan, 425-400 B.C. Bronze H: 112 cm (441/8 in.); DIAM (top): 21 cm (81/4 in.); DIAM (base): 27 cm (10 % in.) 90.AC.17

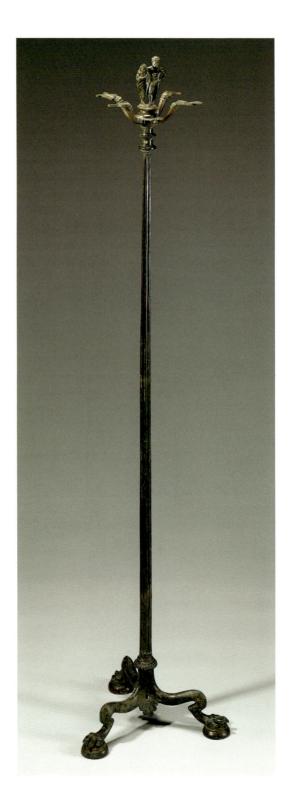

Tall, slender candelabra such as this were common items of furniture in the Etruscan world, where they frequently provided the only available light. Candles would have been attached to the four arms radiating from the top of this candelabrum's stand. Its height suggests that the three lion's paws serving as its base were meant to be placed on the ground rather than on a table.

Well known in antiquity for their skill in working bronze, the Etruscans often topped these practical objects with small, solid-cast figures, turning the whole into an object of art. This candelabra is topped with a satyr and a youth (detail below). The satyr's arm is placed familiarly around the shoulder of his companion, and the connection of the figures is further emphasized by the crown-like headpieces that both wear. Although at first glance this gesture may seem protective, the relaxed pose of the satyr seems at odds with such an interpretation. He stands comfortably with his weight on his left leg and his right knee bent, his left hand resting on his hip. The general composition is reminiscent of later, Hellenistic, sculptures depicting satyrs lasciviously sidling up next to handsome boys, but in this case the sexual element is completely lacking. A number of features point to a workshop in the famous Etruscan center of Vulci as a source for this piece: specifically, the animal paws used as supports and the palmettes that enliven the base of the shaft. The fine overall quality of the piece is also a clue, as is the incorporation of solid-cast figurines into an otherwise utilitarian object. The Etruscan archer on p. 130 is an earlier example of a very similar object and situation.

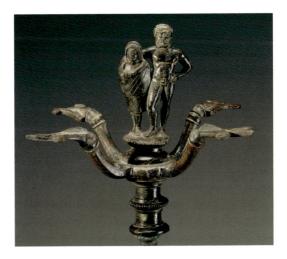

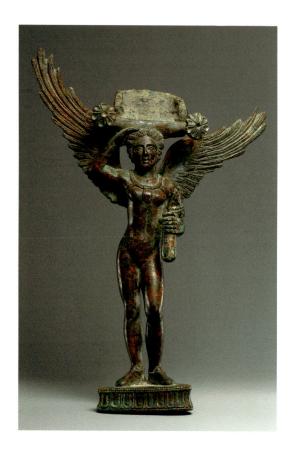

PATERA HANDLE
IN THE FORM OF
A NUDE WINGED
GIRL

Etruscan, 350—300 в.с. Bronze н (with base): 21 cm (8½ in.) 96.ас.34

Etruscans often used human figures as handles for vessels; this nude girl once served as the handle for a patera. She supported the edge of the dish on the top of her head, in a manner similar to ancient mirror handles. She stands on a triangular base with her left leg slightly advanced and her right arm raised, the hand resting on her head. She wears only a pair of soft slippers, a necklace, and, on her upper arm, a bracelet. The relaxed S-curve of the girl's body and her nudity belong to the style of fourthcentury-в.с. Greek sculpture. Unlike many Greek works, however, this figure is not depicted in the fleshy, sensual manner used for contemporary nude females; rather, the girl's lean muscularity echoes the aesthetic generally used for

figures of young men. The figure's nudity, her wings, and the perfume flask (alabastron) in her left hand suggest that she is Lasa, a polyvalent Etruscan divinity who corresponds to Greek nymphs and is frequently associated with Turan, the Etruscan goddess of love. Although her wings recall those of another Etruscan deity, Vanth, the two are distinct, for Vanth is always clothed and is a divinity of death and passage, while Lasa belongs to the world of life and love. Stylistic affinities of this Lasa with a winged figure serving as a handle on a cista from Praeneste (now in the Villa Giulia Museum in Rome) suggest that this figure may also have been manufactured in a workshop at that important Etruscan site.

STATUETTE OF A

Etruscan, 325–300 B.C. Bronze H: 19.7 cm (7³/₄ in.) 96.AB.35

This youth probably originally held either a votive offering or a piece of athletic equipment in his now-missing left hand. The inscription incised along the right side of the figure immediately marks the statuette as a votive object that was dedicated to a god. Translated from the Etruscan it reads: "Avle Havrnas gave this [for or in the] tuthina of the father to Selvans of the boundaries." The word tuthina probably refers to a rural area or village, and the family name Havrna is known from inscriptions incised on a set of banqueting vessels found in a tomb at Bolsena (in central Etruria southwest of Orvieto); those vessels are currently in the British Museum and Vatican collections. Selvans, an Etruscan deity associated with the protection of crops and field boundaries, was worshiped particularly in the area of Bolsena, where this statuette was therefore most likely originally dedicated.

The figure's proportions, with a relatively small head surmounting a lean and muscular frame, recall those of the

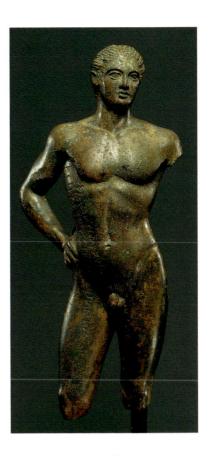

Statue of a Victorious Youth (see pp. 44-45). This type of athletic build was popular in Etruscan sculpture of the last quarter of the fourth century B.C. It differs from the Greek Polykleitan physique—as expressed in the Museum's Statue of Hercules (see pp. 160-161), a Roman copy after a Greek original to which sculptors a generation earlier had turned for inspiration. The rigid frontal pose earlier favored by the influential Classical Greek sculptor Polykleitos is in this figure replaced with an exaggerated S-curve that integrates the figure with the space around it by means of subtle twisting.

Votive Statuette of Hercle

Etruscan, 320–280 B.C. Bronze H: 24.3 cm (95% in.) 96.AB.36

Hercle is the immensely popular Etruscan version of the Greek hero Herakles. Of the many ways that Herakles could be represented, this type, with the lion's skin worn over the head and shoulders like an opera cape, originated in Archaic Cyprus and was actually more popular in outlying areas influenced by Greece, like Etruria, than it was in mainland Greece itself. The perked ears of the lion's skin and the way that it frames Hercle's face like a collar are typically Etruscan, as is the delight in textural embellishment, especially in the treatment of the lion's skin across the back. The type was especially popular during the age of Alexander the Great, when this statue was created. Alexander, who claimed Herakles as his ancestor, often had himself portrayed in the guise of the young hero. For that reason, the modeling of the figure, with broad faceted planes used for the muscles of legs and buttocks combined with anatomically detailed attention to the working of the torso, is similar to the style of Alexander's court sculptor Lysippos. The sculptural result is a powerfully modeled yet fluid and elongated figural type. This Hercle probably held the Apples of the Hesperides in his left hand. Representing the last of his Twelve Labors, the apples were proof that, despite his mature age, Hercle had completed his deeds and was now prepared to take on immortality, as suggested by his godlike physique.

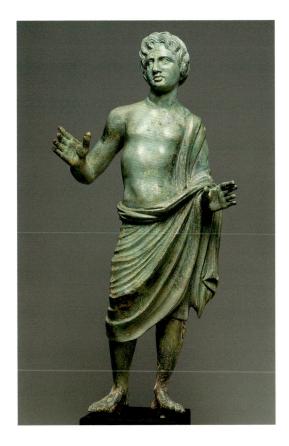

STATUETTE OF A MAN

Etruscan, circa 300–280 B.C. Bronze
H (without casting tangs):
31.6 cm (12 1/8 in.)
96.AB.37

This bronze figure powerfully evokes Etruscan history and style. The dynamic pose, with its sinuous torsion and shifting of weight, is typical for the Hellenistic period and is enhanced by arms raised in an *orans*, or praying position. The expressively modeled face twists to follow the lead of the gesturing right hand. The upturned eyes, furrowed brow, and wavy locks of hair are all traits consistent with portraits of Alexander the Great, who must have provided inspiration for the figure's head.

A votive inscription is engraved on the mantle in two parts. The first runs along the edge of the cloth from behind the left wrist and down: VEL MATUNAS TURCE (Vel Matunas dedicated); the other part follows the slanting folds of drapery across the buttocks: LUR: MITLA: CVERA (precious/sacred gift to Lur). Lur is the name of an Etruscan divinity, and Matunas is a noble South Etruscan family name, recorded both at Caere (modern Cerveteri, Italy) and Tarquinia. The letter forms, however, are typical for the region of Orvieto, the reported provenance of this piece. It is known that the federal sanctuary of the twelve Etruscan cities, the Fanum Voltumnae, was sited not far from Orvieto. There, the princes of Etruria would meet at regular intervals for common worship, political counsel, and the celebration of games. The universal prestige of this pan-Etruscan sanctuary may have led a South Etruscan prince to dedicate a statuette of himself in the likeness of Alexander the Great to a divinity of this region.

PONTIC BLACK-FIGURED AMPHORA

Attributed to the Tityos Painter Etruscan, circa 530-510 B.C. Terracotta H: 35 cm (13½ in.); DIAM (rim): 13 cm (5½ in.) 96.AE.139

Etruria was a very important market for Greek (especially Athenian) ceramics, which were prized both as objects in their own right and as aesthetic inspirations to Etruscan potters and painters. Pontic is the term given to the first Etruscan group of vases painted in the manner of Greek Archaic pottery, though the workshop seems to have been centered at Vulci. The Etruscans were infatuated with Greek myth. They were particularly fond of fantastic or gruesome stories, so this painting by the Tityos Painter of the beheading of the Gorgon Medusa is true to Etruscan taste. The Gorgons were the monstrous children of Phorkys, a hybrid son of the earth and the sea, and his sister Keto. The Greek hero Perseus eventually beheaded Medusa, whose gaze turned people to stone, and her sisters fled over the sea in fright.

As depicted on the side shown here, Medusa slumps in death at the right; Perseus has already fled the scene with her snaky-haired head in a sack. From Medusa's neck are born two winged horses—an Etruscan deviation from the standard Greek story in which the Giant Chrysaor and the winged horse Pegasos are the twin offspring. The enigmatic "dumbbell" objects carried by the enraged sisters are probably symbols of sacred magic power and strength. They are not typical Greek objects, but appear on other vases by the Tityos Painter, in sculpted form in Asia Minor (modern Turkey), and in several examples of Etruscan metalwork, hefted by boxers. Battling rams, a snarling lion and panther, and a deer grazing from a bush fill the lower frieze; on either side of the neck is a feline, heraldically composed of two profile bodies and one frontal head.

Caeretan Black-Figured Hydria

Attributed to the Eagle Painter
Etruscan (Caere), circa 525 B.C.
Terracotta
H: 44.6 cm (17% in.);
DIAM (body): 33.4 cm (13% in.)
83.AE.346

Etruria, the area in modern Italy between Florence and Rome, was an important market for Attic black-figured pottery in the sixth century B.C., and it is not surprising to find a few Greek potters and painters actually setting up workshops there. The workshop at Caere (modern Cerveteri, Italy) seems to have lasted only one generation, with most of the work the products of only two artists and their assistants. Some of the most original and lively compositions of the time came out of this workshop.

The most numerous products of the Caeretan workshop were painted hydriae, water jars with two horizontal handles for carrying and a vertical one for pour-

ing. On this as on other examples, the artist lavished attention and care on precise drawings of large plant ornaments, but the main focus is a snake with its multiple heads painted alternately red and black. The Hydra, as the monster is called, lived in the swamps of Lerna in the Peloponnese and was killed by Herakles. The hero can be seen to the right, attacking with his club and wearing a cuirass and greaves instead of his usual outfit, the lion's skin. As on the Museum's Corinthian Aryballos (see p. 55), a giant crab sides with the Hydra. Herakles, in turn, receives support from his nephew Iolaos, who is equipped with a sickle.

PAINTED Wall Panel

Etruscan, 520-510 B.C. Terracotta with pigment H: 88 cm (34½ in.); W: 52.5 cm (20½ in.); D: 4.5 cm (1½ in.) 96.AD.140

The Etruscans frequently decorated tombs, temples, and secular buildings with brightly painted panels and terracotta figures. On this panel, a poised and dignified youth carries a crooked stick with a forked top, a symbol indicating that he holds a specific office. The youth wears a light-colored tunic and a darker mantle with a decorated border. His figure is rendered in the composite manner characteristic of the late Archaic period, with his chest shown frontally and the rest of his body in profile. Forked staffs like the one depicted here seldom appear in Etruscan painting. In a scene of athletic competition in the Tomba delle Bighe in what is now Tarquinia, forked staffs are held by three men wearing bordered mantles who

address athletes. In painted representations on Greek vases, forked staffs are often held by officials charged with the education and training of athletes. Athletic competitions were frequently convened in honor of the dead, and a figure such as this was perhaps in a scene of an athletic competition that decorated the interior of a tomb. This piece may have come from Caere (modern Cerveteri, Italy), one of the principal cities of Etruria. It was undoubtedly once part of a larger scene: the frieze at the top of the panel is interrupted at both ends, and the youth looks back over his right shoulder toward the missing portion of the composition.

ANTEFIX IN THE FORM OF A MAENAD AND SATYR DANCING

Etruscan, 500–475 B.C. Terracotta H: 54.6 cm (21½ in.); W: 32.5 cm (12¼ in.); D: 16.5 cm (6½ in.) 96.AD.33

This lively couple from the retinue of Dionysos was formed as an antefix, one of many similar moldmade end tiles set along the roof edges of an Etruscan temple or civic building. As well as being decorative, such architectural terracottas served to cover and protect exposed wooden parts of the structure from the elements. It is one of the largest known examples of its type and is said to have come from Caere (modern Cerveteri, Italy). Identical terracotta figures, however, are known to have been made at Veii, in southeastern Etruria, and the type was perhaps invented there. Also, Etruscan terracotta craftsmen were itinerant, traveling widely with their molds to replace and restore temple decoration wherever they might be needed. The maenad holds castanets (krotala) and pulls her face back from the advances of her companion as she moves forward in rhythm with him. The bulging eyes, snub nose, and pointed horse's ears mark him as a satyr, an attendant of Dionysos. The drinking horn he holds evokes the god of wine and adds a sense of revelry to the scene. The antefix's exceptionally well preserved original pigments serve as a reminder that most ancient sculpture and much of the architecture were brightly painted.

PAIR OF DISK EARRINGS

Etruscan, circa 525–500 B.C. Gold DIAM: 4.8 cm (1% in.) 83.AM.2.1 The Etruscans are considered by many scholars to have been the finest goldsmiths in the ancient world. At the end of the Archaic period, when this pair of earrings was made, taste favored highly elaborate ornaments whose form followed Eastern models. The rosettes that make up these disk earrings are a good example, for the rosette is a typically Near Eastern motif. Goldsmiths responded to the demand for luxurious effects by refining their techniques. Three of the best known are used here: repoussé, filigree, and granulation. The tiny humanoid masks that fill the interstices of the small rosettes, each unique, are made by the traditional repoussé technique, where the sheets of gold are hammered into a mold to create the relief features, then finished from the front. Filigree, the manipulation and soldering of wires of gold, and granulation, the melting of small golden beads into patterns, are employed to further embellish the earrings. This pair of earrings was probably made in Caere (modern Cerveteri, Italy), a wealthy and cultured city on the western coast of Etruria. Caere's prosperity came from agriculture and trade with Greeks and Phoenicians, some of it in gold.

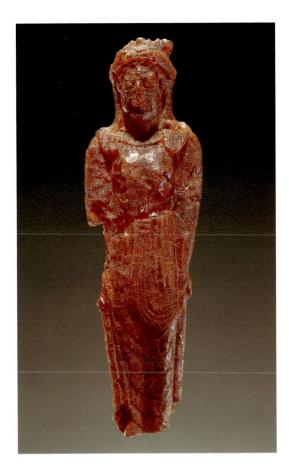

Pendant Carved as a Kore

Italic (South Italy) or Etruscan, circa 525–500 B.C. Amber H: 7 cm (2½ in.) 76.A0.77

This small pendant figure of a girl comes from southern Italy or Etruria, but was carved by a craftsman from the eastern Mediterranean, perhaps from Miletos. She stands facing frontally, with her left arm held stiffly, pulling her drapery to the side. Her right arm is lost below the elbow. Her eyes are shallow and were probably inlaid with another material that is now lost. Atop her head is a flange carved as a bead; the hole bored through the bead served as the pendant's suspension point. The girl's pose and clothing are characteristic of the kore figures created on the Greek islands during the Archaic period, about 700 to 480 B.C. (see p. 15). These figures are found

in larger scale in marble and terracotta throughout the Greek world and served both votive and funerary functions. The style of this kore's belted chiton, with its long overfold and vertical emphasis, her hair covering, and her facial characteristics compare most closely with marble kore sculptures from Miletos and Didyma, cities along the eastern Aegean Sea. In antiquity, this area was populated by migrants from the Greek mainland.

The pendant was probably made as a grave gift. Amber was believed to have regenerative powers and these, combined with the normal funerary or votive function of a kore, made it doubly acceptable as a gift for the deceased.

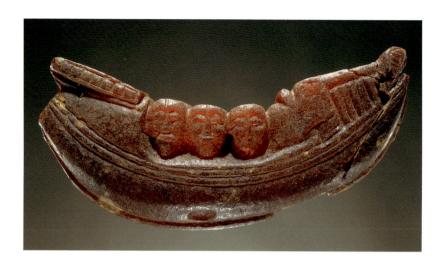

PENDANT CARVED AS A SHIP WITH PASSENGERS

Italic (South Italy) or Etruscan, 500–400 B.C. Amber
H: 4.5 cm (1½ in.);
L: 11.9 cm (4½ in.)
76.40.76

In antiquity, amber, the fossilized remains of tree sap, was considered a luxury material with special powers and purpose. Most of the ancient amber carved in the central and eastern Mediterranean is Baltic in origin, gathered on the shores of the Baltic Sea. It was traded as a commodity along the merchant routes from northern Europe southward, and its physical qualities and rarity made it a precious commodity in the Mediterranean. It was associated with the sun, fecundity, and regeneration. It was also believed to ward off evil and to guarantee a safe passage to the Underworld.

This curving piece of amber was worn as a pendant. There are multiple holes drilled on either side for attachment to another object, perhaps a pin or pectoral. The amber is carved as the curving body of a cargo or merchant ship. The ship is carefully rendered and details like the rails, aphlaston (terminal above the stern), and other ship's parts are incised into the material. No mast or sail is indicated, however, which suggests that the vessel sits at anchor rather than sailing the open sea.

The heads of three passengers peer over each side of the ship. A seventh head of a bearded man is carved in front of the stern castle; in front of him is a tied sack or some other cargo. It is tempting to identify this scene as one related to myth or epic. The sketchiness of the carving, however, makes it difficult to associate with any known imagery; it might be Odysseus and his men, or Jason and the Argonauts, or Theseus and his fellow Athenians sailing to Crete to face the Minotaur.

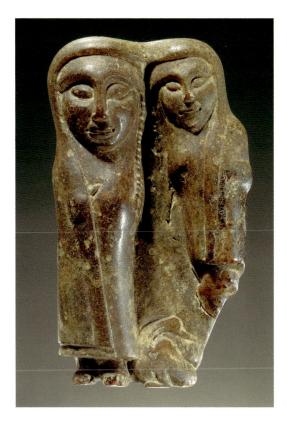

PENDANT CARVED AS TWO FIGURES AND A BIRD

Italic (South Italy) or Etruscan, 500–400 B.C. Amber H: 8.3 cm (3½ in.) 77.AO.85

Two female figures are carved side by side on this pendant. The woman on the left is larger and appears to be holding the smaller figure next to her. Both are enveloped in the same cloaklike garment, and their heads are at the same level. The difference in their sizes may indicate a difference in age; they might be mother and daughter, perhaps Demeter, goddess of vegetation and rebirth, and her daughter, Kore. As amber is associated with rebirth and regeneration, a depiction of Demeter carved in amber would be appropriate. Near the figures' feet sits a small waterfowl, perhaps an egret. If the two figures are deities, it is likely that the bird is their attribute; it is meant to help identify who they are.

In style, the pair compares most closely to Etruscan bronze votive statuettes

that depict cloaked women. The proportions, facial features, and costumes are all similar. What is dissimilar, however, is the way the two figures are grouped together and the presence of the bird with them. Images of gods defined by animal attributes are very rare in early Etruscan art, and it is possible that the pendant is not Etruscan but rather Italic, a product of the indigenous peoples of Italy who inhabited the regions south of Etruria.

STATUE OF
JUPITER
(THE MARBURY
HALL ZEUS)

Roman (Tivoli), A.D. 1–100 Marble H: 207 cm (81½ in.) 73.AA.32

Discovered in the 1700s in Italy, this colossal statue of the king of the gods, called Jupiter by the Romans and Zeus by the Greeks, probably once belonged to the emperor Hadrian (reigned A.D. 117–138), who had a villa very near the findspot. Seated on a throne, Jupiter originally held a scepter in his left hand and a thunderbolt in his right, symbolizing both his authority and the powerful natural forces at his command.

Although carved in a Roman workshop in the first century A.D., this image of Jupiter was inspired by a Greek sculpture of the 4008 B.C., the monumental gold and ivory statue of Zeus created by the sculptor Pheidias for Zeus's temple at Olympia. Pheidias's Zeus was a very famous statue in antiquity; as one of the Seven Wonders of the Ancient World, it was praised by many ancient writers and copied by numerous sculptors. At

12 meters (39.4 feet) high, the Greek statue was so large that the seated Zeus almost touched the ceiling of the temple, giving the impression that if he stood up he would go through the roof.

After this Roman Jupiter was discovered on the grounds of the Villa d'Este at Tivoli in Italy, it was used as the decorative centerpiece in one of the villa's elaborate fountains (as documented in an eighteenth-century etching). Subsequently, Gavin Hamilton, a well-known art dealer who obtained pieces of ancient sculpture for wealthy British collectors, sold the statue to James Hugh Smith Barry, who displayed it in his stately home, Marbury Hall, in Cheshire England. The antiquities in the Marbury Hall collection were eventually dispersed, and J. Paul Getty purchased the Jupiter in 1973.

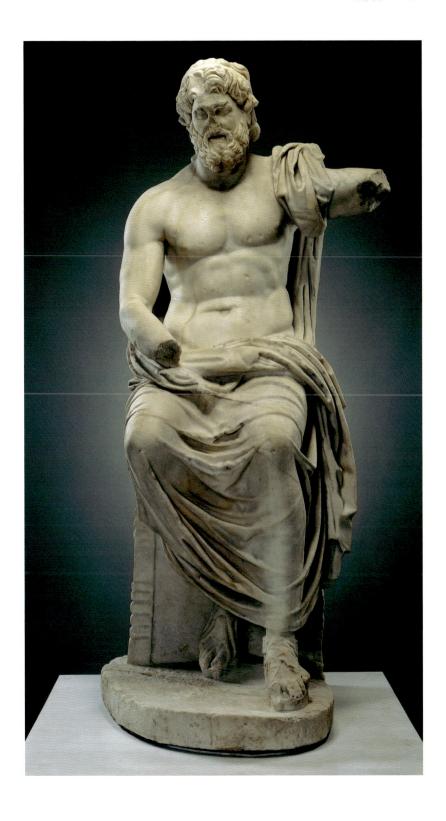

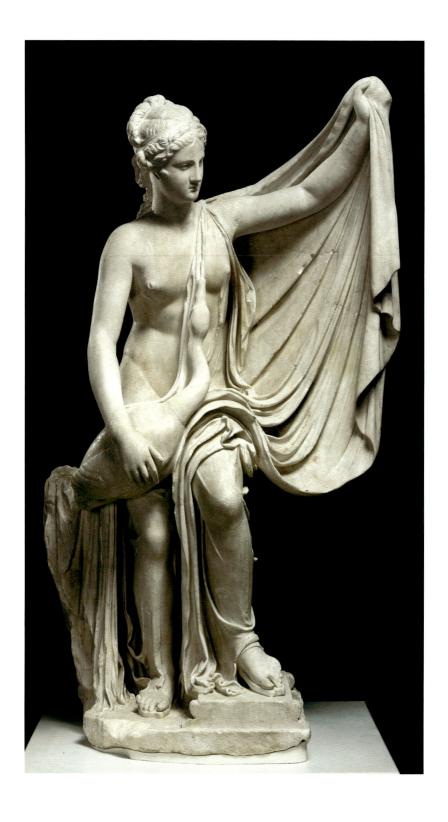

STATUE OF LEDA AND THE SWAN

Roman (Rome), A.D. 1–100 Marble H: 132.1 cm (52 in.) 70.AA.110

Greek mythology tells the story of Leda, a mortal woman and queen of Sparta, who caught the eye of Zeus, king of the gods. Zeus had frequent affairs with mortals but often had to disguise himself as an animal in order to avoid angry husbands and fathers. He appeared to Leda in the form of a swan. Here, she draws the amorous bird into her lap while she holds up a sheltering cloak. After the union, Leda laid two eggs: one bore the twins Helen and Klytaimnestra; the other produced the heroic horsemen Kastor and Polydeukes. Helen grew up to be a famous beauty and queen of Sparta. It was her abduction by a Trojan prince, Paris, that caused the war between Greece and Troy described by Homer in the Iliad.

Found in 1775 in Rome, this marble sculpture is a Roman version of an earlier Greek statue from the 3008 B.C.

attributed to the sculptor Timotheos. Over two dozen statues modeled on Timotheos's original survive, attesting to the theme's popularity among the Romans. The contrast of the clinging transparent drapery on Leda's torso, especially over her left breast, and the heavy folds of cloth bunched between her legs characterizes Timotheos's style. The statue both conceals and reveals the female body, a tension often found in fourth-century sculpture, before actual female nudity became acceptable.

After its discovery, the piece was extensively restored and reworked. Both arms, most of the outstretched cloak, the swan's head, and the folds of cloth between Leda's legs are eighteenth-century restorations. The head, though ancient, is not original to this work, but comes from a statue of Venus.

STATUE OF A COLLAPSING NIOBID

Roman, A.D. 1–100 Marble H: 146.6 cm (57½ in.) 72.AA.126

This fragmentary figure probably comes from a larger sculptural group that depicted the slaughter of the children of Niobe. Niobe, the daughter of King Tantalus of Sipylon and wife of Amphion of Thebes, had made the rash claim that she was as good a mother as Leto, the mother of the gods Apollo and Artemis. Niobe had given birth to fourteen children while Leto had only two. To retaliate for Niobe's act of hubris, Apollo and Artemis killed all of her children. Niobe was so grief-stricken at their deaths that she turned to stone.

This youth, one of Niobe's sons, has been hit with an arrow in his right shoulder blade. With his drapery wrapped around his lower legs, he collapses to his knees and reaches back to try to pull out the now-missing arrow (the hole for the arrow's insertion remains). Although the arms and head of the youth are now

missing, most of his left hand is preserved on his back.

The larger sculptural group of the Niobids was made in the first century B.C. and depicted the deaths of all the children. The earliest known sculpture of the scene was a relief frieze that decorated the throne of the ivory and gold cult statue of Zeus at Olympia. Created by the Greek sculptor Pheidias in the 430s B.C., the statue of Zeus was one of the Seven Wonders of the Ancient World. Pheidias's statue as well as related compositions, like the scene of Niobe's children, were frequently copied by later artists.

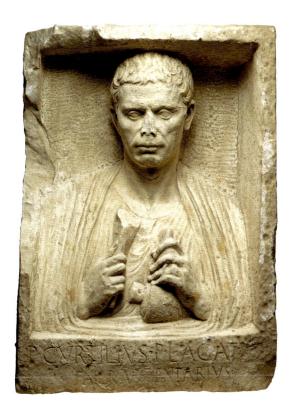

GRAVE RELIEF OF A SILVERSMITH

Roman, 1-25 A.D. Marble H: 79.9 cm (31½ in.); W: 58.5 cm (23 in.); D: 31.7 cm (12½ in.) 96.AA.40

As the Latin inscription P.CURTILIVS P.L. AGAT[US] FABER ARGENTARIVS on the bottom of this commemorative relief tells us, it was made for "P. Curtilius, freedman of Publius, silversmith." The subject is expressively depicted without idealization. His prominent cheekbones, sunken cheeks, slack jaw, and wrinkled neck reflect his age. The pride in his profession is shown not only by the inscription but also by the fact that he chose to be represented with his tools. He is shown using a chasing tool, in his left hand, and what is probably a mallet, in his right, to craft a small vessel. Remnants of lead on the top of the stone indicate that this piece was likely set into a larger architectural funerary monument. Such commemorative structures lined the roads out of Rome and other cities. In addition to being memorials, they also advertised the social and professional status of the deceased.

The class of freedmen, or libertini, was originally made up of freed slaves who were brought to Rome as captives in the second century B.C. Generally, they were educated and possessed valued skills that they could eventually exchange for their freedom. Although they were restricted by certain legal exclusions, such as not being allowed to place ancestral portraits in their household's shrines, and were for the most part less wealthy than the patricians, some were able to amass large fortunes. The Getty's silversmith proudly wears his toga on an expensive funerary monument that would stand as a tribute to the prosperity he achieved through his skill.

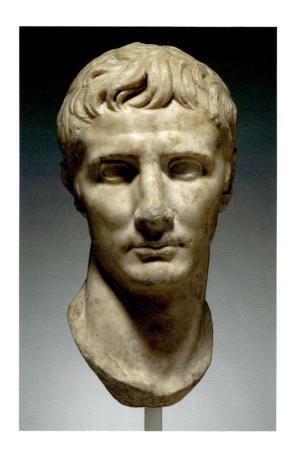

Portrait Head of Augustus

Roman, circa A.D. 50 Marble H: 39 cm (15¾ in.) 78.AA.261

The adopted son of Julius Caesar, Augustus became the first emperor of Rome in 27 B.C. During the new golden age of expansion, peace, and prosperity that followed a bloody civil war, many portraits of the emperor were erected in Rome and throughout the provinces. Augustus used art to help convey his political and social beliefs and to validate his claim to power. To contrast his rule from that of the earlier Roman Republican period, wherein age was emphasized in portraits, images of Augustus always depicted him as youthful, recalling Classical Greek sculpture from the fifth century B.C. Here, his face is smooth and idealized, with a broad cranium, narrow chin, almond-shaped

eyes, aquiline nose, sharply ridged eyebrows, and rounded mouth. His hairstyle is also an identifying feature in that the comma-shaped locks in the center of his forehead turn toward each other to form a pincer. The wide-open eyes and concave temples, however, are more consistent with images of the emperor Caligula (reigned A.D. 37–41) (see facing page) than those of Augustus, suggesting that this portrait may originally have been an image of Caligula that was recarved as Augustus after Caligula's death.

PORTRAIT HEAD

Roman, circa A.D. 40 Marble H: 43 cm (16⁷/₈ in.) 72.AA.155

The third Roman emperor, Gaius Julius Caesar Germanicus (reigned A.D. 37–41) was known more commonly as Caligula, a nickname meaning "little boots" that was given to him during his childhood when he accompanied his father, Germanicus, to a Roman military camp in Germany. An intellectual and a skilled orator with a passion for building projects (the reconstruction of the Theater of Pompey was one among many plans), Caligula has become infamous for his capricious cruelty and insistence upon self-deification. He was assassinated in A.D. 41 by members of his own guard.

This head was originally made to be inserted into a togatus statue, a traditional form of imperial portraiture with Etruscan ancestry (see also the statuette on p. 133). The original would have been a life-size figure dressed in a toga, the distinctive mark of a Roman citizen. Although ancient authors describe Caligula's physical presence in the most unflattering terms, mentioning his pallid complexion, hairy body, bald head, and sunken eyes, the appearance of this portrait is classically ideal, following the type set by the emperor Augustus (see facing page) that had become standard for depictions of members of the Julio-

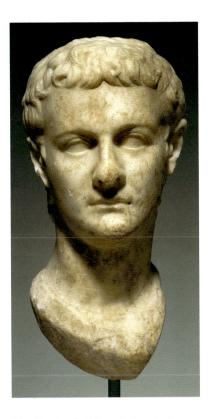

Claudian family. Nevertheless, it also incorporates Caligula's individual features, such as his high forehead, small thin mouth with drawn-in lower lip, and prominent chin. After Caligula's assassination, the Senate requested a damnatio memoriae (official damnation of his memory), by which all images and references to him would be destroyed. Even though Claudius, Caligula's uncle and successor, prevented the enactment of the damnatio memoriae, the memory of Caligula's reign was so repellent that many representations of and references to him were independently destroyed. Portraits are thus rare, and few survive from the city of Rome; this one came from a Roman outpost in Asia Minor (modern Turkey).

STATUETTE OF BACCHUS WITH AN ANIMAL

Roman, circa a.d. 50 Marble H (with plinth): 62.3 cm (24½ in.) 96.AA.211

This figure, easily identified by the wreath of grapes and ivy leaves circling his head, represents the god of wine, called Dionysos by the Greeks and Bacchus by the Romans. The small animal at his side, probably a goat, is symbolically associated with sexuality and emphasizes Bacchus's connection to the natural world and fertility. An Archaistic work, this delicately carved marble sculpture consciously mimics an earlier tradition without copying it exactly. The sculpture reflects specifically the Greek Hellenistic styles of Rhodes and Asia Minor, which themselves recalled the Greek Archaic period. The attentive rendering of the pleats of the figure's multilayered garments, the transparency of the drapery, and the "Archaic smile" are notable characteristics of Greek Archaic art. Yet many clues betray the figure's Roman origin. For example, the foamy appearance of the grapevine wreath was created by pinpoint drilling, a technique popular in Roman sculpture and not used by the Archaic Greeks. However, it is the selfconscious Mannerist style, with its combination of abstraction and naturalism, that most clearly evokes the Archaistic temperament of the figure. Careful attention has been paid to representing in a natural fashion the grapevine wreath and animal skin that Bacchus wears. But this is paired with a highly ornamental treatment of the zigzag folds of the mantle that falls over the figure's

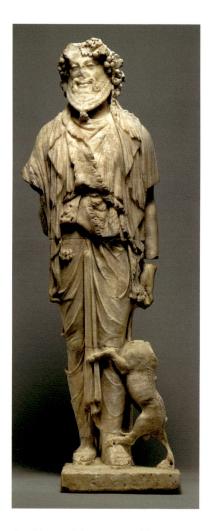

shoulders and the carving of the goat's fleece, most likely inspired by Persian Achaemenid metalwork. Far from simply copying earlier styles, Roman sculptors referenced the past as a way of adding venerability to an image. At the same time, they combined elements from different styles in an attempt to heighten the object's ornamental quality.

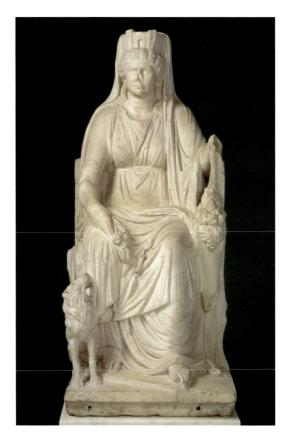

PORTRAIT STATUE OF a WOMAN AS CYBELE

Roman (Rome), circa A.D. 50 Marble H: 162 cm (63¾ in.); W: 70 cm (27½ in.) 57.AA.19

Seated on a throne, this life-size statue of a mature Roman woman is surrounded by emblems of the goddess Cybele: a crown of city walls, fruits and flowers, a tympanum (hand drum), and a lion. The cult of Cybele, also known as the Magna Mater, the great mother-goddess of Anatolia, was introduced to Rome in 204 B.C. at the conclusion of the Second Punic War. Cybele was a founder and protectress of cities, symbolized by the mural crown, and a mistress over wild animals, represented by the lion. Her devotees performed music and ecstatic dances, and so she holds a tympanum. Cybele acquired attributes of other divinities, represented here by a rudder from the goddess Fortuna, and a cornucopia, which was associated with a variety of deities and personifications responsible for agricultural abundance.

The cult of Cybele appealed especially to women, thus it is not surprising that a Roman matron would choose to represent herself in the guise of the goddess. The life-size enthroned statue identifies the subject as a woman of status and high position in Roman society, perhaps someone of imperial stature or a priestess of the goddess. In any case, the combination of a body that is soft, round, and voluptuous with a square face exhibiting a broad chin, firm mouth, and close-set eyes produces a portrait that embodies two traits desirable in Roman women: fecundity and dignity.

The back of the throne and the top of the head are not fully finished, suggesting a niche as the original setting for the statue.

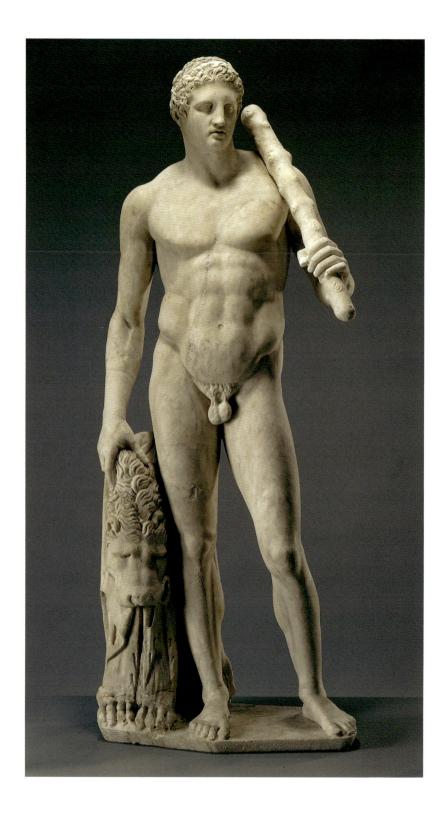

Statue of Hercules (The Lansdowne Herakles)

Roman (Tivoli), circa A.D. 125 Marble H: 193.5 cm (761/8 in.)

One of J. Paul Getty's most prized possessions, this statue of the hero Hercules inspired Mr. Getty to build his museum in Malibu in the style of an ancient Roman villa with a special room created for its display. Hercules (known as Herakles to the Greeks) was the son of Alcmene, a mortal woman, and Jupiter, the king of the Olympian gods. He is best known for the Twelve Labors he completed for King Eurystheus of the Greek city-state Argos. Hercules is frequently shown by ancient artists wearing or holding objects identified with these feats. Here he appears with a club and the skin of the Nemean Lion. which he killed as his first Labor.

Although carved in a Roman workshop in the second century A.D., this statue was very likely inspired by a nowlost Greek statue, probably produced

in the 300s B.C. by the followers of the influential Greek sculptor Polykleitos. As is typical for depictions of Greek heroes, the figure is shown nude, since the Greeks considered male nudity the highest form of beauty.

Found in 1790 near the ruins of the villa of the Roman emperor Hadrian (reigned A.D. 117–138) at Tivoli outside of Rome, this statue may have been one of numerous reproductions of Greek sculptures commissioned by Hadrian, who loved Greek culture. Shortly after its discovery, the statue was restored in Rome, possibly in the workshop of Bartolomeo Cavaceppi. In 1792, it was sold to the English aristocrat Lord Lansdowne, and it remained in the Lansdowne family until Mr. Getty purchased it in 1951.

STATUE OF APOLLO

Roman, A.D. 100–200 Marble H: 146.1 cm (57½ in.) 85.AA.108

Apollo, the patron god of musicians, physicians, oracles, and archers, is depicted here as a young man at rest, standing with his weight shifted onto his left leg. The god wears a cloak draped over his right shoulder, back, and left arm. Several parts of the statue are now missing, including the objects that he held, probably a bow and arrows. The haunches and feathers of the wings of a griffin, the mythical winged feline who often accompanied Apollo, remain at his feet.

The statue is carved in an Archaistic, or deliberately old-fashioned, manner. Although it was made in the 1008 A.D., it resembles statues from the early 4008 B.C. The rows of snail-like curls in the hair on Apollo's forehead are distinctive Archaistic features reproducing the

earlier fashion, yet the corkscrew curls falling in front of his ears clearly indicate a date during the reign of the Roman emperor Hadrian (A.D. 117–138). The Romans, like the Greeks before them, admired the art of earlier times. The use of an antique style lent a sense of venerability and tradition to an object, especially one associated with religion.

The back of the statue was carved with less care, indicating that the figure was originally placed against a wall or in a niche. Roman sculptors frequently chose not to complete the back of a sculpture if it was not meant to be seen. The under-life-size scale of the statue would have made it suitable for display in the private villa of a wealthy Roman.

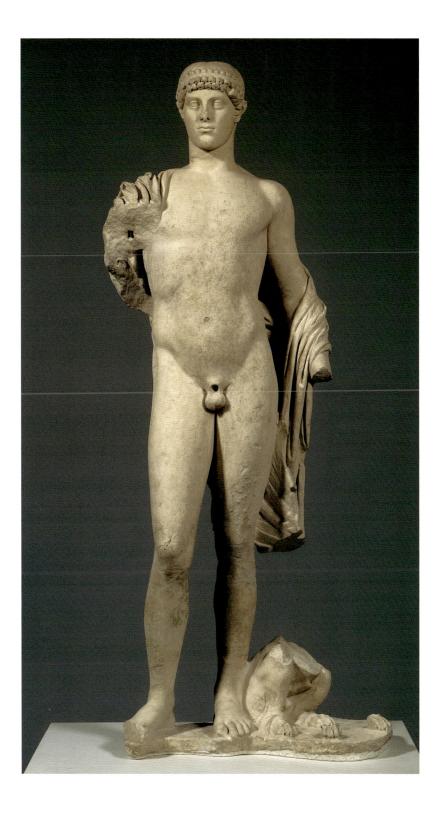

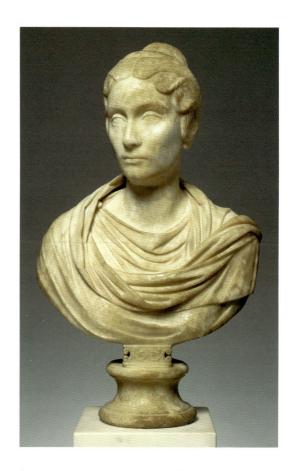

PORTRAIT BUST OF A WOMAN

Roman, A.D. 150–160 Marble H: 67.5 cm (26% in.) 83.AA.44

A quiet elegance radiates from this beautiful portrait of an unidentified Roman matron, carved from a single block of marble. Based upon stylistic evidence, it is possible to determine that she was sculpted during the Antonine period, a time known for widespread peace and prosperity, cultural expansion, and increased freedom for Roman women. The figure's elaborate coiffure is especially useful for dating the sculpture because individuals often followed the fashion trends set by Roman imperial family members. Private portraits of women sculpted during the Antonine period were thus greatly influenced by those of the empress Faustina the Elder, the wife of Antoninus Pius (reigned A.D. 138-161). Faustina wore a braided bun high on her head, as the Getty matron

does. Faustina the Younger's contribution to Roman fashion was undulating waves of hair surrounding the face, which have also been incorporated into this fine individualized portrait. The contrast seen here between the textural treatment of the hair and the highly polished surfaces of the sitter's face is also characteristic of Antonine portraiture.

Appropriately for a Roman matron, this woman wears a *stola* (a loose-fitting tunic), which is fastened with a circular brooch on the right shoulder area, and a *palla* (rectangular shawl). This bust may have been placed in the family's house as part of a shrine or it may have been incorporated into a family tomb. In either case, it was a lasting tribute to the character and image of this Roman lady.

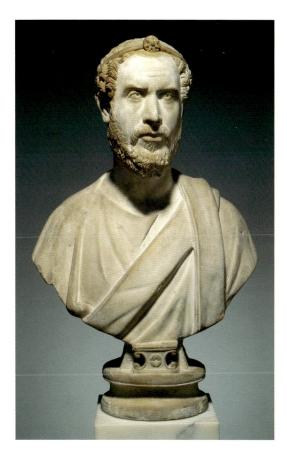

PORTRAIT BUST OF A MAN, PERHAPS A PRIEST OF SERAPIS

Romano-Egyptian, circa A.D. 180 Marble with traces of polychromy and gilding H: 79.5 cm (31 ½ in.) 71.AA.453

The once-gilded diadem encircling this man's head identifies him as a priest or devotee of the god Serapis. The cult of Serapis first appeared in Rome during the first century B.C., and by the time of Augustus it had become a dominant one. Serapis was a syncretic deity popularized by the descendants of Alexander the Great's general, Ptolemy, who ruled Egypt after the Greek empire was split following Alexander's death in 323 B.C. From the Greek pantheon, Serapis adopts features of both Zeus and Dionysos, who, according to Greek tradition, were the divine ancestors of the Ptolemies. The Egyptian culture contributed aspects of Osiris, who for the Egyptians was the father of every pharaoh, and the Apis bull. The complexity of Serapis's character is reflected in the many ways

he was addressed—king, god of the Underworld, savior, and even the greatest god. He exemplifies the many deities that, in combining elements of Greek and Egyptian religion, provided a common bond between native Egyptians and the growing Greek population in Egypt.

Usually portrayed with the basket-shaped *modius* atop his head and holding a cornucopia to show that he was linked with fertility (see pp. 224–225), Serapis was invoked for favors and blessings by the living. The deity logically appears as the companion of Isis, because Serapis is otherwise associated with Osiris, Isis's brother/husband. Traces of red pigment in the priest's hair and blue on his eyes are still visible and give a faint idea of the original bright appearance of this bust.

STATUE OF
A MUSE
(MELPOMENE
OR POLYHYMNIA)

Roman (Asia Minor), circa a.D. 200 Marble H: 97 cm (38¼ in.) 94.AA.22

As acolytes of Apollo, the nine Muses were patron deities of music, poetry, literature, and drama. In fact, the word "museum" denotes an institution suffused with their presence. They were extremely popular in Roman art because they bestowed kleos, or glory, upon the humans they favored. The Muses were often found on sarcophagi, where they connoted the spiritually elevated intellectual aspirations and associations of the deceased. This statue and three others in the Getty's collection, along with a statue of Tyche, goddess of fortune, now in the Museum of Fine Arts in Boston, are thought to have been from Kremna in Pisidia (southwestern Turkey), where they would have been located in a shrine for the cult of the Roman emperor. The fine quality of the carving, the scale, and the high polish

suggest that the group was carved at Aphrodisias (in modern Turkey), a leading sculpture-producing center of the Roman Empire.

Traces of paint on this figure's eyes and gilding in her hair show that color originally enlivened the entire surface of the sculpture. In art, the Muses are difficult to distinguish from one another; the characteristic "Leaning Muse" posture (well known from many examples) has been associated both with Polyhymnia, the Muse of hymns and pantomime, and with Melpomene, the Muse of tragedy. Ancient philosophers were often depicted in the same pose in order to associate themselves with the Muse's powers of contemplation. Here, those powers are conveyed by the figure's intense, otherworldly gaze and the way her chin rests on her fist.

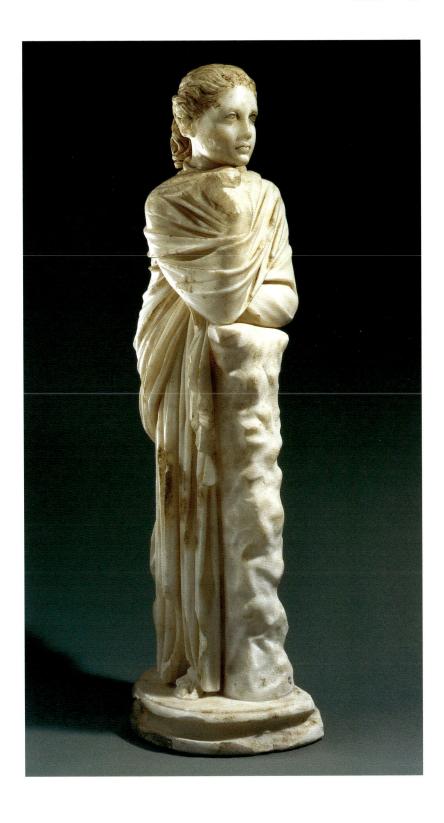

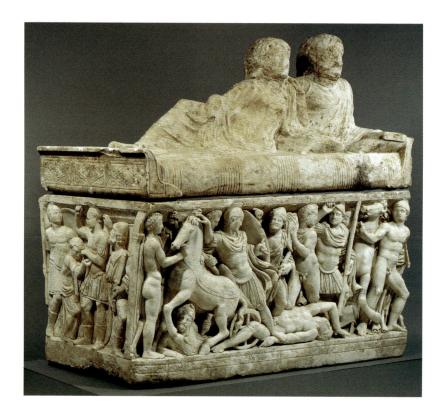

SARCOPHAGUS AND LID

Roman (Athens), circa A.D. 180–220 Marble H (box): 134 cm (53 in.); W (box): 147 cm (58 in.); L (box): 211 cm (83% in.);

H (lid): 100 cm (39½ in.); W (lid): 95 cm (37½ in.); L (lid): 218 cm (86 in.) 95.AA.80

Tales from the Trojan War cycle inspired the three scenes from Achilles' life that decorate this beautifully carved sarcophagus. The box's right end depicts Odysseus discovering the great Greek hero on the island of Skyros, where he was attempting to avoid his foretold fate of an early death in combat. Achilles' decision to accept his fate is shown on the box's left end (shown here), where he dons his armor with Odysseus's help. On the front of the sarcophagus (also shown), Achilles prepares to drag the dead Trojan hero, Hektor, behind his chariot around the walls of Troy. Achilles, showing his arrogance, steps on the body as he mounts the chariot. On the back of the box, Lapiths fight Centaurs. This may be a reference to Achilles' teacher, the Centaur Cheiron, or it may represent an allegorical image of the civilized Greeks as Lapiths versus the uncivilized Trojans as Centaurs. The lid takes the form of a kline, or couch-bed. The heads of two reclining figures are unfinished, as are other parts of the sarcophagus. These areas would not have been completed until the sarcophagus was sold, when portraits of the deceased then would have been carved.

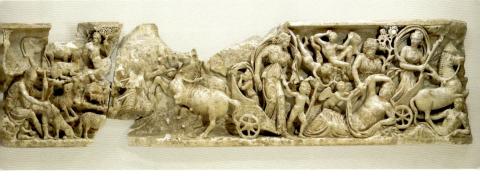

Front of a Sarcophagus WITH THE MYTH OF ENDYMION

Roman, circa A.D. 210 Marble H: 54 cm (21½ in.); L: 214 cm (84½ in.) 76.AA.8

This front panel fragment of a sarcophagus preserves two episodes from the story of Endymion and Selene. Selene, goddess of the moon, fell in love with Endymion, a beautiful young mortal. Jealous of their love, Zeus cast Endymion into an eternal sleep in a cave on Mount Latmus, where Selene visited him every night. The pastoral setting is indicated by the shepherd tending his flock (far left). Selene is in the center, identified by her crescent-moon headdress, alighting from the chariot that she uses to draw the moon across the sky. She is accompanied in her secret nighttime visit by erotes, who signify love. Her rearing horses are held by a winged figure, perhaps Aura, goddess of the wind. Endymion, shown in the pose of eternal sleep, his upper body slightly elevated and his right arm over his head, is uncovered by Eros, Aphrodite's son. Meanwhile, a standing figure, perhaps

Hypnos, god of sleep, pours a potion over Endymion in order to ensure his continued slumber. Because death was equated with eternal sleep, the myth of Endymion was considered particularly appropriate for decorating sarcophagi.

To the right, in a second scene, Selene remounts her chariot and is being carried back to the sky after the encounter. This method of linking a story's subsequent events, known as continuous narrative, is characteristically Roman. In this system, the same figures often appear over and over but in different scenes, showing the progression of a story in much the same way that a comic book does. Though very little of the two sides (and none of the back) of the original sarcophagus remains, a tree on the left edge and the hindquarters of an animal on the right indicate that bucolic scenes most likely continued on the other three panels.

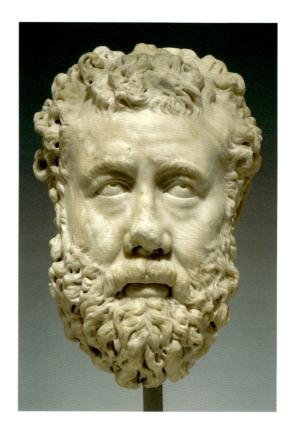

PORTRAIT HEAD OF A BEARDED MAN

Roman (perhaps Greece), A.D. 200–225 Pentelic marble H: 33.4 cm ($13^{1/8}$ in.) 90.AA.21

This portrait of an unknown, mature man, probably carved during Caracalla's reign (A.D. 198-217), exemplifies the often dynamic treatment of personal characteristics in portraiture of the early third century. Although the deeply drilled hair and beard recall similar features in the portraits of the emperor (as the next entry also does), the aging face—with the upward gaze beneath the furrowed brow and the sagging flesh under the eyes and on the cheeks-is distinctly individual. The delicately smooth modeling of its planes, creating the appearance of real musculature and bone beneath the flesh, stands out strongly against the rough contours and drillwork of the surrounding hair and beard. This deliberate contrast between light and dark, smooth and uneven is typical of the finest sculpture produced

during the Severan dynasty, which included the reigns of Caracalla and his father, Septimius Severus (reigned A.D. 193–211).

The world-weary, sad resignation of the man's overall expression suggests, with unusual emotional power, the feelings of tension and uncertainty to which the brutality of Caracalla's regime gave rise. This portrait is a profoundly moving document from an extraordinarily difficult period in Roman history and, although it has suffered some minor damage on the nose, it is amazingly well preserved for a sculpture of that turbulent time.

PORTRAIT BUST OF A BEARDED ROMAN

Roman, circa A.D. 215 Marble H: 61 cm (24 in.) 73.AA.42

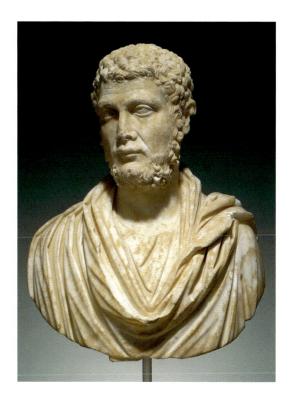

Portraits of Roman private individuals often follow the stylistic conventions of the leading contemporary public figures, such as emperors and their wives. With its subject's distinctive facial proportions and closely cropped hairstyle and beard, this bust not only emulates the physical aspects of the mature Caracalla (reigned A.D. 198–217) but also presents a somberness inspired by images of that emperor. Driven by his vision of Alexander the Great's genius, Caracalla was said to affect Alexander's intense, brooding facial expression, thus creating a look that became a part of his own iconography.

As on other portrait busts of the time, here the smooth surface of the skin contrasts with the rougher textures of hair and drapery (see also previous entry). The large eyes with deeply drilled crescent-shaped pupils placed high in the irises are also characteristic for the period. Their reflective upward glance combines with the man's pensive, firmly set lips to lend an air of psychological introspection to his appearance. The format of a Roman portrait bust favored at this date generally included the shoulders and chest of the sitter. Later the format would extend to include the waist as well.

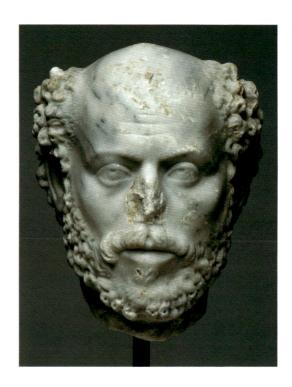

PORTRAIT HEAD OF A BALDING MAN

Roman (Asia Minor), circa A.D. 240 Marble H: 25.5 cm (10 in.) 85.AA.112

This Roman portrait depicts a mature man with an aging, lined brow and curly beard. His expression—characteristic of portraits from the third century, a time of much civil unrest in the Roman Empire—conveys a mood of concerned contemplation and a feeling of uncertainty. The description of Eastern ethnic types seen in later Roman portraiture is linked in this case to the origin of the striking blue-gray stone, which comes from a quarry in Asia Minor (modern Turkey). The head provides a strong contrast to the idealized, clean-shaven faces familiar from Julio-Claudian portraits (see the Portrait Head of Augustus, p. 156, and the Portrait Head of Caligula, p. 157).

This work clearly demonstrates the tradition of Roman realism, especially through particularizing details such as the prominent cheekbones, the overall asymmetry of the features, and the inclusion of a few strands of hair atop the man's otherwise bald head. These

characteristics are strikingly individual, introducing the viewer to a specific person from the past. However, although the subject of this portrait is individualized, the overall composition emphasizes certain standard components. The skillfully created contrast of texture between the highly polished, smooth skin of the man's face and the deeply drilled, undulating surface of his tightly curled hair accentuates the subject's baldness, the faint lines in his brow, and even his calm demeanor. All these elements were stock features in the portrayal of the Classical Greek intellectual. This adherence to a type is further evinced by the man's sunken cheeks, which recall the ascetic look of philosopher portraits of wellknown figures such as the Athenian orator Demosthenes. Altogether, this portrait reflects a careful selection of details that illustrate the inner character of the subject as much as his exterior, physical aspect.

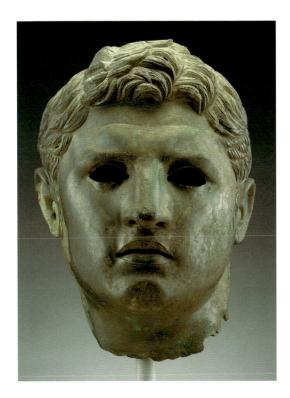

PORTRAIT HEAD OF A MAN

Roman (Asia Minor), 100-1 B.C. Bronze H: 29.5 cm (11½ in.) 73.AB.8

Both Greeks and Romans honored their military heroes, civic leaders, and other notable individuals with commemorative statues. While some sculptures may have been ordered by the honorees, others were commissioned by the subjects' friends or by the local communities in which they were to be erected. Yet, no matter how lifelike the statues may have been, even in ancient times inscriptions identifying the honorees would have been requisite for most viewers.

Once part of a full-size statue, this portrait, with its bulging brow and dense mass of coarsely worked short hair, presents a strikingly forceful, almost intimidating image of the subject, who has turned his head as if suddenly interrupted. In antiquity, when its inset eyes and the copper inlay on its lips were still intact, the portrait must have had an even more powerful impact.

Although it has no extant inscription, images on Roman coins suggest that this

portrait may represent the arrogant Roman general and dictator Lucius Cornelius Sulla (138-78 B.C.). Sulla demonstrated his ability to wage ruthless campaigns in Greece and Asia Minor, where this portrait is said to have been found, and to act equally brutally against his fellow Romans. However, close similarities to the earlier, idealized Hellenistic royal portraiture in the tradition of Alexander the Great, which stressed dynastic legitimacy and connections, make it likely that the portrait depicts a royal prince or local ruler of some eastern Mediterranean country, a man who probably had to establish and maintain his rule through power and force.

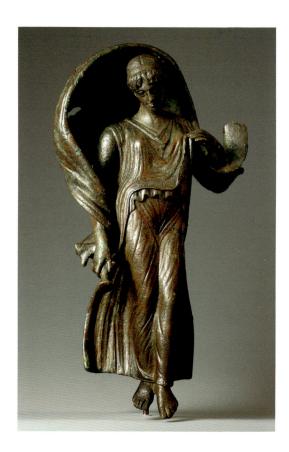

STATUETTE OF A WOMAN, PERHAPS NYX

Roman, 100-1 B.C. Bronze H: 25.4 cm (10 in.) 96.AB.38

The billowing, upswept mantle that arches over the head of this figure identifies her as a celestial creature. The position of her downturned feet, her downward gaze, and the manner in which her peplos clings to her figure and sweeps behind her suggest that she is descending from flight. She may be Nyx, the personification of night. The identity of the object she holds in her right hand is uncertain. It may be a stylized torch, an attribute normally associated with Nyx, or it may be an alabastron, a perfume vessel used here to scatter droplets of sleep on the slumbering world. An alternative identification for the figure would be the moon goddess, Selene, who is also often shown with billowing drapery. Because Selene usually wears a crown with a crescent moon, however, this identification is less likely.

The figure's details, such as the curling locks of hair on her forehead and, behind her headband, the fine lines of hair pulled back into a chignon, are carefully articulated. Her fine-boned face is delicately fashioned, as is her left hand, which gently pulls up the hem of her peplos's overfold. The drapery folds of her garment are carefully used to reveal and enhance her lithe figure. All of these features help to date the piece to the first century B.C., when the Roman world was embracing the arts of Classical Greece.

The function of the statuette remains unclear, but it may have been a decorative attachment for a household item, such as the base of a candelabrum. If she is Nyx, her presence on a lamp holder is more than appropriate.

STATUETTE OF ATHENA PROMACHOS

Roman, 50 B.C.–A.D. 25 Bronze H: 20.7 cm (81/8 in.) 96.AB.176

Athena Promachos forcefully strides forward in this Roman bronze statuette. The divinity, called Athena by the Greeks, Minerva by the Romans, was the virgin goddess of arts, crafts, and war. The word Promachos means "the first in battle," so here Athena is depicted as a warrior. Athena's protective aegis, bearing the head of the Gorgon Medusa, covers her chest and back to below her buttocks. Although originally described as a goatskin, here the patterning on the aegis resembles the scaliness of snakeskin. A griffin, a mythological creature known for its vigilance, crouches atop her helmet. The goddess holds her right arm up high to brandish a now-missing spear and has her left arm advanced to support a now-missing shield. Silver still embellishes Athena's eyes, the Gorgon's head, and the helmet's ornament, but the twenty silver snakes that originally decorated the edge of Athena's aegis are missing.

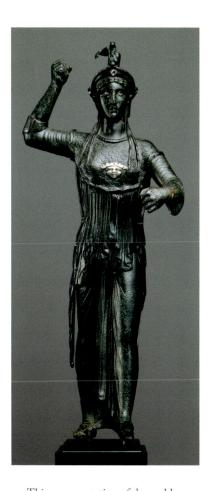

This representation of the goddess intentionally incorporates an Archaistic, or old-fashioned, style. It depicts a statue type, known in many versions, that probably emerged in the first century B.C., with stylistic traits based on a famed colossal statue of Athena Promachos created in the early 400s B.C. for the Acropolis in Athens. The Romans admired Greek sculpture and often produced works that resembled the earlier styles of the Greeks. Romans considered older images of deities, or at least images that looked older, to be more venerable. This statuette probably once occupied a spot in a wealthy Roman's personal household shrine as a protective deity for his family.

MINIATURE PORTRAIT BUST OF A YOUNG WOMAN

Roman, 25 B.C.-A.D. 25 Bronze with glass-paste inlays H: 16.5 cm (6½ in.) 84.AB.59

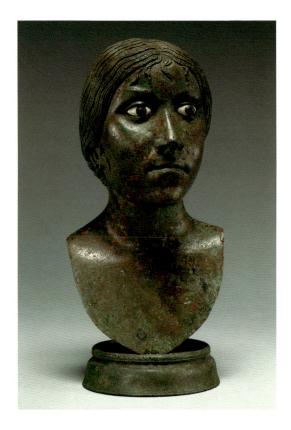

With great delicacy the sculptor has captured the portrait of a young woman. She is represented in the idealized Classical manner that was popular during the reign of the first emperor of Rome, Augustus (27 B.C.—A.D. 14). The glass-paste inlays used for her eyes are preserved here and make her expression strikingly realistic. Her complicated braided and knotted hairstyle was fashionable during the Augustan period, which favored a stylistic return to Greek classicism. Her earlobes were pierced to hold earrings that are now lost.

Numerous small-scale portraits of both the imperial family and ordinary Roman citizens were produced in many media throughout the Roman Empire, especially during the Julio-Claudian period (27 B.C.—A.D. 68). Most were intended for domestic settings. Pliny the Elder recounts the tradition of keeping these images in niches or shrines in order to record a family's genealogy as well as to commemorate its members' notable deeds. Thus, they were not only a tribute to one's ancestors but also a symbol of status for the owner. This portrait was most likely displayed in such a shrine in a Roman house.

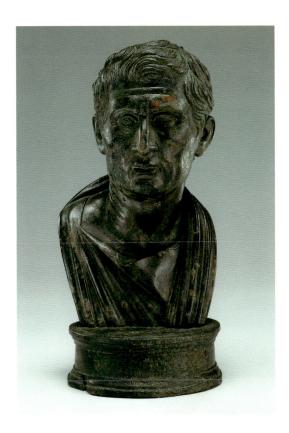

PORTRAIT BUST OF MENANDER

Roman, A.D. 1–25 Bronze H: 17 cm (6³/₄ in.) 72.AB.108

This handsome small bust is a Roman work based on a Greek seated statue, probably in bronze, that had been made in the third century B.C. by the sons of the famous sculptor Praxiteles. An inscribed marble portrait that was once in an English collection but whose whereabouts is not now known had long ago suggested the identification of about fifty portraits of the same subject. Only with the publication of this bronze and the faint inscription of a name in Greek (MENANΔPOC) on its base could the subject's identity be confirmed. It is Menander (342/341-291/290 B.C.), the prize-winning Greek author of more than one hundred comedies.

Born into a wealthy family, Menander learned his craft from an uncle. The welleducated, well-connected young playwright was said to be a handsome man who dressed stylishly and enjoyed a life of ease and luxury. Yet he chose to write in a relatively simple form of Greek more readily understood by a non-upper-class audience. Rather than recount traditional mythological subjects, Menander developed complicated plots, usually about young lovers, that reflected the dilemmas of daily life. After Menander's death, his plays continued to be staged at Athens in revivals. As a poet, he came to be regarded as second only to Homer. His works remained popular even later on in Roman times, when they were imitated and adapted by playwrights such as Plautus and Terence.

The outstanding craftsmanship of this small bronze is especially evident in the lively delineation of the hair, with its distinctive swirl over the forehead, and by the sensitive modeling of the face.

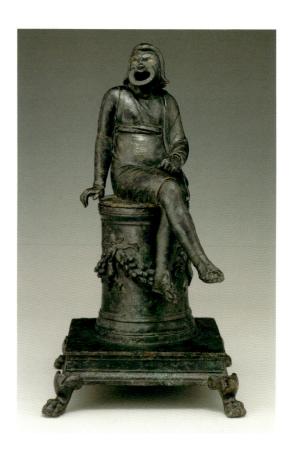

THYMIATERION

Roman, A.D. 1–50 Bronze with silver inlays H: 23.2 cm (91/8 in.) 87.AC.143.1

This thymiateron, or incense burner, takes the form of an actor wearing the garb and mask associated with productions of Greek New Comedy. His costume consists of a short tunic worn over long-sleeved, long-legged tights, a mantle, and sandals. The mask, with a knit brow over the silver-inlaid eyes, broad nose, and trumpetlike mouth all framed by a rolled arrangement of hair, is designed for comic effect and would have been used for the role of a leading slave. Seated on a round altar and leaning back on his right hand, the actor keeps his left hand in his lap. That hand is pierced to hold a detachable object, probably a wig to be employed in a plot involving disguises and mistaken identities. Following the tradition of Hellenistic art, comic actors portraying slaves

seated on altars became a familiar subject in Roman art. The motif was inspired by Greek and Roman comedies in which the characters seek sanctuary from their masters and revel in the knowledge that they can taunt them with impunity as long as they stay on the altar.

A trio of cupids holding garlands of fruit, grain, pine needles, and pinecones bound together with ribbons encircles the cylindrical altar that is fixed to a square, footed stand. The top of the altar is a lid that swivels aside on a single pin, and the bottom is perforated, allowing the smoke and fumes from burning incense to rise through the hollow body of the figure and emerge from the mouth. No doubt this thymiaterion formed a pair with the Museum's incense burner in the form of a singer (see next entry).

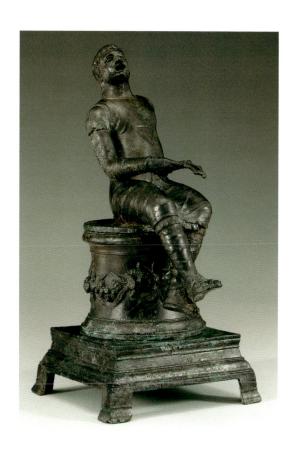

THYMIATERION

Roman, A.D. 1-50Bronze with silver inlays H: 19 cm ($7\frac{1}{2}$ in.) 87.AC.144

With his head thrown back and mouth opened wide, a singer performs while sitting on an altar. In a transposed, somewhat modified interpretation of the posture of the actor featured in its companion piece (see previous entry), this singer leans back on his left arm while holding in his right hand a sistrum, a rattle-like musical instrument, and crosses his legs at the ankle. Like the actor, he wears a style of dress identified with the theater—a sleeveless tunic that in this case is either fringed or worn over another finely pleated tunic, longsleeved, long-legged tights, and sandals. Unlike the actor, however, he has no mantle and, more significantly, no mask, suggesting that he does not play a speaking role but is a mime requiring neither mask nor special guise. Because the

sistrum is associated not with the theater but with Isis, a goddess of Egyptian origin whose cult became established throughout the Greek and Roman world, he may be portraying a chanting priest of Isis.

Resting upon the squarish platform and decorated with garlands of grain, fruit, and pinecones strung on bucrania (skulls of oxen), this altar resembles the one the actor uses. Like that thymiaterion, this statuette serves a practical as well as decorative purpose. It also has a swiveling top to allow the insertion of incense and ventilation holes in the bottom to provide the draft for burning it. The smoke and fragrance rising up through the figure's body would have curled out his mouth.

Head of the Young Bacchus

Roman, A.D. 1-50Bronze with silver inlays H: 21.6 cm (8½ in.) 96.AB.52

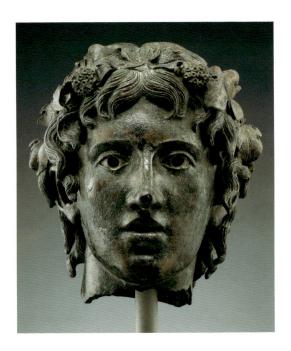

This beautifully wrought head represents the youthful god of wine and fertility, Bacchus (known to the Greeks as Dionysos). The wreath of twisted ivy entwined in his curling locks confirms his identity: ivy was associated with Bacchus because it is evergreen. The whites of his eyes are silvered, and his irises were once inlaid with colored stone or glass paste to create a startlingly realistic image. Holes preserved at the back of the eyes allowed for the attachment of the irises. The long, curling locks that hang down his neck were cast separately from the head and attached after casting.

The figure's fleshy cheeks, slightly tilted head, and wavy locks recall sculptures of the Classical period of Greek art, most notably the work of the sculptor Polykleitos. This style was especially popular in the Roman world during and after the reign of Augustus (27 B.C.-A.D. 14).

It is likely that this head was once attached to a full-length statue of the god. The piece may have served a purely decorative function as household ornament, or it may have been used as an elaborate lamp holder. Two statues of youths with a similar facial type that served as lamp holders were found in Pompeii; a third, which also wears an ivy wreath, was found in Morocco; and a fourth was found at Antequera (in modern Spain).

STATUE OF AN INFANT, PERHAPS CUPID

Roman, A.D. 1–50 Bronze with silver and copper H: 64 cm (25¹/₄ in.) 96.AB.53

Depicted as a chubby toddler, the subject of this bronze sculpture is not immediately clear because the attributes that the figure may have worn or was once carrying are now missing. Although in the visual arts a variety of gods and heroes were depicted as children, including Hercules (known to the Greeks as Herakles) and Bacchus (Dionysos to the Greeks), few appeared as frequently as Cupid. The identification of this figure as Cupid is plausibly suggested by the remains of metal attachments, poorly preserved on the back of the infant, that most likely were for fastening wings onto the body.

Here the god stands with his weight on his left leg, leaning a bit awkwardly, as one might expect for such a young child. Empty holes now mark the place where inset pupils of stone or glass paste once lay, lending an unfocused, almost dreamy quality to his gaze. The irises are silvered, and the figure once had silver teeth, both testaments to the fine quality of workmanship and detail lavished upon this sculpture. The wreath worn by the child incorporates leaves into a wrapped fillet that falls forward over his shoulders; the hanging ribbons

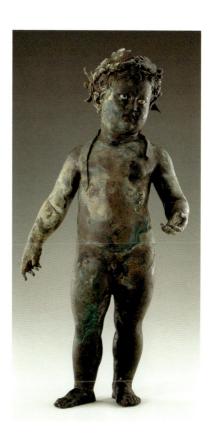

are made of hammered sheet-copper. The warmth of the copper complements the whitish silver used for the teeth and eyes. Although resembling vine leaves, which are typically found in depictions of Bacchus, the leaves and nuts on this wreath are those of a plane tree. The shade of such trees was a popular venue for philosophers and philosophical discourse, and the presence of such a wreath may allude to a philosophical association or setting for the statue.

Bronze statues such as this became popular in the gardens and courtyards of Roman houses, where they served a primarily decorative function. Such may have been the location of the Getty sculpture in its original setting: a villa, like the Villa dei Papiri at Herculaneum, which inspired the design of the Getty Villa in Malibu.

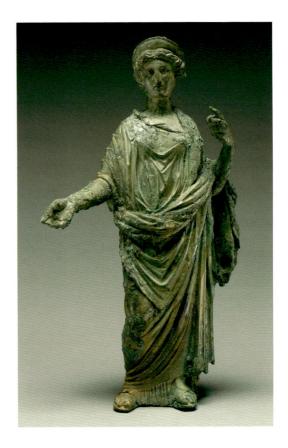

STATUETTE OF CERES OR JUNO

Roman, A.D. 50-75 Bronze H: 32 cm (12½ in.) 84.AB.670

With the long tunic and heavy mantle traditionally worn by Roman matrons, this bronze statuette could at first glance be regarded as the figure of a mere mortal, but the crescent-shaped diadem marks her as a deity. She stands with her left arm upraised and her right extended. The style is classicistic, reflecting a purely Greek form. The interpretation is thoroughly Roman, however, incorporating a mannered symmetry in the hair and folds of drapery together with a stolid, somewhat heavy gravity of facial features.

It is uncertain who this deity may be. Some divinities appearing on Roman coins are similarly attired and hold objects that specifically identify them, but this figure's identifying attributes have not survived. The position of the left hand indicates that it grasped a staff or some object with a long shaft; the open right hand held something smaller, perhaps a bowl or fruit. Comparable images on coins suggest the figure is most likely either Ceres, usually shown with a long torch or scepter in her left hand and stalks of wheat in her right, or Juno, who holds a staff in her left hand and a patera (offering dish) in the other.

The patina and modeling of this figure closely resembles that of the Statuette of Roma or Virtus (see next entry) and the Relief with Two Togate Magistrates (see p. 184), suggesting that all three were probably produced in the same workshop. The openings on their backs indicate that they were decorative attachments on some item, such as a large piece of furniture or a ceremonial wagon.

STATUETTE OF ROMA OR VIRTUS

Roman, A.D. 50-75 Bronze H: 33.1 cm (13 in.) 84.AB.671

With her pose, her helmet, and the short tunic that bares one breast in the style of an Amazon, this Roman figure possesses the monumental quality of life-size works and reflects the strong inspiration on Roman artisans of Greek Classical sculpture created centuries earlier by masters like Pheidias and Polykleitos. However, the Attic-type helmet she wears indicates that she is not an Amazon. Although the identifying attributes she once held are now missing, numismatic evidence indicates that the figure is either Roma, the personification of Rome and her Empire (and thus the most Roman of Roman images) or Virtus, the personification of valor.

Similar images, clearly identified by inscription, first occur on coins issued in A.D. 69 during the reign of the emperor Galba (A.D. 68–69). Like them, this figure once held a spear in her left hand. According to the parallel types on coins, if she were Roma, she would have supported in her right hand a small statue personifying victory. Virtus would have held a sheathed short sword with the handle directed outward and the tip

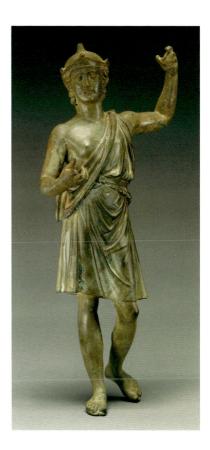

toward her waist. On monumental Roman historical reliefs, Roma often appears as the warrior goddess who accompanies emperors on formal occasions, such as their departure for battle and return from a successful campaign. Whether as goddess, personification, or symbol, Roma's image has persisted as one of the Western world's most long lived political-religious representations.

This figure, like the related ones of Ceres or Juno (see previous entry) and the togate magistrates (see p. 184), has an opening on its back where it can be attached to another object, perhaps a vehicle or piece of furniture.

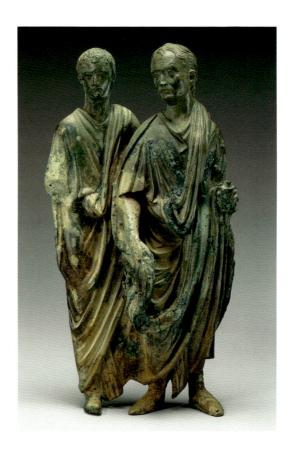

Relief with Two Togate Magistrates

Roman, A.D. 50-75 Bronze H: 26 cm (10 /4 in.) 85.AB.109

Although the detailed treatment of their faces and heads may seem to have been intended to represent specific individuals, it is more probable that the images of these two men are (in a Hellenistic convention continued by the Romans) depictions of generic, well-known types. Based on features associated with particular roles, these two figures could represent an aging intellectual and his younger attendant. Similar figures can be seen on the Ara Pietatis, a Roman marble relief of a procession dated to the same time, the mid-first century A.D.

Whether meant as particular individuals or not, the men's dignified style of dress, with the togas and shoes appropriate to patricians, leaves no doubt about their status as members of the upper class. The scroll held in his left hand implies that the older man may be

a civic official or priest participating in a solemn public ceremony, perhaps an event including a sacrifice or libation, to which both he and the younger man have turned their attention.

Because of its open back, this piece, like the Museum's statuettes of Ceres or Juno (see p. 182) and Roma or Virtus (see p. 183), must have been affixed to a commemorative monument of some type, but whether that was a trophy, an altar, a chariot, a funerary wagon, or even a piece of furniture cannot be ascertained. Clues to this bronze's date lie in the manner in which the togas are draped and the hairstyles, especially that of the older man, which find comparisons on representations from the time of Nero (reigned A.D. 54–68) in the later Julio-Claudian period.

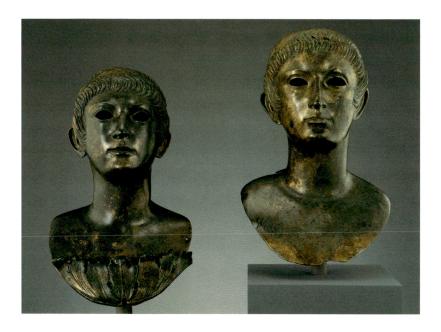

Pair of Portrait Busts

Roman (Gaul), A.D. 60-70 Bronze H: 40.6 cm (16 in.) 89.AB.67.1

H: 40 cm (15¾ in.) 89.AB.67.2 Although these two portraits seem almost identical, they were not produced from the same mold. One bust has a band of acanthus leaves affixed to the bottom, and the other one almost certainly had the same kind of floral element. The now-empty eye sockets of both portraits were once inlaid with realistic eyes fashioned from colored materials such as glass paste or marble. Only subtle differences distinguish the portraits from one another. For example, the wave of the hair across the forehead, a style popular during the reign of Nero (A.D. 54-68), shows minor variations in the arrangement of the locks, helping to impart an individuality, however slight, to each portrait. The portraits originally had long, separately made strands of hair affixed to the backs of their heads in a hairstyle associated with camilli, boys who served as assistants in the ritual sacrifices for various Roman cults. The same hairstyle also characterized tirones, special attendants in a military youth organization known as the Iuventus (Latin for "young men") that enjoyed favored status under Nero. The Iuventus prepared the aristocratic young men of Rome and its provinces for military service and subsequent government posts. Under Nero, it also formed an imperial honor guard.

The style of the busts and the emphasis on their frontal view, together with the simplistic treatment of the backs of the heads, suggest that they were made in the northern Roman province of Gaul, where they probably were displayed in a local shrine of the *Iuventus*.

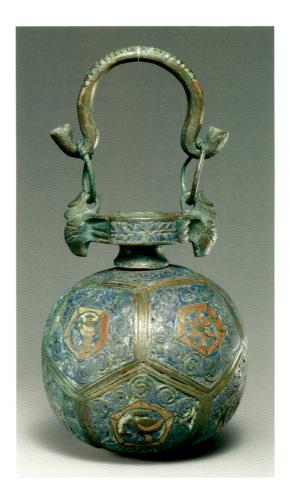

ARYBALLOS

Roman (Gaul), A.D. 70–100 Bronze with red and blue champlevé enamel H (without handle): 10.5 cm (41/8 in.) 96.AC.190

This heavy, round-bottomed vessel is shaped like an Archaic Greek aryballos (an unguentarium, or flask for holding oils or ointments), but the handle has a typically Roman imperial arrangement: its two elephant's-head protomes, missing their trunks, curve from the rim toward the bottom, surmounted by a pair of rings to which the handle is attached. The handle, held in place by loops of wire, has a pattern of enameled squares flanked by triangles. The top of the flask's rim is embellished with a row of alternating red and blue triangles and its side with a stylized laurel wreath. The body, made in four separate parts soldered together, is covered with a network of twelve pentagonal panels, each

of which has an inner border with a scroll on a blue enamel background, and red central pentagon enclosing a roundel. The roundels contain either a bird, a rosette, or a radiate crown of triangles. The serrated edges of the pentagonal fields allow better adherence between enamel and bronze.

This unguentarium resembles a number of related bronze vessels with champlevé enameling that have been ascribed to the northern reaches of the Roman province of Gaul, in what is today Belgium and north France. The closest parallels are a group of vessels deriving from a workshop that may have been at Anthée, near Namur in Belgium; it is possible that this aryballos was made there.

BUST OF A MAN

Roman (perhaps Spain),
A.D. 90–110
Bronze
H: 38 cm (15 in.)
85.AB.110

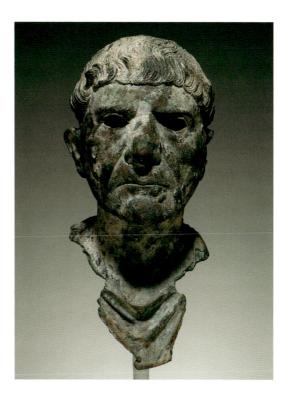

Embodied in this image and emphasized by the gaunt cheeks and thin, downturned lips are the qualities of gravitas (seriousness) and severitas (self-discipline) admired by the Roman people. The grim face conveying the personality and age of this man recalls the veristic, sometimes unflattering nature of Roman Republican portraiture that found renewed favor under the Flavian dynasty (A.D. 69-96). The arrangement of the hair follows a trend set by Nero (reigned A.D. 54-68), in which the locks are combed over the forehead in a parallel wave pattern, but comparable styles also appear on portraiture from the time of Trajan (reigned A.D. 98-117). The sitter bears a resemblance to images on coins and to some life-size portraits that have been identified as Trajan's father, a Spaniard who had distinguished military and civil careers and died in A.D. 100.

Rome's involvement in the Iberian Peninsula began in the third century B.C. when the Romans fought the first of the Punic Wars against the Carthaginians of North Africa. In 206 B.C. the Carthaginians were driven out of Spain, and by 19 B.C. the entire peninsula was under Roman control. It provided the first two non-Italian-born Roman emperors, Trajan and his adopted heir to the throne, Hadrian (reigned A.D. 117–138).

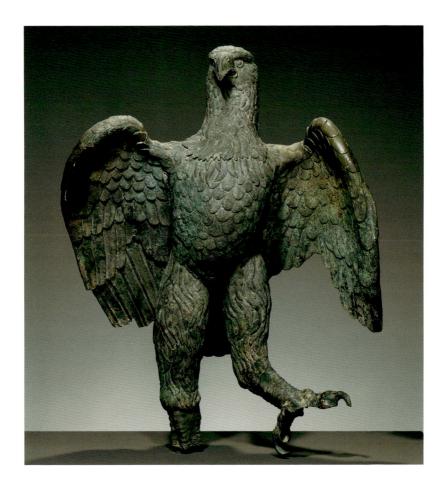

STATUE OF AN EAGLE

Roman (Asia Minor),
A.D. 100–300
Bronze
H: 104.2 cm (41 in.);
W: 78.7 cm (31 in.)
72.AB.151

Staring ahead with a penetrating gaze, this eagle creates an imposing image. Its large hooked beak appears sharp enough to easily rip the flesh of its prey. Each feather covering the eagle's body is carefully detailed, with individual barbs incised. Its outstretched wings suggest that the raptor has just landed on its perch.

As companion and attribute of Jupiter, king of the gods, the eagle was an important symbol in Roman culture. Eagles represented victory and military might. The bird also symbolized the deification of the emperor, and an eagle was often released during an emperor's funeral to represent the ruler's spirit ascending to the gods. A large and independent sculpture of an eagle, such as this one, is rare in Roman art. Its raised left claw may have rested on a globe or thunderbolt, other emblems of Jupiter.

STATUETTE OF MARS/COBANNUS

Roman (Gaul), A.D. 125–175 Bronze H: 76 cm (29% in.) 96.AB.54

Unusual in its size, style, and the excellence of its craftsmanship, this dedication was clearly a valuable commission for an important cult shrine. The base of the statuette is inscribed in Latin:

AVG[vsto] SACR[vm] DEO COBANNO
/ L[vcivs] MACCIVS AETERNVS /

IIVIR EX VOTO (Sacred to the venerable god Cobannus, Lucius Maccius Aeternus,

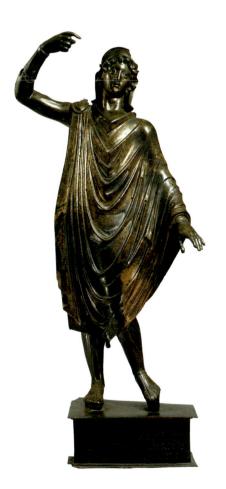

duumvir, [dedicated this] in accordance with a vow.) Several other important bronze objects were discovered together with this work, including two portrait busts and two additional statuettes also dedicated to Cobannus. The name of the god is rarely attested elsewhere, making this find particularly important for the study of religion in the Roman Empire. The family of Aeternus, on the other hand, is known from other inscriptions, and Lucius Maccius himself was clearly of high standing, as indicated by his title of duumvir, one of the two chief magistrates of a Roman colony.

Cobannus appears to have been a deity local to Gaul (modern France) who was identified with Mars, Roman god of war. The helmet on the figure's head as well as his pose—with the right arm bent and raised, the left arm extending slightly forward—recalls Roman representations of Mars. On the basis of such images, the Getty's statuette is most likely to have held a staff or spear in his right hand while grasping the top edge of a shield with his left. In many other details, however, this figure differs from Roman works. For example, his cloak, long-sleeved tunic, and leggings reflect the local dress of the northern Roman provinces rather than typical Roman military clothing. His helmet, instead of being a typically Greek version appropriate for a god associated with Mars, conforms to a specific style worn by Roman legionaries; it helps date this piece to the mid-second century A.D. Because a number of Gallic deities were assimilated by Mars, each with its own characteristics, the unusual features of this figure may have been meant to convey specific qualities of the god rather than simply to differentiate Cobannus from his Roman counterpart.

STATUETTE OF JUPITER

Roman, A.D. 100–200 Bronze H: 30.5 cm (12 in.) 96.AB.42

The production of this statuette in the second century A.D. demonstrates the longevity of certain figural types throughout antiquity. The original model for the image is believed to be a life-size bronze statue of Zeus, the Greek equivalent of the Roman Jupiter, from the fourth century B.C. by the Greek sculptor Leochares; in 22 B.C., three-and-a-half centuries after its creation, the sculpture was taken to Rome and installed as the cult statue in the newly inaugurated temple to Jupiter on the Capitoline hill. This statuette represents Jupiter Tonans (Jupiter the Thunderer), who once held a thunderbolt in his right hand while leaning on an upright scepternow missing—in his left. Because of the renown of Leochares' sculpture, the image was very popular and often copied. As a result, the type inherited many innovative details during its long history. The Getty's statuette displays an intriguing combination of Hellenistic and Roman characteristics, including the typically Hellenistic exaggerated rendering of the musculature and the symmetrical arrangement of the beard and hair, which deliberately imitates Greek Archaic art. The long, curling moustache, for example, is very close to that of an Archaistic Roman sculpture also in the Getty collection, the Statuette of Bacchus with an Animal (see p. 158).

The image of Jupiter Tonans became common in certain areas of the empire, including Gaul (modern France), where this statuette is said to have been found. The large size of the work and its derivation from a cult image in a major temple endow it with religious significance; it may have served as a devotional image in a household shrine. The sheer number of versions of Jupiter Tonans figures that have survived from antiquity — more than one hundred are known — indicates that they may have been used as votive objects offered as dedications to the god.

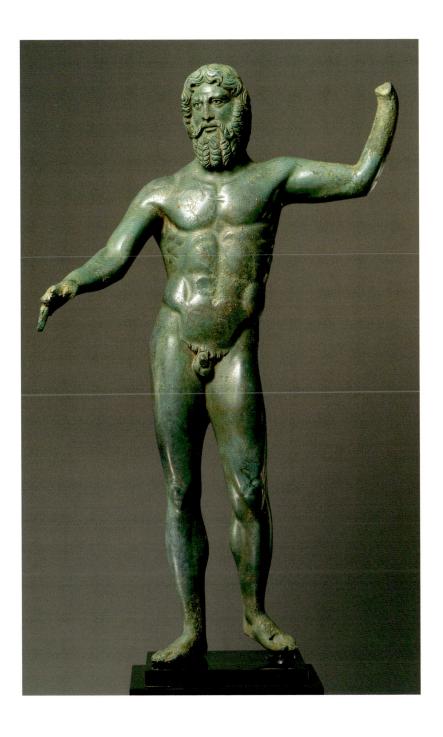

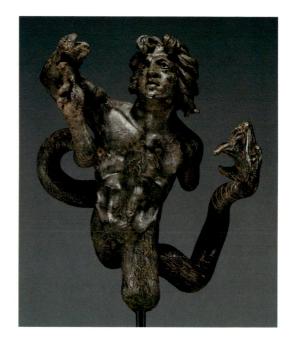

STATUETTE OF A SNAKE-LEGGED GIANT

Roman, A.D. 180–220 Bronze H: 14 cm (5½ in.); W: 12.5 cm (4½ in.); D: 7 cm (2½ in.)

The Giants were a mythological race of monsters who were overthrown by the gods, the children of Kronos and Rhea. The battle between the gods and Giants, known as the Gigantomachy, was an artistic theme that became popular during the fifth century B.C. It was seen as a metaphor for the contest between civilization (represented by the gods) and barbarity (represented by the Giants), and its popularity continued into the Roman period. The best-known representation of this combat is the Hellenistic relief frieze from the Great Altar of Zeus at Pergamon (now in the Pergamon Museum in Berlin).

This Giant's inhuman nature is clearly evident in his legs, which are formed as writhing snakes with large, gaping, fanged mouths. If his snaky legs aren't enough, the whorls of hair on his chest and shoulders and the wild unkempt hair on his head provide other clues to his bestiality. The Giant is depicted in the midst of combat with a now-missing foe. He falls forward with his right arm

held up over his head in a position of defense. Parts of his right hand and lower arm are missing, perhaps because the molten bronze did not completely fill the mold when the figure was made. His lower left arm is also missing; it may have been cast separately and attached to the figure.

This statuette was once part of a composition that depicted either a single combat between the Giant and a god, or a larger group with many figures. Such multi-figured groups were often used in Hellenistic and Roman times to decorate furnishings, such as the bases of candelabra; they were also mounted on ceremonial vehicles such as chariots or wagons. The Greek letter kappa incised on this Giant's left buttock may have been a mark to indicate the figure's original placement within a composition. Another small statuette of a Giant in the Museum's collection (see p. 46) was probably once similarly incorporated into a larger group arrangement.

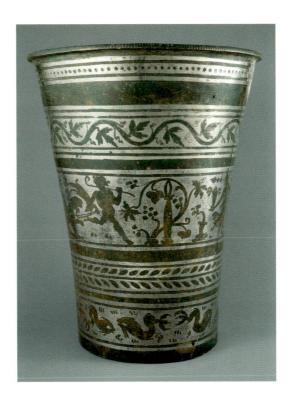

SITULA

Roman, A.D. 220-320 Bronze with tin plating H: 33.5 cm (13½ in.); DIAM (rim): 27.2 cm (10½ in.) 96.AC.55

This elegant vessel once had a swinging handle and served as a situla, or bucket. The shape derives from the Greek kalathos, a tall, flaring basket. In both the Greek and Roman worlds, these types of baskets had many uses, but were especially associated with woolworking and the harvest. The lively decoration of the vessel was achieved by the application of tin onto the surface of the bronze. The various designs were cut out of the tin plating and thus appear reserved against the background, thereby creating contrasting color effects. This technique is very unusual and is known in only a few preserved examples. The place of manufacture of the situla remains uncertain, but the closest parallels come from the area of modern Switzerland and southern Germany.

The animated figures and floral ornaments were enhanced by the detailed use of incised lines and small dots. The

five decorated rows, which alternate with plain tin stripes, comprise (from the top) disks, a grapevine, Bacchus (Roman god of wine) and his retinue, laurel leaves, and dolphins swimming amid stylized waves. In the main frieze, the god, holding a thyrsos (a wand wreathed in ivy and vine-leaves with a pinecone at the top) and large drinking vessel, reclines on a chariot drawn by panthers, one of which is ridden by Cupid, Roman god of love. A nude young satyr with a shepherd's staff leads the group. The figures that follow the chariot include a chubby little old silenos playing a lyre, goat-legged Pan playing his pipes, and a maenad. The latter holds a thyrsos, like Bacchus. The grape-filled kalathos the maenad holds in her right hand is remarkably similar to the shape of this vessel itself.

FOLDING TRIPOD

Roman, A.D. 250-300 Bronze H: 106 cm (41¹/₄ in.) 96.Ac.203

Tripods like this one were used to hold basins in which burnt sacrifices and libations were offered to the gods. This tripod's folding legs, which made it portable, are decorated on top with a narrative showing the life cycle of a horse. The horses stand on flat plates from which project L-shaped hooks that supported the now-lost cauldron. In a vignette representing infancy, a mare suckles her foal. A bridled stallion energetically rearing beside a small tree characterizes the prime of life. Old age is embodied in the last depiction, where an aged stallion with weakened legs

and a bell around his neck gently lowers his head to drink from a kantharos. This drinking cup may represent a victory prize or, because it is a shape often associated with Bacchus (a divinity connected not only with wine but also the afterlife), allude to the Bacchic paradise that followed this life. One of the tripod's legs has a semicircular projection that is decorated with a protome of a snarling panther. When the tripod was folded, this projection served as the carrying handle; when the tripod was open, utensils could be suspended from it.

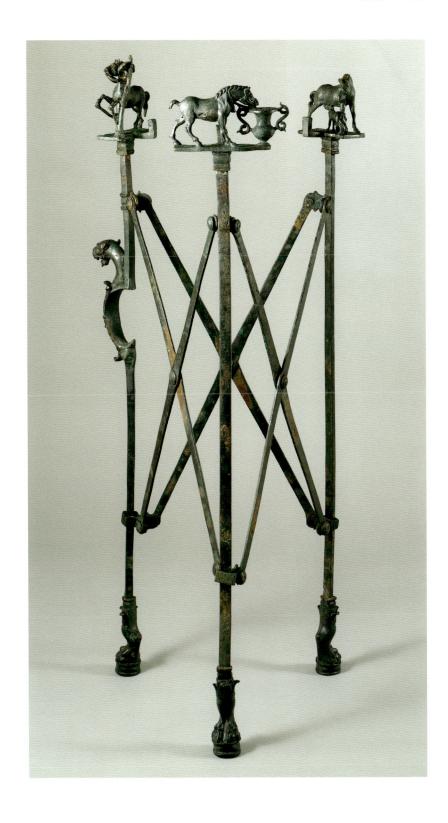

STATUETTE OF A BULL

Roman (Pompeii), 100 B.C.-A.D. 75 Silver with gilding H: 14 cm (5½ in.)

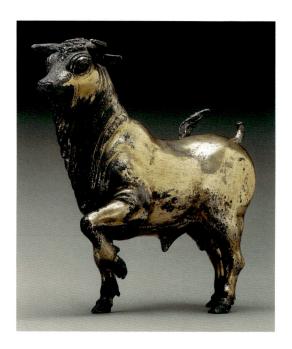

Discovered in Pompeii between 1780 and 1790, this statuette of a powerfully modeled bull became part of the collection of Maria Christina of Savoy, the queen of the kingdom of the Two Sicilies. The statuette originally belonged to a Pompeiian family who perished during the eruptions of Mount Vesuvius in A.D. 79. As Pompeii was being freed from its covering of ash and volcanic debris in the eighteenth century, many precious objects, such as this bull, came to light in almost perfectly preserved condition. This figure was cast in silver and then coated with gold, a luxury object indicative of its original owner's social status and wealth.

The bull would have stood with other statuettes of gods, goddesses, and divinities in a domestic shrine (lararium), where it would have been an object of devotion and veneration by household members. The animal probably represents the king of the gods, Jupiter, who often took the guise of a bull in mythological legends. The bull's sculptor has modeled its anatomy in a naturalistic manner. For example, the loose skin under the animal's neck is carved as a series of pliant folds. The horns curve forward above the ears and the eyes have incised pupils, irises, and lashes. The beast stands erect with one leg cocked, tail curled up onto its flank, and head raised as if catching the scent of a potential foe. The bull embodies the strength and power inherent in the mightiest of all the gods, Jupiter.

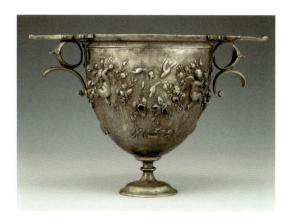

PAIR OF CUPS

Roman, 50-25 B.C. Silver H: 12.4 cm (4% in.); DIAM: 11.2 cm (4% in.) 75.AM.54

H: 12.3 cm (4⁷/₈ in.); DIAM: 11.6 cm (4⁵/₈ in.) 75.AM.55

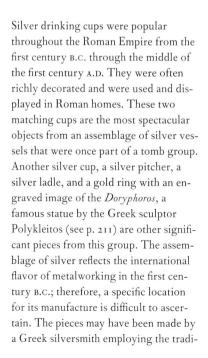

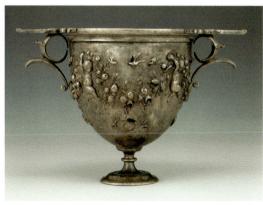

tions of Asia Minor (modern Turkey), or they may have been made in Asia Minor itself, perhaps at Pergamon, Ephesos, or Antioch.

On each of these cups, four flying cupids support a continuous garland tightly bound with taeniae (fillets). Intertwined in the garlands are pomegranates, apples, grapes, olives, pinecones, and acorns. Birds fly above the garlands; below them, various objects, including a tympanum (drum), a cista (basket), cymbals, and pipes, decorate the cups. The iconography is somewhat enigmatic because the motif of garlandbearing cupids survives from the art of Pergamon as well as Pompeii, where Second Style wall paintings (popular in the first century B.C.) show cupids accompanied by birds and musical instruments.

BOWL WITH CRANES

Roman (Alexandria), circa 25-1 B.C.
Silver
H: 7-3 cm (2½ in.);
DIAM: 10-3 cm (4 in.)
72-AM.33

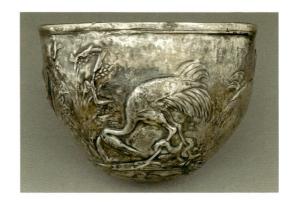

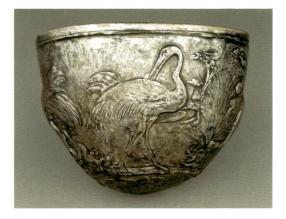

This silver bowl is decorated in relief with four cranes in a landscape teeming with animal life and opulently stylized vegetation. The artist has captured the cranes in a variety of poses that convey their natural habitat and actions. The crane shown in the upper photo battles with a snake that has entwined itself around the bird's legs. The one in the lower photo preens its feathers, gracefully turning its head to reach its back.

The motif of cranes set into a landscape was a popular decoration on cups during the early Augustan period at the end of the first century B.C. The combination of naturalism and ornamentalism on this cup suggests that a talented silversmith in Alexandria, Egypt, probably made it. Ancient marks on the cup's surface indicate the former presence of handles and a foot that are now missing.

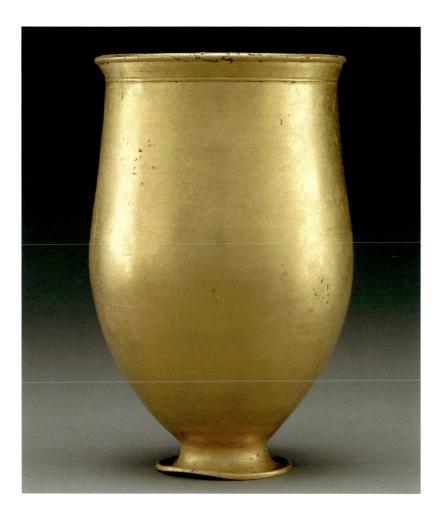

BEAKER

Roman, A.D. 1–100 Gold H: 13.7 cm (5 % in.) 2001.6 This beaker is one of only six Roman gold vessels known to have survived from antiquity. Its deep, subtly convex body rises from a small flanged foot and ends in a slightly flared rim. The only decorative embellishments to the elegant profile are two incised lines below the rim. An abbreviated dotted Latin inscription on the underside of the flanged foot records the vessel's weight as two libra, one *sescuncia*—the equivalent of 24.54 ounces. The actual weight of the vessel is 23.15 ounces, and the difference between the inscribed weight and actual weight may indicate that the vessel once had a lid.

Unlike their counterparts in silver (see the cups on p. 197 and the bowl on the facing page), glass (see pp. 205 and 206), and precious stones, the six surviving Roman gold vessels are not decorated with relief designs.

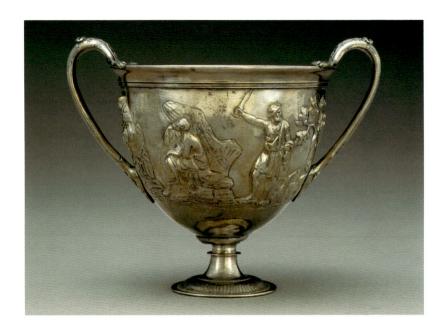

Two-Handled Cup

Roman, A.D. 1–100 Silver H: 12.5 cm (4½ in.); DIAM: 16.3 cm (6½ in.) 96.AM.57 Complete sets of silver found throughout the Roman world attest to the fact that, during the later years of the Roman Republic, tableware made of that valuable metal was no longer a luxury restricted to the very wealthy. For Romans of growing prosperity, many items in silver —trays, dishes, vessels, ladles, and spoons—replaced those of bronze and pottery.

Repoussé—working metal with hammers and punches—was the technique used most frequently to ornament metal drinking cups such as this one with a wide range of motifs ranging from mythological subjects and images of festive occasions to scenes of outdoor life and nature.

The inspiration for the primary scene on this cup comes from an episode in Homer's *Odyssey*. When Odysseus finally left the sorceress Circe after a yearlong stay on her island, Circe directed him to sail west to the entrance to the Underworld, where he could seek out the spirit of the blind seer, Teiresias, and question him about returning home to Ithaca. To summon the ghost, Odysseus was to offer a sacrifice of sheep. Here, at the right, with his upraised sword in his right hand, Odysseus stands beside a tree and the body of a slain ram; the ram's blood has convened the shades of the dead. In the adjacent rocky setting sit Teiresias (center) and another spirit (at the left).

On the other side of the cup, additional figures engage in a discussion; they may represent philosophers or the Seven Sages rather than other shades of the dead.

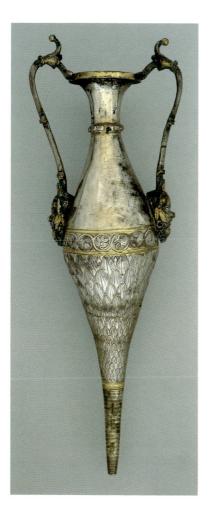

AMPHORA-RHYTON

Roman, A.D. 300–500 Gilded silver H: 38 cm (15 in.); DIAM (body): 8.8 cm (3½ in.) 92.AM.12

An amphora (storage vessel) and a rhyton (drinking/pouring vessel) are combined here in a vase type that is unusual and survives in few examples. The elegant arching handles, decorated with foliate forms and geese's heads at the gilded rim, are attached to the elongated body of the vessel with the heads of ivy-wreathed satyrs. As members of the retinue of Bacchus, god of wine, satyrs frequently appear as handle attachments for vessels that presumably held wine.

This piece was probably used to aerate wine before it was served. The fifteen rows of overlapping vertical feathers that adorn the bottom half of the vessel recall the decorative patterns on other silver vessels (see the bowl on p. 94). A number of stylistic details, including the knobbed handles and the elongated profile of the vase, both characteristic of fourth- and fifth-century-A.D. vessels, help to date this piece to the end of the Roman Empire. In addition, the ornamental collar of overlapping horizontal feathers is typical of later metal and glass pieces, and the incising on the satyr's irises and pupils also points to a late date. As further confirmation, scientific analysis has revealed that the gilding, which adds to the object's opulence, is made of a mercury amalgam, a mixture that was used only in the late Roman period.

PLATE WITH RELIEF DECORATION

Late Antique, A.D. 500–600 Silver H: 45 cm (17½ in.); W: 28 cm (11 in.) 83.AM.342 The allegorical scene that decorates this large plate represents the philosophical dispute between Science and Mythology. This is one of a number of "picture-dishes," plates in which figural scenes fill the surface, which first became popular in the second century A.D. The two seated men engaged in discussion are identified by Greek inscriptions as Ptolemaios, an astronomer, mathematician, and geographer who represents scientific knowledge (on the left), and Hermes Trismegistos, who represents traditional wisdom as embodied in mythology. Between the seated men is a globe. The woman with her hand to her chin behind Ptolemaios is labeled Skepsis, a personification of speculation or doubt. The inscriptions identifying the enthroned figure at the top of the plate and the woman behind Hermes Trismegistos are missing. The subject and style of this plate have been associated by some scholars with the European Mannerist period (1525-1600), but its silver content and method of manufacture point to an ancient origin. Radiographic photography revealed a faint pattern of vines and leaves on the underside of the plate, confirming its ancient date; this design is characteristic of similar pieces produced in late antiquity.

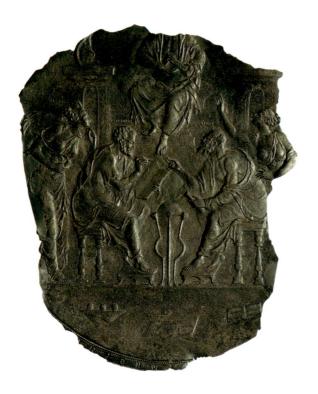

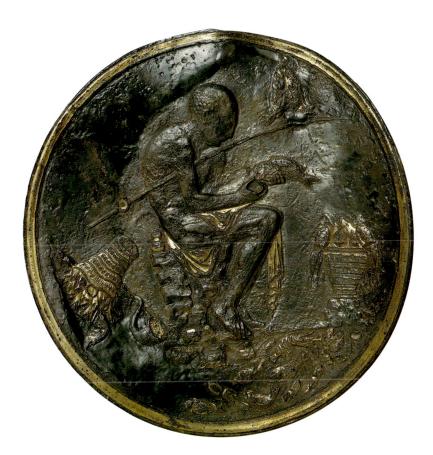

PLATE WITH RELIEF DECORATION

Late Antique, A.D. 500 – 600 Silver with gilding DIAM: 60 cm (23% in.) 83.AM.347 An old fisherman sits in a rocky landscape at the edge of the sea, which is teaming with various marine animals, and removes a fish from his hook. Two fish hang from the wall in the background and the rest of his catch overflows from the baskets around him. Gilding enhances the luxuriousness of this object, which exemplifies the continuity in late antiquity of Hellenistic traditions—in this case, the tradition of representing genre scenes on expensive materials. This silver plate may have been found with the one on the facing page.

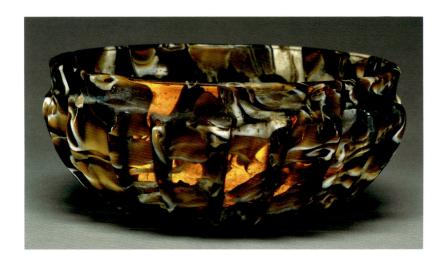

RIBBED BOWL

Roman, 100 B.C.–A.D. 100 Glass H: 7.5 cm (3 in.); DIAM: 18 cm (7½ in.) 72.AF.37 The brown-and-white glass used to make this bowl was deliberately blended to imitate agate, a naturally banded precious stone. In antiquity, ceramic and glass vessels were often more affordable substitutes for pieces made from expensive materials like agate.

Both multicolored and monochrome ribbed bowls were popular during the first century B.C. and first century A.D. Bowls of this shape were made by fusing and sagging the glass. First, small pieces of brown and white glass were heated together to create the appearance of agate. The fused glass was then flattened into a disk and ribs were formed on its top. In the final step, the ribbed disk was placed over a hemispherical mold and reheated to sag and assume its final form.

This bowl was discovered in 1764 in the park of the Château of Ripaille (located on the south shore of Lake Geneva in France). The bowl was found within a round lead container and held the ashes and partially burnt bones of a cremation burial. The burial gifts found with the human remains included a fragmentary bone fibula (pin) worked in relief and formed as a rosette; an emerald cabochon; a gold ring with an engraved black stone bezel; and two glass vials, each 4 inches long. The current whereabouts of those burial gifts is not known.

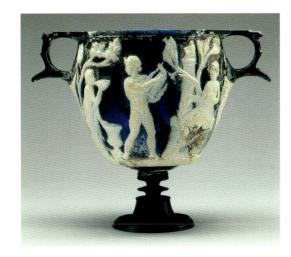

Cameo Glass Skyphos

Roman, 25 B.C.-A.D. 25 Glass H (preserved): 10.5 cm (4/% in.); DIAM: 10.6 cm (4/% in.) 84.AF.85

Many surviving Roman cameo glass vessels display scenes that refer to Bacchus, god of wine, or his followers, and this skyphos, or drinking cup, is no exception. A satyr—a creature typically associated with Bacchus-stands in the center of one side of the cup, playing a lyre. He looks back at the half-draped woman behind him, who leans against a large krater (a vessel for water or wine) and sips from a bowl. On the right, a half-draped figure holding a cup sits on a rocky outcrop. A tree and a tall stele topped by an enthroned, draped deity, perhaps Cybele, are situated behind her. The seated figure reaches forward to place an offering (perhaps incense) to the deity on a flaming altar.

On the other side of the cup, a half-draped woman sits upon stacked rocks. With one arm resting atop her head, she looks back at the female attendant behind her, who holds out a shallow box (cista) that is covered with a cloth. To the left, a satyr holds a set of panpipes in his right hand and cradles a pedum (crooked stick) in his left arm; he looks back at the two women. The trees behind the flanking figures emphasize the outdoor setting in which the scene

takes places. The frontal heads of bearded Pans or satyrs are carved below the handles. Satyrs and Pan often accompanied the wine god and participated in his drunken revels. As this vessel is a drinking cup, their use as a decorative element here is quite appropriate.

The iconography of this cup's two principal scenes relates to religious rituals and votive offerings, but the identities of the figures portrayed are not completely clear. Ariadne, Bacchus's consort, is likely the seated woman partaking in a scene of ritual initiation, in which the religious mystery is about to be revealed to her by the attendant holding the covered cista. On the vessel's other side, she may be the woman sipping from the bowl, shown as an acolyte drinking wine as a part of the religious ritual. The gaze of the lyreplaying satyr toward her emphasizes her importance in the scene.

Cameo Glass Flask

Roman, 25 B.C.—A.D. 25 Glass H: 7.6 cm (3 in.); DIAM (body): 4.2 cm (1% in.) 85.AF.84

Though glassmaking had been known since the third millennium B.C., new processes and techniques for manufacturing glass continued to be developed. The method for making cameo glass was one of the highest technical achievements of the glass industry during the Roman period. Two or more layers of hot glass in different colors were overlaid and then carved away in cameo technique to create a low-relief scene. Cameo glass resembles precious layered stones, such as banded agate, which were carved in the same manner, and it is possible that the artisans who carved cameo glass worked primarily in stone.

Some scholars believe that the scenes encircling this diminutive perfume flask are part of a narrative from the life of the Egyptian god Horus, son of the goddess Isis. When Horus was killed by a scorpion's sting in Heliopolis, the sun god, Aton-Re, sent the god Thoth to restore Horus to life. The two youths depicted on the flask may be Horus. On one side (shown here), a young boy holding a garland worships Thoth, depicted as a baboon seated atop an altar. On the other side, a boy offers stalks of grain before an altar with a uraeus (sacred snake) carved on its

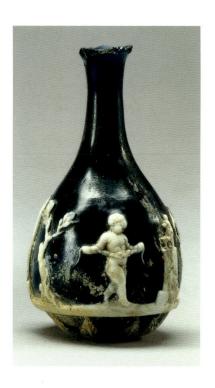

side, a reference to Horus's mother Isis. Behind this altar stands Aton-Re, shown as a pharoah holding a crooked staff and a vessel. Heliopolis, the story's locale, is indicated by the presence of a tree and an obelisk carved with hieroglyphs. A decorative rosette is carved on the flask's underside.

A second interpretation of the images refers to events in Rome, specifically to the arrival of two obelisks from Heliopolis in 10 B.C. One was erected in the Circus Maximus (an arena for chariotracing) and the other in the Campus Martius (Field of Mars). Still other scholars believe that the Egyptian imagery carved on the flask is evocative of Egypt itself and has no relationship to a specific myth or event.

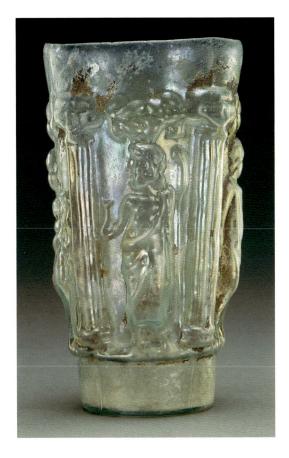

Mythological Beaker

Roman, A.D. 50-75 Glass H: 12.6 cm (5 in.); DIAM: 7 cm (2 1/4 in.) 85.AF.83

Vessels made by inflating hot glass into a mold were popular from the first century A.D. on. Their creation was not possible until the technique of inflating glass with a blowpipe was developed in the previous century. Molds used for glass production were made of fired clay, plaster, wood, and metal. Most were simple two-part molds, but others were more complex and were made up of three or more parts. The mold used to inflate this beaker was constructed of four side panels and a base disk.

This vessel is decorated with a frieze of four figures standing between columns embellished with suspended floral swags. On the basis of their attributes, the figures have been identified as Neptune, god of the sea (shown here);

Bonus Eventus, the personification of good fortune; Bacchus, god of wine; and Hymen, god of weddings.

This vessel is part of a larger corpus of mythological beakers that have been divided into four groups based on their figural combinations. There is no single figural composition from the Hellenistic or Roman period that includes all of the figures found on the vessels, thus it seems unlikely that they were culled from a larger representation and combined together in fours on the beakers. The function of the beakers is also unclear. The rims of the vessels were often left sharp, making them unsuitable for drinking. They may have been gifts to the deceased; at least two were found in burials.

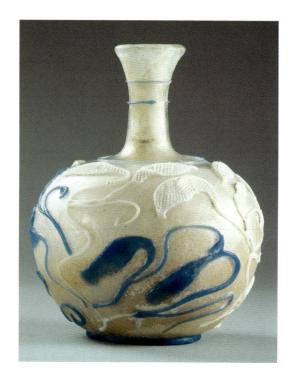

Snake-Thread Flask

Roman, A.D. 200–300 Glass H: 14.2 cm (5½ in.); DIAM (rim): 3.6 cm (1½ in.); DIAM (body): 11.6 cm (4½ in.) 96.AF.56

This free-blown flask of colorless glass has a globular body with a narrow neck and slightly flared rim. The neck is ornamented with an applied blue-glass trail, and a similar trail is wound on the base to provide a foot for the flask. The decoration on the body consists of blue and white trails arranged in foliate patterns. From undulating stems, flattened leaves spread over the curving surface of the flask.

So-called snake-thread glass was developed first in the glass workshops of the eastern Mediterranean. Two stylistic groups coexisted: one with freely applied trails, another, known as the flowerand-bird group, with figural representations. Shortly after its appearance in the eastern Mediterranean, snake-thread glass spread to the western provinces of the Roman Empire, particularly the provincial capital city of Colonia (modern Cologne, Germany), where many

examples have been excavated. The products of the eastern workshops are characterized by the use of colorless glass for both the body and trails, the crosshatched impressions on some of the flattened trails, and the flower-and-bird patterns found on some of the vessels. The western workshops incorporated colored trails into their designs and impressed the trails with rows of single, rather than double, crosshatched lines.

This flask is an eclectic mix of shape, color, and patterning that successfully blends elements ascribed to both eastern and western manufacture. The use of multicolored trails and the globular shape of the flask compare closely to examples excavated in Cologne. The decoration of the flask belongs to the flower-and-bird style, however, and its trails are crosshatched. These two elements make it more likely that the flask was produced in an eastern atelier.

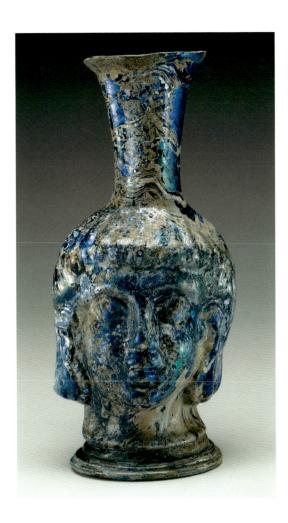

HEAD FLASK

Roman, A.D. 300–500 Glass H: 17.2 cm (6¾ in.); W: 8 cm (3⅓ in.) 85.AF.320

The production of ceramic, metal, and glass vessels shaped as human heads has a long history in ancient art. This flask, which dates to the fourth or fifth century A.D., shows the popularity of the type in the later Roman period. The flask is shaped as the head of a long-haired youth. His features are idealized, and he might represent a youthful god, perhaps Apollo.

The flask was made by inflating hot cobalt-blue glass into a two-part mold. Once the mold was removed from the glass, the flask's wishbone handle and circular foot were applied. In a final step, the slightly flared rim was formed after the vessel was removed from the blow-

pipe; the finished flask was then placed into an annealing oven to cool. When it was manufactured, the flask was a uniform cobalt-blue color. Over time, as the glass has aged, a layer of iridescence has formed on the surface.

Five other head flasks of the same shape and size have survived from antiquity. The style of their handles and bases suggests that they were manufactured during the fourth or fifth century A.D. at a workshop in the eastern Mediterranean; recent archaeological finds from Israel of similar, but smaller, head flasks reinforce this conclusion.

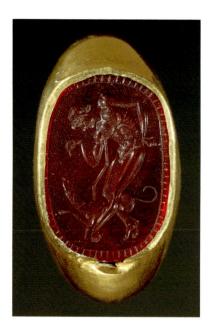

GEM ENGRAVED
WITH A YOUTH
AND DOG
INSET INTO A RING

Italic, 300–100 B.C. Carnelian and gold H (gem): 1.81 cm (½ in.); W (gem): 1.32 cm (½ in.); DIAM (hoop): 2.8 cm (1½ in.) 85.AN.165 Carved on the surface of this gem is a scene of a nude youth leaning on a crooked staff bending over to feed his dog. The young man delicately balances himself on the balls of his crossed feet as the dog lifts his snout toward the scrap of food held in the youth's left hand. The dog is long and lean with a smooth coat; called a Lakonian hound, it was the breed commonly used in ancient Greece for hunting. A hatched border surrounds the pair, enclosing them in a tight composition. The poses of both the youth and the dog have been arranged in a manner suited perfectly to the elongated shape of the gemstone. Even on this small scale, the unknown gem carver has carefully modeled both figures, depicting the anatomical proportions and musculature in a naturalistic manner.

The theme of a youth and his dog was very popular in ancient art in all media beginning in the 4008 B.C. It is found on both Archaic Greek gems and Etruscan scarabs. The use of the motif on this gem, as well as the style of the figure, is Archaistic, or intentionally old-fashioned. The native Italic people and the Romans, like the Greeks before them, admired the styles of earlier times, and traditional styles could elevate the importance and status of an object. The original setting, the type of border surrounding the scene, the use of small drilled holes for details, and the shape of the ring itself are typical for Italic gems of this period.

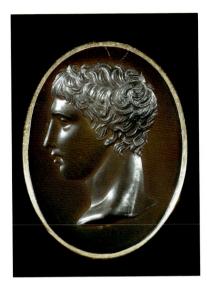

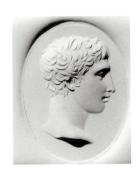

GEM ENGRAVED
WITH A
HEAD OF THE
DORYPHOROS
INSET INTO A RING

Roman, 50–40 B.C.
Dark green chalcedony and gold
H (gem): 2.24 cm (% in.);
W (gem): 1.73 cm (1½ in.);
DIAM (hoop): 2.49 cm (1 in.)
75.AM.61

Carved into the stone of this ring is the head of one of the most famous Greek statues ever made, the Doryphoros, or Spearbearer, by the artist Polykleitos, cast in bronze about 440 B.C. Polykleitos created his statue to illustrate certain aesthetic theories that he explained in the Kanon. His book has not survived, but references to it by other ancient writers imply that the Greek words symmetria (symmetry) and rhythmos (rhythm) expressed its main principles. According to Polykleitos, a statue should be composed of clearly definable parts, all related to one another through a system of ideal mathematical proportions and balance. Polykleitos's works were very popular with the Romans in the first century B.C. and first century A.D. Roman artists created numerous replicas and variations of his sculptures in addition to reproducing them in other media, such as engraved gemstones.

In Roman society, which emphasized display, this ring, with its carved gemstone set into heavy gold, advertised the wearer's wealth as well as his culture and learning. Upper-class Romans demonstrated their good taste by surrounding themselves with items of Greek art, including jewelry.

The ring was buried with a group of objects containing late-first-century-B.C. silverware (including the silver cups on p. 197), a gold diadem, and a gold aureus of Mark Antony minted in Asia Minor in 34 B.C. The coin appears to be in mint condition, suggesting that the objects were buried shortly after 34 B.C.

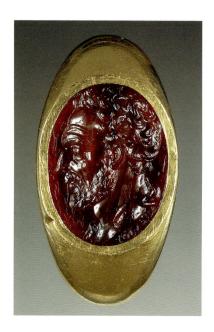

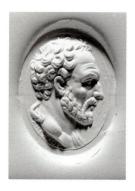

GEM ENGRAVED
WITH A PORTRAIT
OF DEMOSTHENES
INSET INTO A RING

Signed by Apelles
Roman, 25–1 B.C.
Carnelian and gold
H (gem): 1.9 cm (½ in.);
W (gem): 1.5 cm (½ in.);
DIAM (hoop): 3.36 cm (1½ in.)
90.AN.13

A carved portrait of the Greek orator Demosthenes decorates the gem of this large gold ring. Demosthenes, the most famous of Athenian orators, lived from about 384 to 322 B.C. He is perhaps better known today for overcoming a difficult speech impediment than for his politics. He was vehemently opposed to—and outspoken about—the gathering power in Macedonia under Philip II and his son, Alexander the Great. Although never successful in his campaign to sway political sentiment against the Northern Kingdom, he created many political enemies in Athens and Macedonia in the attempt. When the Macedonians occupied Athens in 323 B.C., Demosthenes was condemned to die, but he committed suicide first.

Depictions of orators on Roman gems are quite rare, but in the early Roman Empire portraits of Demosthenes in all media became popular. Many portraits in both marble and bronze have survived, but this gem portrait is one of only four such portraits that exist today.

Gem carvers did not often sign their work, except in the late first century B.C. The engraver Apelles signed his name in Greek on the face of the stone as "Apellou" (son of Apelles). Apelles worked in Rome in the late first century B.C., but his Greek name suggests that he was a Greek craftsman who had moved to Rome, the cosmopolitan imperial capital, where there would have been a larger market for his work.

CAMEO OF PERSEUS WITH THE HEAD OF MEDUSA INSET INTO A RING

Roman, 25 B.C.—A.D. 25 White on brown sardonyx and gold H (cameo): 1.75 cm (½6 in.); W (cameo): 1 cm (½6 in.); DIAM (hoop): 2.06 cm (½6 in.) 87.AN.24

The Greek hero Perseus stands contemplating the decapitated head of the Gorgon Medusa. In his left hand, he holds the *harpe*, or curved sword, that he used for the deed. The nude hero has a cloak thrown over his left arm, and he wears the winged sandals given to him by the god Hermes.

The image on the cameo may be derived from a bronze statue of Perseus made in the 400s B.C. by the Athenian sculptor Myron. This depiction of the hero is unusual and implies some confusion on the part of the artist. According to the myth, looking at the face of Medusa instantly turned the viewer to stone. This gem appears to conflate the Perseus story with a well-known motif of the period, that of an actor gazing at a mask on a column.

Popular among the Romans, cameos frequently depicted Greek statue types. Multilayered gemstones or glass were carved so that a white relief stood out against a dark background, usually blue or brown. The identity of the carver

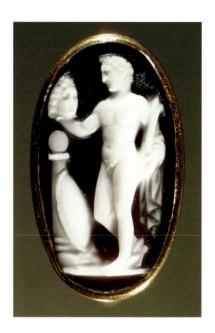

of this cameo is unknown, but because cameos and cameo carving are often associated with the city of Alexandria in Egypt, he may have lived in the North African empire. The production of cameos originated in the Hellenistic period, after the advance of Alexander the Great's armies to India opened up the East to the Greek world. Onyx from India and Arabia was the stone most frequently used in antiquity for cameos. Like the technique of cameo carving, the ring's shape—a hoop expanding upward to form an oval bezel-was also introduced during the Hellenistic period and remained popular for centuries.

Assemblage of Gold Jewelry

Roman, A.D. 250–400 Gold with various inlaid and attached stones, including sapphire, emerald, garnet, and glass paste Various dimensions 83.AM.224–.228

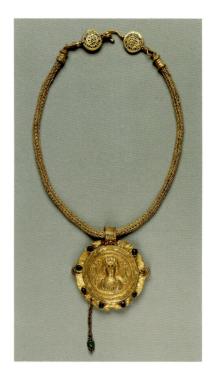

Found together, this collection of jewelry presents a fascinating mélange of materials and techniques—and also serves as a reminder that, in times of violent uprisings or war, treasured valuables were sometimes buried by an owner who did not survive to retrieve them later on.

An elaborate gold belt (top right) is the centerpiece of the assemblage. It is composed of twenty-three square links made from gold coins of several fourthcentury-A.D. Roman emperors framed by green glass; a central medallion with three pendant attachments and inlays of glass and semiprecious stones on the front and a relief of opened acanthus on the back; and an adjustable hook fastener. Emperors in the fourth century A.D. wore jeweled belts and coin belts as part of their official regalia, but only women of the imperial court seem to have had belts with the central decorative ornament.

The pendant of one of the necklaces (top left) is a gold repoussé medallion

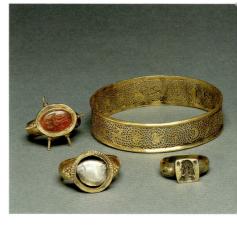

depicting the frontal bust of a woman wearing a diadem and jewelry that, together with the flanking personifications of victory holding wreaths, indicate she may be an empress. Another necklace's pendant, a gold-mounted cameo with the opposed busts of a couple, was originally a brooch; it exemplifies the tendency in late antiquity to reuse jewelry elements.

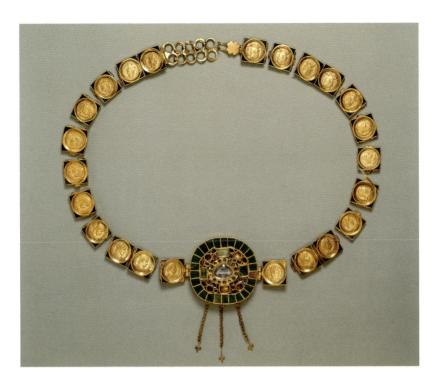

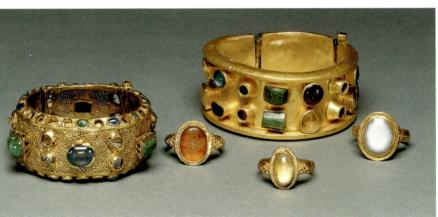

Among the distinctive pieces that comprise the remainder of the assemblage (bottom photo) are two openwork gold bracelets, one (left) decorated with animals within floral scrolls and another (center) encrusted with vibrantly colored gems. A third bracelet (right) is designed as a solid cuff inlaid with glass and precious stones. One of the rings is mounted with an engraved intaglio

(far left), four are mounted with semiprecious stones (second from left and three far right), and one has an engraved bezel (third from left).

Although the incorporation of preexisting elements into many of the pieces suggests a paucity of artistic creativity at the time of manufacture, the ensemble clearly evokes the opulence and decadent splendor of the late Roman Empire.

FRAGMENT OF A FRESCO DEPICTING LANDSCAPES

Roman, 50–25 B.C. Plaster with pigment H: 91 cm (35¾ in.); w: 80.5 cm (31¾ in.) 96.AG.170

The landscapes depicted on this wall fragment are characteristic of the Second Style of Roman painting. This style, popular in the first century B.C., is marked by illusionism: the wall is not a closed, solid surface but an opening to a world beyond it.

The left panel shows a square temple whose roof is adorned with ornamental sculpture. Two groups of figures stand before the edifice. The scene on the right is filled with more figures and buildings, including a round temple. Red panels with floral embellishments frame the two landscapes. Two columns of different style flank the panels. The direction of the painted shadows cast by the columns indicates that this fragment was once part of a wall that was to the right as one entered the room. The columns rest upon a shelf that was probably about

3 feet above the ground. The painted zone below this shelf, called the dado, very likely consisted of a series of painted or real marble panels that met a mosaic floor.

Both landscape panels display an unusual greenish tinge. Some scholars believe this color to be the natural result of aging; the pigment was originally blue but, over time, changed to green. Others believe that the green color was deliberately selected and might depict window glass. In antiquity, naturally colored glass, including glass used for windows, often had a greenish or yellowish tinge due to chemical elements present in the sand used to make it. But landscapes with a solid-color wash are characteristic of Second Style paintings, and the green color used here may simply be an expression of that style.

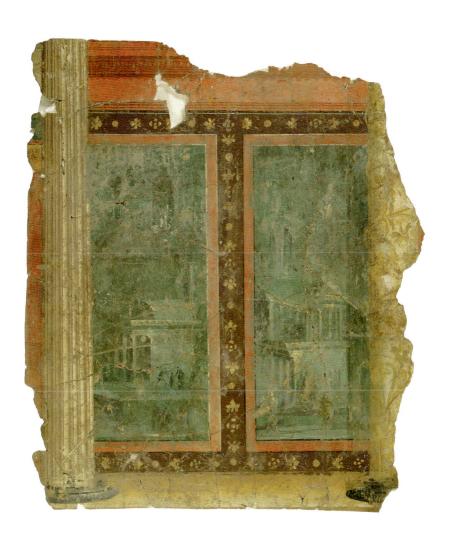

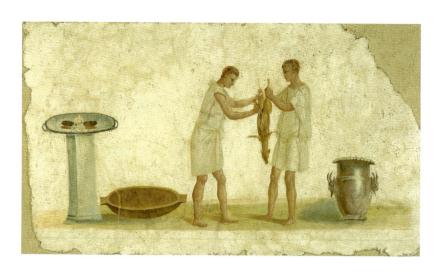

FRAGMENT OF A
FRESCO DEPICTING
THE PREPARATION
OF A MEAL

Roman, A.D. 50-75 Plaster with pigment H: 69.5 cm (27 1/8 in.); W: 127 cm (50 in.) 79.AG.112

The scene painted on this fragment of a wall provides a glimpse into the domestic activities of a Roman household. In the center, two men clean the carcass of a small, cloven-hoofed animal, perhaps a goat or fawn. The figure on the right grasps the feet of the animal while the man on the left slices into the belly with a woodenhandled knife. To the right is a large krater (mixing vessel) with a scalloped rim and handles in the shape of goats' heads. The color and sheen of the elaborate vessel suggest that it is made of silver. Details of the goats' heads are accentuated with dots and splashes of black and white paint to show their shadows and highlights. To the left, a silver tray with a beaded edge and rounded handles holds a head of garlic and other foodstuffs, perhaps bread, fruit, or olives. The tray rests atop a pillar. On the ground below it is a large wooden bowl. The bowl may be there to hold the cuts of meat sliced from the animal's body when the men are finished with their butchering, and the items on the tray might be used to season the meat prior to cooking.

The shadows cast by the krater and the figures of the men suggest that this fragment came from a wall that was to the right when one entered the room. The scene seems complete, as the ground begins abruptly at the right, and appears to be fading out at the left. Although the decorative framework that once surrounded it is not preserved, it is likely that this wall was painted in the Fourth Style of Roman wall painting, in which large scenes were set in the middle of walls and surrounded by fantastic architecture.

Roman, circa A.D. 70 Plaster with pigment H: 45.7 cm (18 in.); w: 38 cm (15 in.) 72.AG.86

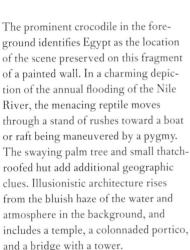

Combats between pygmies and various opponents, including crocodiles, were frequently depicted as humorous subjects in Hellenistic and Roman art. Images related to Egypt became more

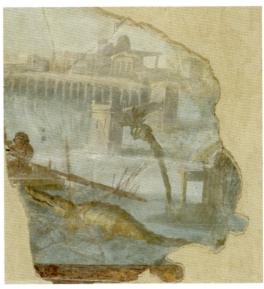

widespread in Roman art after Egypt was annexed as a province of Rome following the defeat of Cleopatra and Mark Antony at the battle of Actium in 31 B.C., and their subsequent suicides in 30 B.C.

The remains of a red border at the top and bottom of the fragment indicate the size of the original scene. The additional, darker stripe along the bottom may belong to the painted frame of another scene below, and this fragment may have been placed high on the wall. Small landscape vignettes like this one were popular in both the Third and Fourth Styles of Roman wall painting. These vignettes were often set within a larger field of color and were intended to take on the appearance of a framed picture hung on the wall.

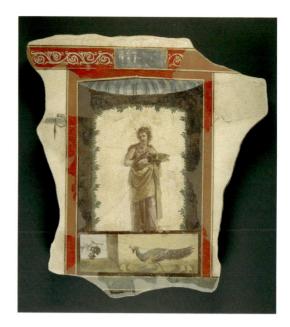

Fragment of a Fresco Depicting A Marnad

Roman (South Italy), A.D. 1–79 Tempera on plaster H: 81.2 cm (32 in.); W: 77.2 cm (30 1/8 in.) 83.AG.222.4.2

Ironically, the volcanic flow and falling ash that killed residents and destroyed cities around the Bay of Naples when Mount Vesuvius erupted in A.D. 79 also preserved many private and public buildings that otherwise would have been completely lost to us. Among the discoveries during excavations centuries later were frescoes, or wall paintings, a decorative tradition developed by the Greeks and continued by the Romans.

Because wealthy Roman citizens were particularly concerned about security, their dwellings had few exterior windows. Homes were built around inner courtyards that brought natural light and fresh air indoors, and windowless rooms were enhanced with frescoes, which could signal the owner's prosperity and social position. Thus, the walls likeliest to be seen by visitors were given the most elaborate treatment and showed that the owners kept up with the

latest trends. However, a wall painting's essential purpose was decorative, and frescoes could provide closed or windowless areas with the luxurious illusion of openness and distant views.

In creating frescoes, artists painted directly onto wet plaster walls, a technique that helped to make the colors long lasting and vivid as they bonded with the drying plaster. Among the wall paintings in the Museum's collection are several related to Bacchus, god of wine and fertility. This fresco, from that group, depicts within a frame of architectural and vegetative elements a female figure, possibly a maenad, holding a large dish. Companions of Bacchus, maenads, meaning "frenzied ones" in Greek, had acquired their name by participating in the exuberant, sometimes violent, rites inspired by the god. In the panel below the maenad, a peacock struts left toward a bunch of grapes.

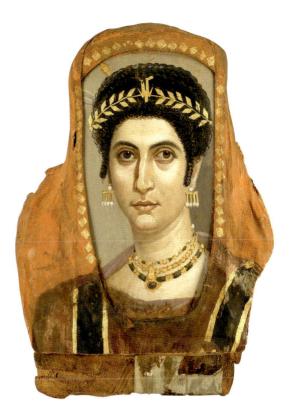

MUMMY PORTRAIT

Attributed to the Isidora Master Romano-Egyptian (Ankyronpolis, Egypt), A.D. 100–110 Encaustic and gilt on a wooden panel wrapped with linen
H: 48 cm (18% in.);
W: 36 cm (14% in.);
D: 12.8 cm (5 in.)
81.AP.42

Mummy portraits from Roman Egypt fused two traditions, that of Pharonic Egypt and that of the Classical world. The painting styles and techniques come from the Classical world, but the inclusion of the portrait panel as part of the wrappings of the deceased belongs to very ancient Egyptian funerary practices. The portrait helped the individual survive death in physical form by providing a substitute body for the spirit to inhabit should the corpse be destroyed. Because this portrait is preserved with some of its linen wrappings intact, it helps us to understand how the panels that have since been removed from their wrappings were used.

This portrait depicts a refined and socially prominent woman. The name Isidora is painted in black ink on the left side of the wrappings and might be hers. She is shown as an elegant matron, with elaborate jewelry and hairstyle.

They reflect current style and help date the portrait to the early years of the second century A.D., during the time of Trajan (reigned A.D. 98–117).

The portrait was painted in a technique called encaustic, in which the pigment was mixed with beeswax and applied to the panel. We know that the mummy wrappings were painted after the portrait panel was inserted into the linen because some of the orange-red paint on the linen around the upper part of the panel dripped onto the panel itself. The gold for the wreath across her hair, the lozenges surrounding the panel, and the stripes edging her clavi (the dark stripes on her clothing that denote her social rank) were added after the painting was completed. The use of the orange-red paint and the applied gold-foil lozenges around the panel indicate that the mummy came from El-Hibeh (ancient Ankyronpolis).

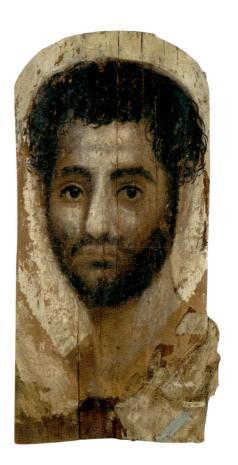

MUMMY PORTRAIT OF A BEARDED MAN

Romano-Egyptian (Egypt),
A.D. 140–160
Encaustic on wood, linen
H: 43 cm (16% in.);
W: 22.5 cm (8% in.)
73.AP.94

Very little ancient Greek painting survives, but painting was known to be one of the more highly regarded art forms in antiquity. Mummy portraits give us a glimpse of the styles and techniques used to create the famous, but now-lost, wall murals mentioned by authors such as the Greek geographer Pausanias, who wrote in the second century A.D. The methodologies associated with mummy portraits continued on in the eastern Mediterranean Byzantine tradition of icon painting.

In this highly individualized portrait, the bearded man is depicted seated at an angle with his head turned to the left to gaze out at the viewer. His hair is painted in unruly curls that end at the top of his ears, while his beard appears to be closely cropped to conform to the narrow contours of his face. The artist has used white effectively to highlight the contours of the cheeks, long nose, and high forehead. The eyes are surrounded by darker hues, with only the upper lashes clearly marked out in darker paint. The luxuriant hair and beard date the portrait to the mid-second century A.D.

Some of the linen mummy wrappings survive on the bottom of the panel. They are preserved at an angle on the lower corners, as the linen was wrapped diagonally around the upper part of the body to enclose the panel. Uncharacteristically, there are no traces of painted clothing on the figure of the man.

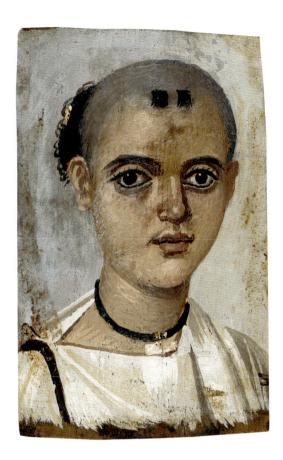

Mummy Portrait of a Youth

Romano-Egyptian (Egypt),
A.D. 150–200
Encaustic on wood
H: 20.3 cm (8 in.);
W: 13 cm (5% in.)
78.AP.262

Of the portraits that have survived from Roman Egypt, the most poignant ones portray children. This young boy's head is shaved, except for a Horus lock on his right side and two tufts of hair at the forehead. His natural hairline is suggested by the darker hue on his scalp. An amulet hangs from a strap around his neck, and a gold pin set with miniature garnets is affixed to his Horus lock. In antiquity, children wore amulets to protect them from harm. When the child reached puberty, such charms were usually put aside as part of the rituals of reaching adulthood.

This portrait may have been done from life; the shadows beneath the boy's eyes and the pallor of his skin seem to suggest an illness. His eyes are large and expressive, with individual lashes delineated above the darker outline of the eye. After death, the panel was placed over the face of the deceased and bound into the linen wrappings of the body. The panel has been removed from its wrappings, but it is still possible to see their outline where the pigment no longer survives on the bottom edge, and along the left and right sides where there is discoloration from bitumen used to hold the linen wrappings together. The portrait was painted using the encaustic technique, in which the pigment is suspended in beeswax and then applied to the wooden panel.

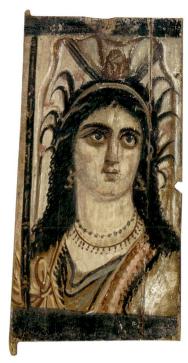

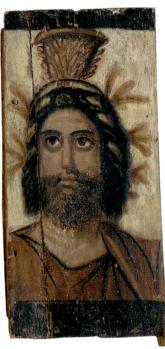

THREE PAINTED
PANELS FROM
A SHRINE WITH A
PORTRAIT OF
A BEARDED MAN,
THE GODDESS ISIS,
AND THE
GOD SERAPIS

Romano-Egyptian (Egypt), A.D. 225-250Tempera on wood Bearded man panel: 36×37.5 cm ($14\% \times 14\%$ in.); Serapis panel: 39×19 cm ($15\% \times 7\%$ in.); Isis panel: 40×19 cm ($15\% \times 7\%$ in.) 74.4P.20-.22 These three painted panels were joined together to form a personal shrine dedicated to the memory of the bearded man who is depicted in the largest of the panels. The panels showing the Egyptian gods Isis (on the left) and Serapis (on the right) formed the doors of the shrine, and the images of the deities were positioned to face the viewer when the doors were closed. Once opened, the gods were no longer visible, but the image of the deceased was revealed. Although the framework that held all three panels together is lost, the wooden dowels on which the door panels pivoted are still present on the Isis and Serapis panels.

The depiction of Isis is the most complicated of the three. The goddess wears an elaborate floral wreath and uraeus (sacred snake) crown covered by a transparent veil. Her pendant dolphin earrings stand out against the rich black of her cascading hair; two necklaces encircle her throat. She wears an undergarment of brown accented with black and green, and a robe of ocher and red. A black staff with an ocher and red ornament stands at the panel's left edge.

Serapis wears his best-known attribute, the *modius*, atop his head (see also the portrait bust on p. 165). He also wears a twisted diadem and a leafy wreath. His clothing is sedate, rendered dark brown with black and ocher highlights.

The bearded man is portrayed with straight dark hair, cut to frame his face. His beard is short and curly, and his red lips contrast with the blackness of his facial hair. He holds a sprig of leaves in his right hand, and a garland of floral petals in his left.

All three images are painted in the tempera technique, in which the pigment is suspended in a soluble binding agent, most often animal glue. The paint is applied over a layer of white gesso. The palettes of the door panels and portrait vary. The Isis and Serapis panels have a white background with darker zones above and below. The palette of the clothing, hair, and attributes is generally in earth tones, with ochers, reds, blacks, and browns. The bearded man, however, is shown against a pale gray background, with the palette enhanced by his red lips, floral garland, and sprigs of greenery.

Glossary

Cross-references within this Glossary appear in SMALL CAPS.

AEGIS

A divine emblem associated with the Greek gods Zeus and Athena, consisting of a scaly animal skin with a fringe of snake heads and the GORGON Medusa in the center (to ward off evil). In ancient art, Athena is often depicted wearing an aegis over her clothing like a breastplate.

AMPHORA (pl. amphorae)

A medium-size terracotta pot with two vertical handles, narrower neck, and bulging body. Very common in antiquity, amphorae were used for storing and transporting oil, wine, grains, and other commodities. Their shape changed somewhat over time, the bodies becoming more or less rounded, the necks more or less set off from the bodies, and so on. Various modifiers of the name (for example, neck-amphora, belly-amphora) indicate a specific shape of vase.

ARCHAIC PERIOD

The period from about 700 to 480 B.C. in the Greek world.

ARYBALLOS (pl. aryballoi)

A small terracotta vessel with a bulging body and narrow neck. It was used to hold perfumed oil.

ATTRIBUTE

An object closely associated with or characteristic of a person, divinity, or object.

ATTIKA

The area of Greece around the city of Athens.

BLACK-FIGURE TECHNIQUE

A style of decoration used on ancient Greek ceramics beginning in the late seventh century B.C. The figures or decoration are painted in black on the unfired clay so that they appear as silhouettes in the finished product. Details are incised through the black paint to appear in the color of the underlying clay. See also RED-FIGURE TECHNIQUE.

CHIMAIRA

A mythical fire-breathing monster with the head of a lion, the body of a goat, and the tail of a snake. The Chimaira was slain by the hero Bellerophon.

CHITON

The basic Greek garment. Resembling a tunic, the chiton is made of lightweight, pleated cloth. Women's chitons were ankle length, men's were knee length.

CISTA (pl. cistae)

A small to medium-size, usually cylindrical basket or chest made of metal or wood. *Cistae* were used for storing small objects such as cosmetics and jewelry.

CLASSICAL PERIOD

In Greece and the areas under Greek influence, the period ranging from approximately 480 B.C. (the sack of Athens by the Persians) to 323 B.C. (the death of Alexander the Great).

CORINTHIAN

ARCHAIC pottery from Corinth dating from about 625 B.C. onward. The phase following protocorinthian generally favors larger figures painted more quickly. Exotic hybrid creatures were added to the more natural collections of the Protocorinthian style.

CULT STATUE

A statue of a deity housed in the central room of a temple.

CYCLADIC CULTURE

A Greek Bronze Age culture that flourished in the Cyclades (a group of islands in the Aegean Sea) from about 3000 B.C. to 1100 B.C. Small stone figures from this period, known as Cycladic idols, are characterized by simplified, nearly abstract, renderings of the human form.

DIADEM

A narrow ribbon or fillet worn across the forehead, with the ends tied at the back and left hanging down the neck. In antiquity, diadems were insignia worn only by divinities and royalty.

DINOS (pl. dinoi)

Medium- to large-size, almost globular terracotta vessel with no handles or foot. Dinoi were used for mixing wine and water.

EROTE (pl. erotes)

The Greek depiction of Eros, the god of love, as a small, nude, winged baby.

FIRST STYLE

The oldest style of Roman wall painting, dating from 200-80 B.C. First Style is characterized by the simulation of marble in paint and stucco.

FOURTH STYLE

The last style of Roman wall painting, seen from A.D. 62 onward. This "baroque" style combines the spatial vistas of Second Style with the fantastic architecture of the Third. The style's large, narrative panels often depict subjects from Greek mythology.

GIANT

Any of the large, monstrous creatures born to Ge (Earth) and Uranus (Sky) to avenge Zeus's destruction of their half-brothers, the Titans. The Giants fought and lost a fierce battle with the Olympian gods called the Gigantomachy.

GORGON

Any of three mythical Greek female monsters (Medusa, Sthenno, and Euryale) whose horrific appearance turned those who looked at them to stone. For this reason, the disembodied head of Medusa, who was beheaded by the hero Perseus, was often used as an evil-averting device.

GRIFFIN

In Greek mythology, hybrid creature combining characteristics of a lion, bird, and snake.

HARPIES

In Greek mythology, winged beings, part women and part birds, who personified storms and were blamed for snatching away food or carrying people to their death.

HELLENISTIC

Meaning "Greeklike." In Greece and the areas under Greek influence, the Hellenistic period ranges from about 323 B.C. (the death of Alexander the Great) to 30 B.C.

HERM

A stone marker in the form of a square pillar surmounted by a bust or a head at the top and with male genitals further down. Herms were often placed at crossroads or at the entry to a house.

HIMATION

A large rectangular cloth of heavy material worn as an outer garment by Greek men and women. The himation was typically draped over one shoulder and wrapped around the body.

HOPLITE

A heavily armed Greek infantry soldier. A hoplite's equipment included helmet, corselet, and greaves; he carried shield, spear, and sword.

HYDRIA (pl. hydriae)

A medium-size jug with one vertical and two horizontal handles. The name derives from the Greek word for water, which hydriae were used in antiquity to store and transport.

KANTHAROS (pl. kantharoi)

A drinking cup with two vertical handles and a tall foot. Kantharoi were made of terracotta or metal, including silver and gold. The kantharos is associated with Dionysos, god of wine.

KORE (pl. korai)

Meaning "young woman" or "maiden" in Greek, the term *kore* refers also to a statue of a draped standing female figure.

KOUROS (pl. kouroi)

Meaning "young man" in Greek, the term *kouros* refers also to a statue of a nude male youth. Kouroi were represented standing frontally, stepping forward on one foot.

KRATER

A medium- to large-size bowl with two handles and a large, open mouth. Kraters were used for mixing wine and water.

KYLIX (pl. kylikes)

A two-handled drinking cup with an open, shallow bowl usually set on a tall, slender foot. Variations in form are classified as Type A, Type B, or Type C.

LEKYTHOS (pl. lekythoi)

A small to medium-size terracotta vessel with a cylindrical body, narrow neck, and one vertical handle. Lekythoi were used for pouring offerings of wine or oil on graves. Lekythoi carved in marble served as grave markers.

LOUTROPHOROS (pl. loutrophoroi)

A tall, slender terracotta vessel with a high, narrow neck. Loutrophoroi were used for carrying water for ritual ablutions, particularly at weddings.

MAENAD

A female follower of Dionysos, god of wine. In ancient art, maenads are often shown nude or partially dressed.

MANNERISM

A style of Greek art characterized by affected or exaggerated poses.

MEDUSA

See GORGON.

MODIUS

Basket for measuring grain. Depicted as a head ornament on statues or vase-paintings, the *modius* is a divine attribute.

OINOCHOE (pl. oinochoai)

A medium-size, one-handled ewer used for holding and pouring wine. Oinochoai were made of terracotta or metal.

OLPE (pl. olpai)

A small to medium-size ewer with one vertical handle. More elongated than oinochoai, olpae were used to hold liquids.

ORIENTALIZING PERIOD

In Greek art, the period from about 725 to 625 B.C., when oriental motifs were introduced. See also PROTOCORINTHIAN.

PANATHENAIA

Ancient Greek festival held every four years in Athens to honor that city's patron goddess, Athena. Panathenaic prize AMPHORAE were awarded to the victors of the athletic games held during the festival.

PATERA

A shallow, round dish used for libations in rituals.

PELIKE (pl. pelikai)

Medium-size, two-handled terracotta pot resembling an amphora, but wider toward the base.

PEPLOS

Heavy, woolen outer garment worn by Greek women. The peplos was belted at the waist and pinned at the shoulders.

PROTOCORINTHIAN

A style of pottery decoration developed during the ORIENTALIZING PERIOD in Corinth, the greatest center of pottery distribution of its time. The style is characterized by miniaturization of motifs and the use of animal friezes.

PYXIS (pl. pyxides)

A small, cylindrical, lidded container for small objects such as jewelry. Pyxides were made of terracotta, metal, or, presumably, wood.

RED-FIGURE TECHNIQUE

A style of decoration used on ancient Greek ceramics from the late 5008 B.C. through the end of the third century B.C. The background is painted black and the figures and decoration remain the reddish color of the clay. The reserved (unpainted) areas of the figures allow the painter to add much more detail than was the case in BLACK-FIGURE TECHNIQUE.

REPOUSSÉ

A relief pattern or ornament on metal raised by hammering from the reverse side.

RHYTON (pl. rhyta)

A drinking horn, often in the shape of an animal or human head. Rhyta could be made of horn, terracotta, or metal.

ROMAN WALL PAINTING

See FIRST STYLE; SECOND STYLE; THIRD STYLE; FOURTH STYLE.

SATYR

In Greek mythology, a male being with pointed ears and a goat's tail who was part of the entourage of Dionysos, god of wine. Often shown nude, satyrs are characterized by their love of sex and wine. See also SILENOS.

SECOND STYLE

The first representational style of Roman wall paintings, dating to about 80–20 B.C. Second Style creates the illusion of perspective, often seen through a screen of columns set on a dado.

SEVERE STYLE

A transitional style of early Classical Greek sculpture prevalent from about 480 B.C. to about 450 B.C.

SILENOS (pl. sileni)

A Greek god portrayed in art as a wild male with animal features. Silenos is associated with wildlife and with Dionysos, god of wine, and is also regarded as the father of the SATYRS. Sileni are usually represented as old men with horse's ears, while satyrs are generally youthful and have goat's legs.

SIRENS

Mythical bird-women on the islands off western Italy who sang sailors to their deaths. Most famously, the Sirens were unsuccessful in seducing Odysseus and his men with song.

STELE (pl. stelai)

A upright commemorative stone slab, usually with painted or carved decoration and/or inscription. Stelai were often set up as grave markers.

SYMPOSION

In ancient Greece, an exclusively male drinking party where men enjoyed wine, conversation, and entertainment.

THIRD STYLE

A style of Roman wall painting from the period 20 B.C. to A.D. 50. In Third Style paintings, the images are enclosed by dark panels and the architecture depicted is flimsy and often fantastic.

THYMIATERION (pl. thymiateria)

An incense burner usually made of bronze, silver, or terracotta. The perfumed smoke of the incense would escape through decorative openings. Thymiateria were functional objects but may also have been placed in tombs as funerary offerings.

TONDO

The central circle inside the bowl of a KYLIX, where an image is usually painted.

VOTIVE

Related to religious vows and devotion; any religious offering or dedication.

Index

A	aryballoi, 53, 55, 99, 186, 226
Achilles, xx-xxi, 23, 69, 72, 106, 168	Asia Minor, 52-53, 166, 172-173, 188
acrolithic sculpture, 104	askos, 111
Adonis, 81, 115	Asteas, 120–121
Agrippina (Roman empress), xi, xii	Atalanta, 59
Aeschylus, 122	Athena, 33, 42, 55, 61, 73, 82-84, 111, 175
Ajax, 69	Athena Promachos, 111, 175
alabastron, 100	Athens, 59-84, 168-169
Alexander the Great (Macedonian king),	Aton-Re, 206
25, 43, 44, 87, 93, 123, 138-139, 171	Attalid dynasty, 27
Alexandria, 93, 198, 213	Attika, 22, 226
altars, 115	Augustus (Roman emperor), 156, 176,
Amazons, 72, 130	180
amber pendants, 145-147	
amphorae, 58, 60–61, 64, 75, 82, 84, 122,	В
140, 226	Bacchus, 158, 180, 193, 205, 207.
amphora-rhyton, 201	See also Dionysos
Anatolia, 3, 159	Bareiss Painter, 61
Andokides, 62	Barry, James Hugh Smith, 150
Andromeda, 118, 123	beakers, 5, 199, 207
Ankyronpolis, 221	Bellerophon, 56, 127
antefix, 143	bell-krater, 119
Antimenes Painter, 63	Berlin Painter, 75
Antoninus Pius (Roman emperor), 164	black-figure painting, 55-63, 70,
Apelles, 212	140-141, 226
Aphrodisias, 166	Boëthos of Chalkedon, 47
Aphrodite, 30, 80, 81, 83, 88, 93,	Boiotia, 20
104-105, 115, 124	Bonus Eventus, 206
Apollo, 31, 32, 38, 90, 107, 125, 131, 154,	Boreads Painter, 56
162–163, 166, 209	bowls, 4, 94-95, 198, 204
Apollodoros, 67	bronze sculpture
Apollonius of Rhodes, 74	Etruscan, 130–139
Apulia, 112, 118–119, 123–125	Greek, 31–38, 40, 43–47, 49
archer, statuette of, 130	Roman, 173–195
Argos, 33, 40	South Italian, 109–113
Ariadne, 205	Tartessian, 11
Aristodamos of Argos, 33	bronze vessels, 38-39, 41-42, 50-51
armor, 110, 112-113	Brygos Painter, 69
Arsinoë II (Ptolemaic queen), 93	bulls, depictions of, 10, 98, 196
Artemis, 38, 59, 97, 125, 154	

C	Dionysos, 36, 37, 41, 43, 47, 50, 76, 78,
Caere, 141–144	101. See also Bacchus
Caivano Painter, 122	Dioskouroi, 34
Caligula (Roman emperor), 156, 157	Dodona, Sanctuary of Zeus at, 34
Calydonian boar hunt, 59	Douris, 70-71
calyx-kraters, 78, 121	
cameo glass, 205–206	E
Campania, 122	Eagle Painter, 141
candelabrum, 134–135	Egypt, 93, 165, 198, 213, 219, 221-225
Caracalla (Roman emperor), 170, 171	elderly, depictions of, 49, 74, 75
Carpenter Painter, 65	Eleusis, 77
Carthaginians, 187	Elgin, Lord (Thomas Bruce), 19
Cassiopeia, 118	Elgin Kore, 19
Cavaceppi, Bartolomeo, 161	El-Hibeh, 221
Cepheus, 118, 123	Endymion, 169
Ceres, 182	Eos, 71
Cerveteri, 141–144	Epimenes, 85 – 86
Chalkis, 58, 113	Eriphyle, 40
Chimaira, 56, 127, 226	
	Eros, 41, 81, 83, 93, 123, 124, 169
Choregos Painter, 119 Circe, 200	erotostasia, 88
	Etruria, 128–147
cista, 132, 226	Euphronios, 64, 68, 76
Claudius (Roman emperor), 157	Europa, 121
Cobannus, 189	Eurystheus (Argive king), 55
Cologne, Germany, 208	Euthymides, 64
Colonia, 208	Eutychides, 28
Copenhagen Painter, 78	
Corinth, 34, 53–55, 112–113	F
Crete, 31, 51	faience, 99–100
Cupid, 181	Faustina the Elder, 164
cups	Faustina the Younger, 164
Greek, 56-57, 59, 62, 65-69, 71	felines, depictions of, 11
Roman, 197, 200	fertility, images of, 2, 36
Cybele, 159	filigree, 144
Cyclades, 5-9, 85-86, 227	First Style of Roman painting, 227
Cyprus, 2-4	flasks, glass, 206, 208-209
	Fortuna, 28, 159
D	Foundry Painter, 76
Darius Painter, 125	Fourth Style of Roman painting, 218,
Deianeira, 33	219, 227
Delos, 30	furniture support, Tartessian, 11
Demeter, 77, 147	, rarressam, rr
Demodokos, 31	G
Demosthenes, 172, 212	Galba, Servius Sulpicius (Roman
Didyma, 14, 145	emperor), 183
dinoi, 63, 72, 77, 227	Ganymede, 71
Diomedes, 58	
Diometros, jo	Gaul, 185, 186, 189, 190

gem carving, 85–87, 210–213 Ge Pantaleia, 78 Getty, J. Paul, x–xxi, 150, 161 Giants, 42, 46, 73, 192, 227 glass vessels, 204–209 gold jewelry, 88–93, 127, 144 gold vessel, 199 Gorgon. See Medusa griffins, 32, 107, 113, 162, 175, 227 Grotta-Pelos culture, 6	Isidora Master, 221 Isis, 165, 179, 206, 224–225 Italy, 102–127 ivory appliqué, 101 Izmir, 26 J Jason and the Argonauts, 116, 146 jewelry, 85–93, 126–127, 144–147, 210–215 jugs, 3, 10
H Hades, 77 Hadrian (Roman emperor), vii, xi,	Juno, 182 Jupiter, 150–151, 153, 188, 190–191, 196. See also Zeus
150, 161, 162, 187 Hamilton, Gavin, 150 Harpies, 74, 227 harpist, statuette of, 8 Hektor, 168 Helen, 33, 80, 83, 124, 153 helmets, 112–113 Herakles, xi–xvi, 33, 41, 43, 55, 61, 72, 73, 120, 138, 141, 160–161 Herakles knot, 88, 90, 93 Hercle, votive statuette of, 138 Hercules. See Herakles Hercules, statue of, x–xiii, 160–161 Hermes, 47, 83, 202, 213 Hermes Trismegistos, 202 herm, 47, 228 Herodotos, 72 Hesperides, 120 Hippodamia, 125 Homer, 31, 58, 63, 106, 200 horse armor, 110 horsemen, depictions of, 34, 108 Horus, 206 hydriae, 38–39, 41, 141, 228	K kalpis, 41–42, 74 Kampos Group, 6 kandila, 6 kantharos, 76, 228 Kapaneus, 122 Kastor, 34 Kekrops (Athenian king), 71 keras, 37 Kerch vases, 83 Kleophrades Painter, 72–74 Klotho, 49 Klytios, 46 Kore, 77, 147 kore statues, 15, 19, 114, 145, 228 kouros statues, xxi, 14, 16–17, 60, 130–131, 228 Kremna, 166 Kreon (Theban king), 122 kylikes, 56, 65–69, 71, 228 L Lakonia, 35, 56
Hymen, 207 Hypnos, 73, 124, 169	Lansdowne, Lord, vii, xi, 161 Lansdowne Herakles, xi–xiii, xvi,
I idols, Cycladic, 7–9 Inscription Painter, 58 Iolaos, 55, 73, 141 Ionia, 14, 52 Iphikles, 55	160–161 Lasa, 136 lebes, 50–51 Leda, 124, 152–153 lekanis, 106 lekythoi, 70, 79–80, 120, 228 Leochares, 190

Neptune, 206

Leto, 38, 125, 154	Nereids, 106, 118
lions, depictions of, 35, 51, 99	Nero (Roman emperor), 184, 185, 187
lip cup, 57	Nessos, 33
loutrophoroi, 123–125, 228	Nike, 82, 89, 93, 110, 114, 122
Lydos, 60	Nikodemos, 82
lynx rhyton, 96	Niobe, 38, 125, 154
lyre player, statuette of, 31	Nyx, 174
Lysippides Painter, 62	J / / ·
Lysippos, 25, 44, 138	0
V 11	Odysseus, 58, 69, 146, 168, 200
M	oinochoai, 48, 52-53, 229
Macedonia, 24, 25	Okeanos, 78
maenads, 143, 220, 228	olpe, 54, 229
Magna Mater, 159	Olympia, Sanctuary of Zeus at, 32, 33
Makron, 71	Onesimos, 68
Marbury Hall Zeus, 150-151	Orpheus, 116–117
Maria Christina of Savoy (queen of the	Orvieto, 139
Two Sicilies), 196	Osborne House Painter, 57
Mars, 189	Osiris, 165
Marsyas Painter, 84	, ,
Medea Group, 61	P
Medusa (Gorgon), 62, 109, 110, 126, 140,	Paestum, 120–121
175, 213, 227	Painter 20, 10
Megara, 18	Painter of Athens 1826, 79
Meidias Painter, 80	Painter of Boston C.A., 59
Meleager, 59	Painter of Louvre MNB 1148, 124-125
Meleager Painter, 81	Painter of Malibu 85.AE.89, 54
Melpomene, 166	Painter of the Frankfort Acorn, 80
Menander, 177	Painter of the Wedding Procession,
Menelaos (Spartan king), 33, 80	82-83
Metope Group, 123	Pan, 101, 205
Miletos, 52-53, 145	Panathenaic amphorae, 82, 84
Minerva, 175	Paris, 80, 83
mirror, bronze, 109	Paros, 15
Mithradates VI (Pontic king), 87	Parthian vessels, 94-96
mummy portraits, xviii-xix, 221-223	patera, 136, 229
Muses, 166–167	Patroklos, 106
Mycenaea, 10	Pausanias, 222
Myron, 213	Pegasos, 56, 127, 140
	Peleus, 59, 72
N	pelike, 83, 229
naiskos, 24	Pelops, 125
Naxos, 7, 9	Pergamon, 27, 197
Near Eastern influences, 11, 51, 53, 54,	Persephone, 81, 111, 115
144	Perseus, 118, 123, 140, 213
Nemesis, 107	Phayllos of Kroton, 64
Nontro	D1 1

Pheidias, 150, 154, 183

Phineus (Thracian king), 74	sarcophagi, 168–169
phlyax vases, 119	satyrs, 36–37, 50–51, 68, 135, 143, 193,
Phoenicians, 11, 53	205, 229
Pictorial-style pottery, 10	scarabs, engraved, 85-86
Piombino, 133	sculpture. See bronze sculpture; stone
Pioneers, 64, 75, 76	sculpture; terracotta sculpture
Pistoxenos, 78	Second Style of Roman painting,
plastic vases, 53	216, 229
plates, silver, 202-203	Selene, 169, 174
Pliny the Elder, 44, 87, 176	Seleucid empire, 94, 100
Polydeukes, 34	Selvans, 137
Polygnotos, 40	Septimius Severus (Roman emperor), 170
Polyhymnia, 166	Serapis, 165, 224–225
Polykleitos, 43, 137, 161, 180, 183, 197,	Seven Against Thebes, 166
211	shield strap, 33
Pompeii, 196, 197	Siana cup, 59
Pompey the Great, 87	Sicily, 104
Pontic vases, 140	silver jewelry, 126
Poseidon, 118, 133	silver sculpture, 196
Pothos, 121	silver vessels
Praxiteles, 177	Greek, 48, 97–98
protomes, 32, 51	Parthian, 94–96
Ptolemaios, 202	Roman, 197–198, 200–203
Ptolemies, 43, 93, 100, 165	Sirens, 111, 116–117, 230
Pyrgoteles, 87	Sisyphus Group, 118
Python, 71	Skepsis, 202
	Skylla, 121
pyxides, 6, 54, 229	skyphos, 205
R	
	Smyrna, 26
ram, aryballos in shape of, 53	snakes, depictions of, 120, 141, 198
red-figure painting, 64–69, 71–78,	Spain, 11, 187
80-81, 83, 118-119, 122-125, 229	Sparta, 35, 56
Reggio, 58	Spedos-type sculpture, 7, 9
reliefs, 23, 108, 155	stag rhyton, 97
repoussé, 144, 200, 229	Steiner Master, 9
Rhegion, 58	stelai, xx-xxi, 18, 20-22, 26, 230
Rhesos (Thracian king), 58	stone sculpture
Rhodes, 52, 53, 99	Cycladic, 7–9
rhyta, 96–97, 201, 229	Cypriot, 2
Roma, 183	Greek, 14–30
Rome, 153, 159	Roman, 150–172
rosette, 144	South Italian, 104–108
	stone vessels, 5, 106
S	Sulla, Lucius Cornelius, 173
Sabina (Roman empress), xi–xii	Syleus Painter, 77
Samos, 32, 57	symposion, 62-63, 78, 81, 230
Santa Eufemia Master, 127	Syriskos, 78

T Taras, 108, 114-116 Tartessos, 11 tebenna, 131, 133 Teiresias, 200 Tekmessa, 69 terracotta sculpture, Greek, 114-117 Thea, 77 Thebes, 122 Theos, 77 Theseus, 60, 146 Thessaly, 23, 24 Thetis, 23, 72, 106 Third Style of Roman painting, 219, 230 Thoth, 206 Thracians, 18, 58 thymiateria, 114, 178–179, 230 Timotheos, 153 Tinia, 133 Titans, 78 Tityos Painter, 140 Tivoli, xi-xii, 150, 161 Trajan (Roman emperor), 187, 221 Triptolemos, 77 Triton (sea god), 121 triton, 48 Trojan War, 58, 69, 106, 168 Turan, 136 Turkey, 3, 14, 26, 27, 52, 166 Tyche, 28-29, 93, 166

V Vanth, 136
Veii, 143
Victorian Yearly

U

Victorious Youth, statue of, 44–45 Villa dei Papiri, vii, xv–xvi, xxi Virtus, 183 volute-kraters, 72–73, 81, 118 votive relief, 23, 230 votive statuette, 138, 230 Vulci, 130, 132, 135, 140

W wall paintings, 142, 216–220 white-ground painting, 70, 79 Wild Goat pottery, 52–53 wreaths, funerary, 88–90

Xerxes, 18

Z

X

Zeus, 25, 71, 121, 122, 124, 169.

See also Jupiter

Zeus Ammon, 25

zone cup, 62

Acknowledgments

Considerable efforts of many people are required to complete a book of this scope, and I owe all of them my gratitude. Most important among them are the members of the Antiquities Department, both past and present, who shared the writing of the more than two hundred entries included in this new publication. Marit Jentoft-Nilsen, John Papadopoulos, Karol Wight, Janet Burnett Grossman, Mary Louise Hart, and Elana Towne-Markus all tackled this prodigious task with enthusiasm and dedication. They were assisted by Kara Nicholas, Susanne Ebbinghaus, and Elizabeth de Grummond, who served as interns while the manuscript was in preparation. Thanks are owed as well to our team of skilled conservators, including Jerry Podany, Maya Elston, Jeff Maish, Susan Lansing Maish, and Eduardo Sanchez, who undertook new restorations and delicate retouching of many objects so that they could be included, often with new

photography. The preparation of the numerous excellent illustrations involved several skilled photographers, principally Ellen Rosenbery working together with Jack Ross, Lou Meluso, and Anthony Peres of the Museum's Photo Services Department, but also freelance photographer Bruce White, who provided some of the images for objects originally in the Fleischman collection. Our search for archival photographs to accompany the introduction was made successful by the aid of two associates. David Farneth, Institutional Archivist, Getty Research Institute, guided us with liberal thoroughness. Finally, Stephen Garrett, Mr. Getty's architect who oversaw the construction of the Villa and then served as the Museum's first Director, shared his personal archive with exceptional generosity.

Marion True

Net-Pattern Bowl, detail (see p. 95).